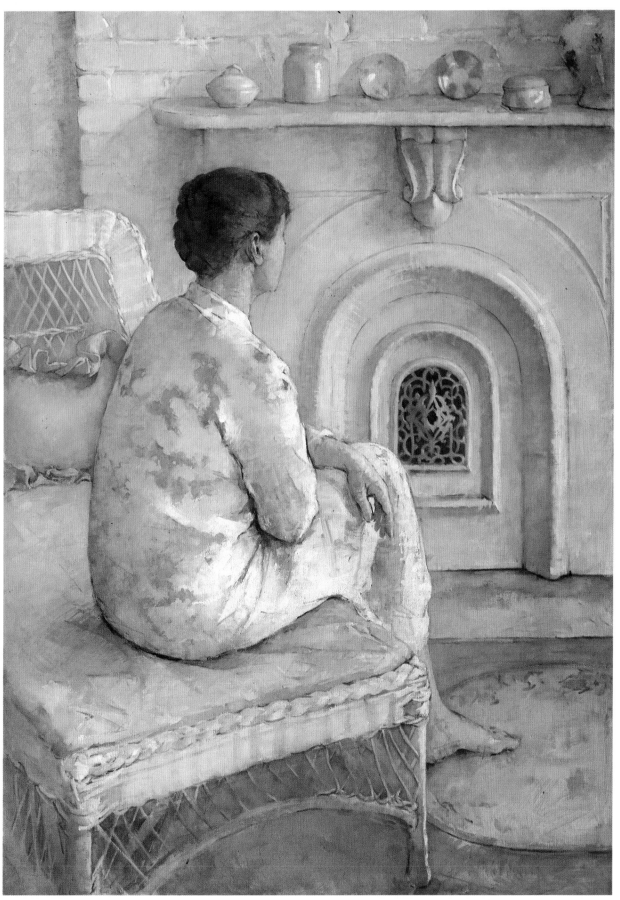

MARBLE FIREPLACE, oil on canvas, 56″ × 40″ (142.2 × 101.6 cm), collection of Bette and Howard Fast.

A PAINTERLY

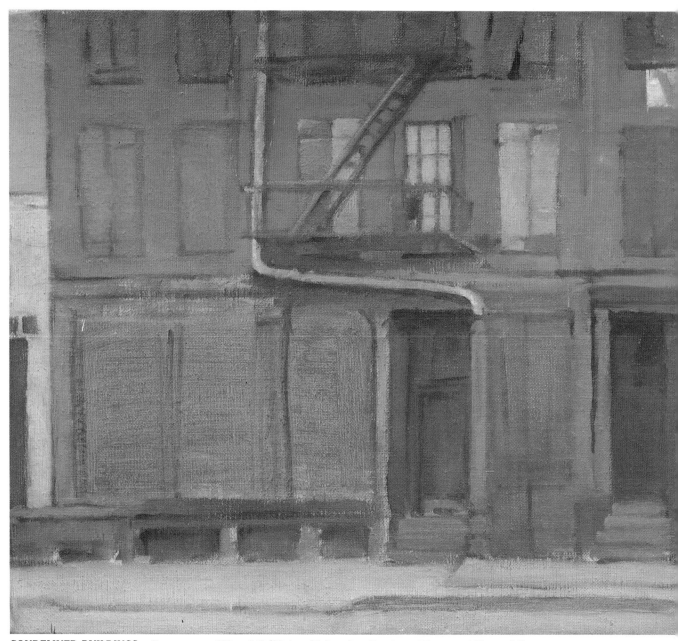

CONDEMNED BUILDINGS, oil on canvas, 12″ × 24″ (30.4 × 60.9 cm), collection of Bette and Howard Fast.

APPROACH

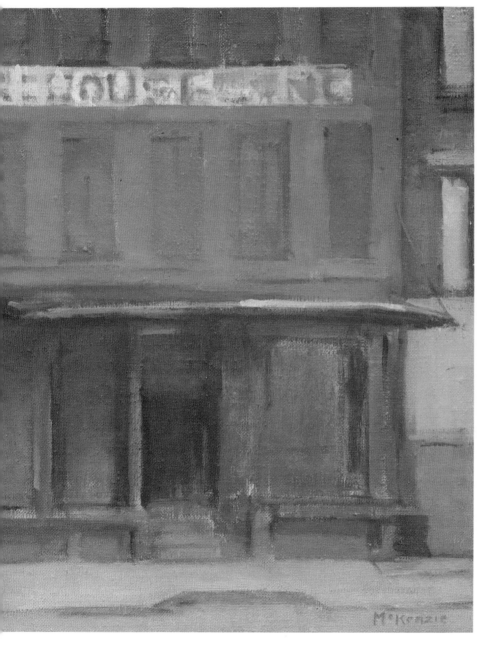

Mary Beth McKenzie

WATSON-GUPTILL PUBLICATIONS/NEW YORK

All photographs in this book, with the exceptions of those on pages 16, 17, and 50, were provided by Tony Mysak of Studio Nine, Inc.

Copyright © 1987 by Watson-Guptill Publications

First published 1987 in New York by Watson-Guptill Publications, a division of Billboard Publications, Inc., 1515 Broadway, New York, N.Y. 10036

Library of Congress Cataloging-in-Publication Data

McKenzie, Mary Beth.
 A painterly approach.

 Includes index.
 1. Painting—Technique. I. Title.
ND1500.M35 1987 760′.028 87-16203
ISBN 0-8230-3492-5

Distributed in the United Kingdom by Phaidon Press, Ltd., Littlegate House, St. Ebbe's St., Oxford.

Manufactured in Japan

1 2 3 4 5 6 7 8 9 10 / 92 91 90 89 88 87

in memory of my mother and father

to Tony

I wish to express my appreciation to a number of people for their assistance in the preparation of this book. Above all, I want to thank Bonnie Silverstein, my editor, for urging me to write this book. Her enthusiasm for my work and for this project encouraged me to actually undertake it. I want to thank Candace Raney for editing with such care and Areta Buk for her design of the book. I am especially grateful to Rose Kaplin; she helped me to put many of my thoughts into words and to express my ideas more clearly. Several of my students were very helpful to me; they read chapters-in-progress and made valuable comments that made me think about just what it was that I was trying to say. They are Dan Gheno, Lauren Goodrich, Gitte Blass, and Michele Liebler.

I would very much like to thank all of the people who have been a part of my work: the many models who have devoted their time to posing for me over the years, in particular Victoria Prewitt and Maya Farnsworth.

I especially want to thank my husband, Tony Mysak, for the excellent photographs of my work and also for his love and support.

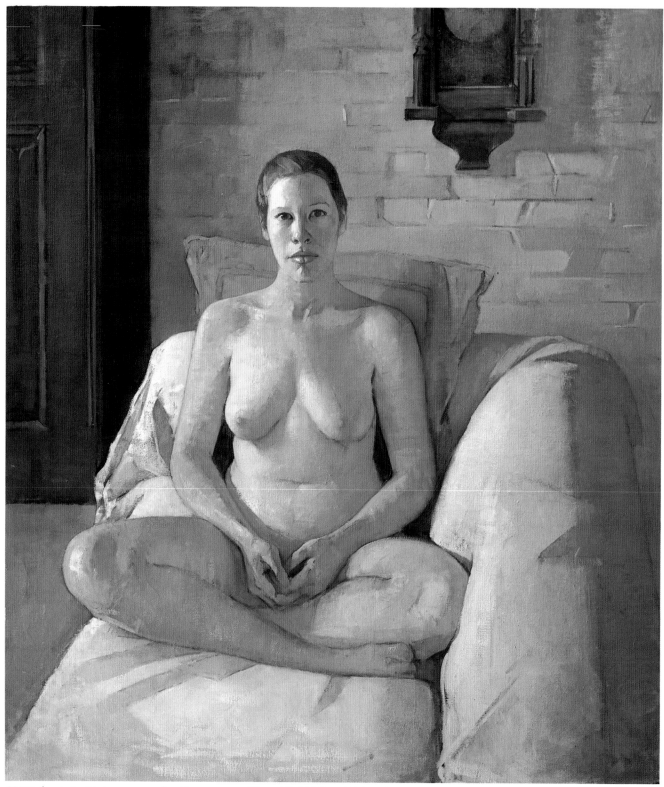

MAYA (seated with legs crossed), oil on canvas, 51″ × 46″ (129.5 × 116.8 cm), collection of the artist.

CONTENTS

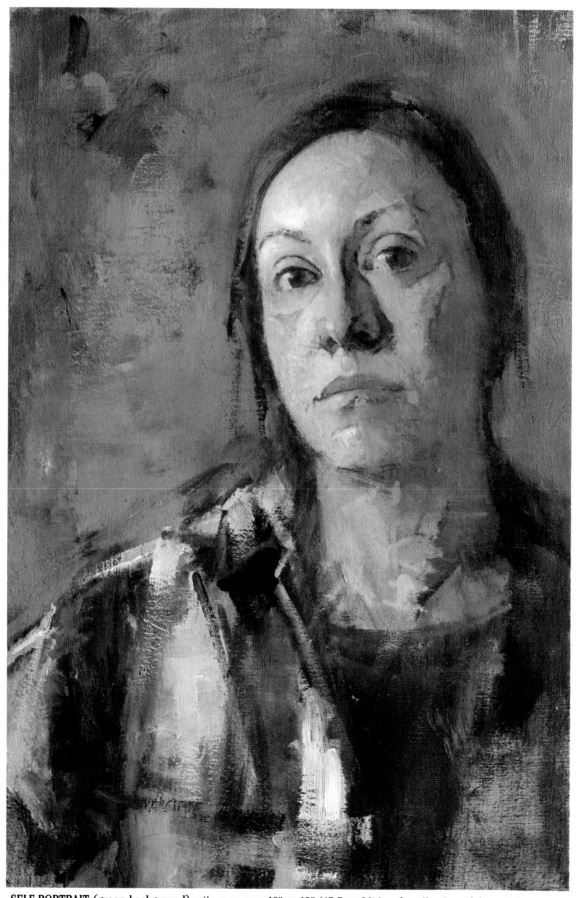

SELF-PORTRAIT (green background), oil on canvas, 18″ × 12″ (45.7 × 30.4 cm), collection of the artist.

INTRODUCTION

In this book I am not offering a formula or a specific set of procedures to follow. I describe my basic approach to painting and give you some ideas to work with. I think that painting is extremely personal. Depending on your temperament, each of you will find your own way of working. The word *painterly* is usually thought to mean "working in a loose manner," but that is not my meaning here. What I am suggesting is that you approach painting in a broader, more abstract way, and that you deal with the entire canvas and not just with parts of it. I believe that a painting should develop as a whole and that you should think in terms of color and form and relationship and rely less on drawing, particularly in the early stages. By *painterly* I am suggesting that you make the forms happen with color as opposed to line, whether you are working in oil, pastel, or monotype.

The process of writing has forced me not only to find a way of expressing my views but to examine and clarify them. Although I found this process very difficult, it has been a valuable experience. Writing this book has also forced me to examine my work and the direction it is taking. I hope that my painting will continue to develop and change. Seeing it this way, all together, somewhat like a show, is not only very interesting to me but, I suspect, will prove to be very helpful as I go on with my work.

—Mary Beth McKenzie
New York City, 1987

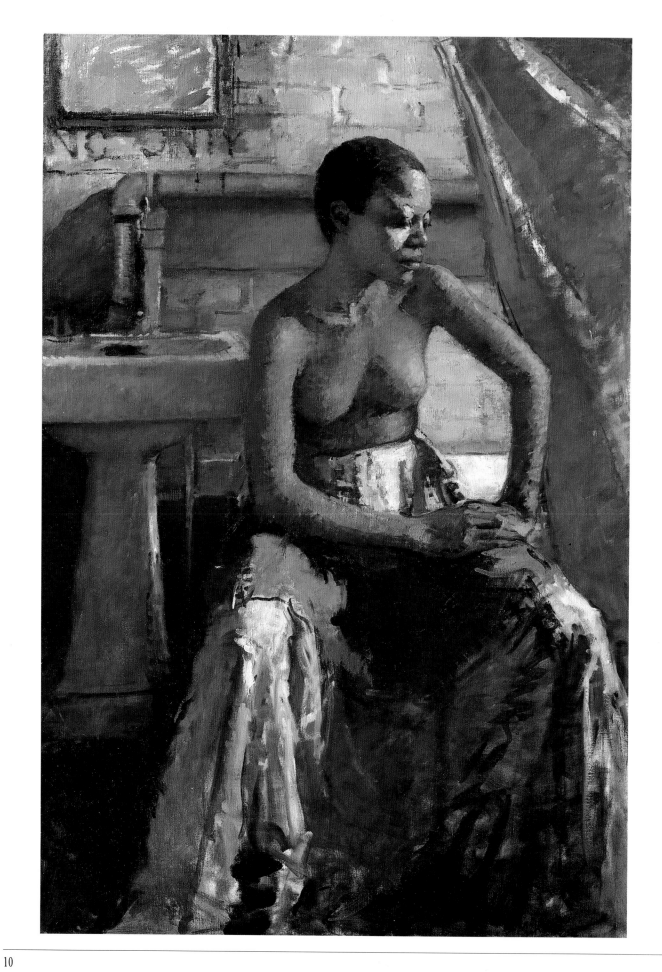

EVOLVING AS AN ARTIST

In this first chapter I describe my own development as an artist: starting to paint on my own, my work habits, and what or who directly or indirectly shaped my development. The paintings reproduced here are early ones and are among the first paintings that I felt were totally mine, without any direct influence from my instructors.

Growth for an artist is generally slow and unconscious. Real progress takes place over a long period of time. As you develop your ability to draw and paint, and as you expose yourself to more of what has been done by others, your views will change. This is a continuing process. I find that students are usually too concerned with results, with coming away with a finished painting, instead of being concerned with what can be learned from each attempt. In the beginning, I think you learn faster by doing many starts and taking each painting a little further. Something valuable, something that will deepen your understanding, can be learned from each painting. Often you learn more from a painting that doesn't succeed. Hard work is one of the most important elements in the development of any artist. Everything comes out of the work, and you have to paint and paint and go through canvas after canvas.

Unless you approach painting with a highly experimental attitude and are willing to take risks with your work, your progress will be extremely slow. It's important to continually challenge yourself, to set up problems for yourself in order to develop your technique, and to experiment with new ideas. Vary your approach; try different mediums, different-sized canvases, unusual points of view, more ambitious compositions. Always try to extend your reach. In this way your work will continue to change and develop naturally. You must evolve as an artist, and this is really a lifelong process.

DRAWING

Although I seldom do "finished drawings," I draw all the time. I carry a small sketchbook with me and sketch on buses and subways, or out on the street. This is a wonderful way to study people (hopefully unobserved) and to keep a record of your thoughts and observations—almost like a personal diary. These sketches are sometimes a source of ideas for paintings, but I usually do them just because I really love to draw. You gather a lot of information about people when you observe them in the way that you must to sketch them. Because you must work so quickly, you are forced to grasp the essentials, and as a result, you sharpen your perceptions.

I also attend an open sketch class once or twice a week where I can work freely from a live model. The best way to develop your drawing ability is to draw from life as much as you can. Most art schools offer sketch classes, and they are generally not very expensive. If such a class is not available, you can organize a small group to share the expense of a model on a regular basis. Learning to draw is an on-going process of discovery that should continue as long as you continue to draw.

Sometimes I think that drawings are even more personal than paintings because drawings are so imme-

JACKIE
oil on canvas, 50″ × 34″ (127.0 × 86.3 cm),
collection of the artist.

Although the composition in this painting is complex and there are many areas with strong light and dark contrasts, I feel that I was successful at maintaining the integrity of the figure while stating the shadow patterns abstractly. I intentionally left less important parts of the painting loose and somewhat unfinished.

WOMAN SLEEPING ON A SUBWAY
pencil on paper, 4⅛″ × 5³⁄₁₆″ (10.5 × 13.2 cm).

WOMAN ON A BUS
pencil on paper, 5⁹⁄₁₆″ × 3⅞″ (13.9 × 9.8 cm).

diate. All the lines of a drawing remain on the paper, and you can see how the drawing evolved. You can see how the lines were searched for and the choices that were made when certain lines were emphasized. A drawing can be very direct (and even crude) or extremely polished and be effective. I suggest that you do a lot of drawing and also study the drawings of artists whom you admire. You might even consider copying some of their drawings as a form of exercise. I particularly love the drawings of Rembrandt, Degas, Matisse, Käthe Kollwitz, and Egon Schiele. All of these artists devoted a great deal of themselves to drawing.

DRAWING AS IT RELATES TO PAINTING

I want to impress upon you the importance of drawing in relation to painting. When you paint, you draw and paint at the same time; the two are inseparable. A painter hopes to render form through color, not through drawing an outline and coloring it in. Drawing does not consist only of line; there is another kind of drawing. Every painting has a skeleton, or structure, a drawing underneath, even if the lines are not immediately visible. There you find the large movements and rhythms, the outlines of the shapes, their directional movements and relationships to one another, and in the patterns of the large masses of both light and dark. The eye is directed to move purposefully through the painting, and it is the artist who determines this movement through drawing.

Line also has its place in painting and can be beautiful in itself. There is nothing more beautiful than a line that brings out a form and tells you something about it. This can be a real line or it can be the edge where one shape meets another, without the use of an actual line between them. The figure can be drawn by painting only the negative shapes that surround it, by using the background color to make the edge.

ANATOMY AND PERSPECTIVE

I studied anatomy extensively at the Boston Museum School and also attended a series of lectures on anatomy at the Art Students League. What I found most valuable, however, was a sculpture class with an instructor who was very concerned with anatomy. Working in three dimensions made me more aware of the structure of the body and of how the muscles actually work than I had been when merely learning their names and drawing them out of context. I can no longer name each bone and muscle, but I am left with an awareness and understanding of what is underneath and how the body moves. I believe that the study of anatomy is valuable for artists. I also believe that some study of sculpture is very valuable for painters. It gave me an altogether different feeling for form than I had had before.

Although I feel that the formal study of perspective is unnecessary, I think it is essential to understand the basic principles. This knowledge, together with accurate perception, should solve most of the problems that crop up during the course of a painting. Further study of perspective is a matter of special interest and is not for everyone.

INDIRECT INFLUENCES

I have a large collection of books and catalogs with good-quality reproductions. These books cover a wide variety of subjects: painting, drawing, printmaking, sculpture, art history, architecture, and photography. Many represent individual artists: artists of the past and contemporary artists who interest me. Some of my books are technical (dealing with such things as the chemistry of painting, the uses of various materials, and the care and maintenance of works of art).

Without your realizing it, everything you read or do or see has an effect on your view of the world; therefore, you should experience as much as possible. Although painting is the focus of my life, all the arts (especially literature, film, and all the performing arts, particularly the theater) are interesting to me and affect my work.

All artists have been influenced by the work of other artists. Knowledge of the lives of individual artists and the times they lived in can give you a very different understanding of their work. Elements of their lives may be very similar to your own. Try to figure out what makes you respond so strongly to certain paintings. You will probably develop many influences. Many will remain

COURTROOM SKETCH
pencil on paper, 4″ × 5¾″ (10.1 × 14.6 cm).

This drawing and the two above are from sketchbooks that I always carry with me. These sketches were done very rapidly from life without the subject's knowledge. I rarely get to take these drawings as far as I would like to because people frequently change their position, particularly if they suspect that I am trying to draw them.

constant, but some will change as you do. As you seek new means of expression in your work, you may come to admire an artist who a year earlier did not appeal to you. Be open to this; it is probably because you have come to understand what that artist was after. Since you are searching and changing yourself, your response to other artists will also change.

An enormous amount may be learned by looking at and studying paintings. I spend a lot of time in museums. I consider myself very fortunate to live in New York City where I have access to so much; there are so many permanent collections, and many traveling exhibitions come here. Not only is this inspiring, but when I'm

having trouble with a painting I often find solutions to problems.

Since so many important works of art are in Europe, I highly recommend travel and study in Europe. Not only can you see art but the whole experience will be invaluable, because learning about and knowing other cultures gives you a broader grasp of humanity. If you can't go to Europe at the present time you should at least try to go to the nearest big city, especially to see an important traveling exhibition.

Nothing can compare with actually seeing and experiencing a painting. No matter how good the reproduction, a photograph in a book cannot evoke the same response

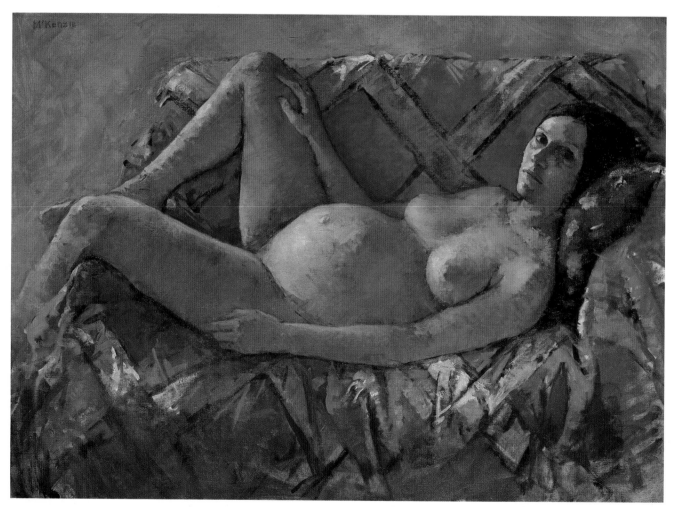

FIRST CHILD
oil on canvas, 32″ × 44″ (81.2 × 112.2 cm),
collection of the artist.

I found the curved and weighty forms of the woman very interesting in relation to the angular shapes of the bedspread. While laying in the shadow patterns of the model's body, it seemed to me that things kept changing. I finally realized that the baby's movements were affecting the form.

MARK ALAN ISAACSON
oil on canvas, 36″ × 24″ (91.4 × 60.9 cm),
collection of the artist.

I started this painting in the winter, but I worked on it for so long that my friend had to pose in his winter jacket in front of the air conditioner in order for me to finish it. Fortunately, he is a very close friend.

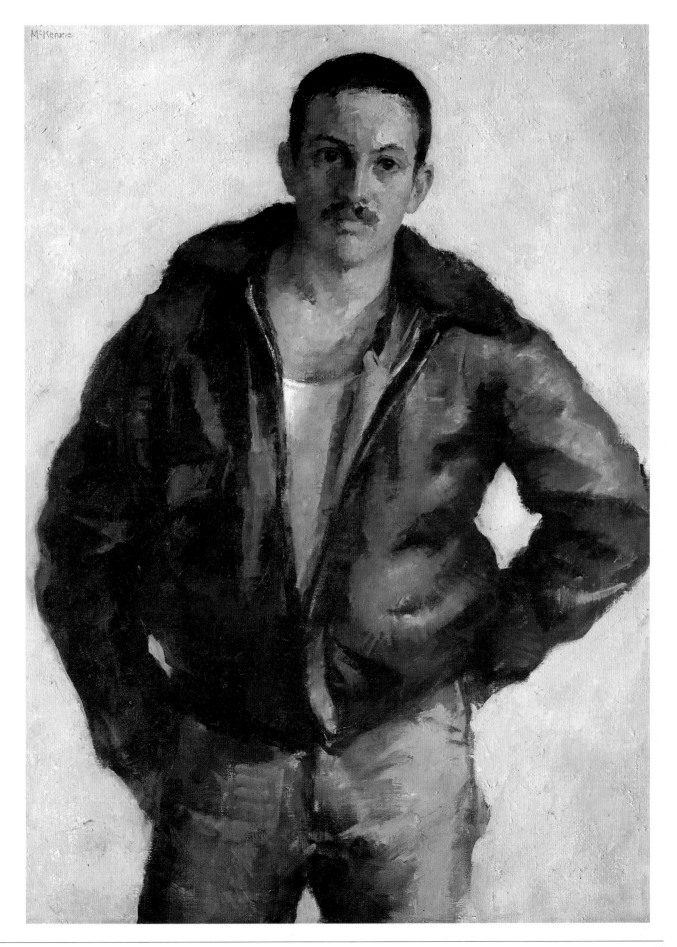

or give you any idea of scale or the impact of color or a sense of the paint surface. Before going to Spain, I thought I was familiar with Velásquez. Nothing I had seen prepared me for the awe I felt standing in one room of the Prado with all four court jesters before me. In Florence I was overwhelmed by the *Battle of San Romano* by Paolo Uccello and later by the other two paintings that comprise this triptych, which I later found in Paris and London. The design is beautifully complex and simple at the same time. I was deeply moved by the paintings of Egon Schiele which I saw for the first time in Vienna. I had seen photographs, but they had no effect on me compared to the actual paintings. There are certain artists whose work cannot be seen at all unless you go to where the work is, for example: the frescos of Piero della Francesca. It's impossible to get a sense of the paintings without actually seeing them. Many of Michelangelo's sculptures are part of settings that he designed. In fact, in many instances, the setting itself is as important as the individual pieces. While traveling in Europe not only did I see certain artists for the first time, but I also came away with a fuller appreciation of artists with whom I was already quite familiar.

Copying paintings, which can be done at any museum, is a good means of learning from the past. You should keep in mind, however, that you are copying the result, not the process. My class has copied paintings with meaningful results at the National Academy of Design galleries during an Abbott Thayer exhibit and during a self-portrait show. The students were forced to try new things and to break habits they were developing. Copying is a wonderful way to increase your understanding and a very personal way of experiencing a painting. By analyzing a painting so closely, you can understand it in a way that you can't by just looking at it for the same amount of time. Many artists in the past copied artists they admired.

DIRECT INFLUENCES
My early and very valuable training was with José Cintron in Cleveland, and then with Daniel E. Greene in New York City. Although I only studied a short time with Robert Brackman, I feel his influence as a teacher very strongly. I am indebted to these people.

Robert Philipp had a tremendous influence on me. While I was still in his class at the National Academy of Design, he asked me to pose for him at his studio in Carnegie Hall. I have such fond memories of his studio, crammed with paintings of various sizes and at various stages of development. I learned so much from this exprience, watching him paint, seeing the paintings develop, and also getting to know him, which I did over the next twelve years. He was seventy-five when I met him, and his remarkable enthusiasm and excitement for

life as well as for painting was contagious. I never left his studio without feeling a renewed motivation and inspiration. He really enjoyed the act of painting, and through his bold handling of paint I became aware of a more sensuous side to painting, a lushness of paint surface and a beauty of color. I loved his loose, seemingly effortless way of working.

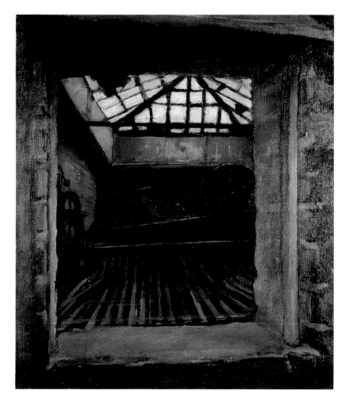

ELEVATOR SHAFT
oil on canvas, 23″ × 26″ (58.4 × 66.04 cm), collection of the artist.

On the roof of my building I opened a door and found an unsuspected little world, the top of the elevator shaft. The equipment is old, still in use, and probably is just the way it was at least seventy-five years ago. A considerable amount of this painting was done using a painting knife.

WORK BENCH
oil on canvas, 30″ × 24″ (76.2 × 60.9 cm), collection of John Calver.

Still life is not a frequent subject for me, but when I do paint one it is usually because I respond to an arrangement of objects that already exists. These jars sat on a workbench that serves as a counter in my kitchen, and I became fascinated by their various shapes and patterns. Also, at that time I had just discovered Breughel's work and was very interested in his way of directing the eye through a very complex pattern of colors and shapes.

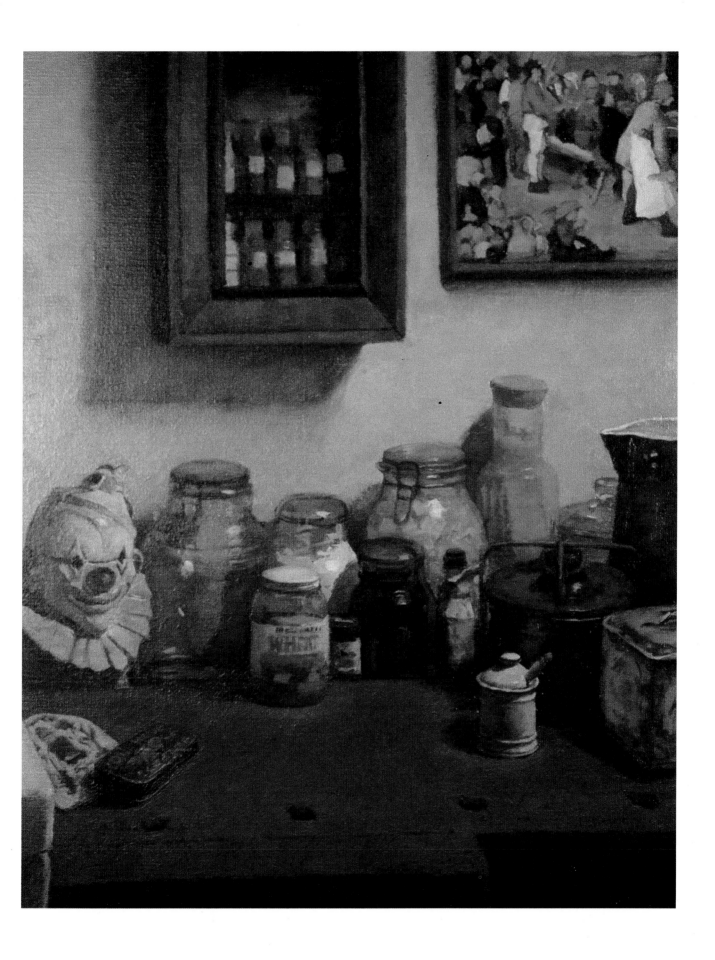

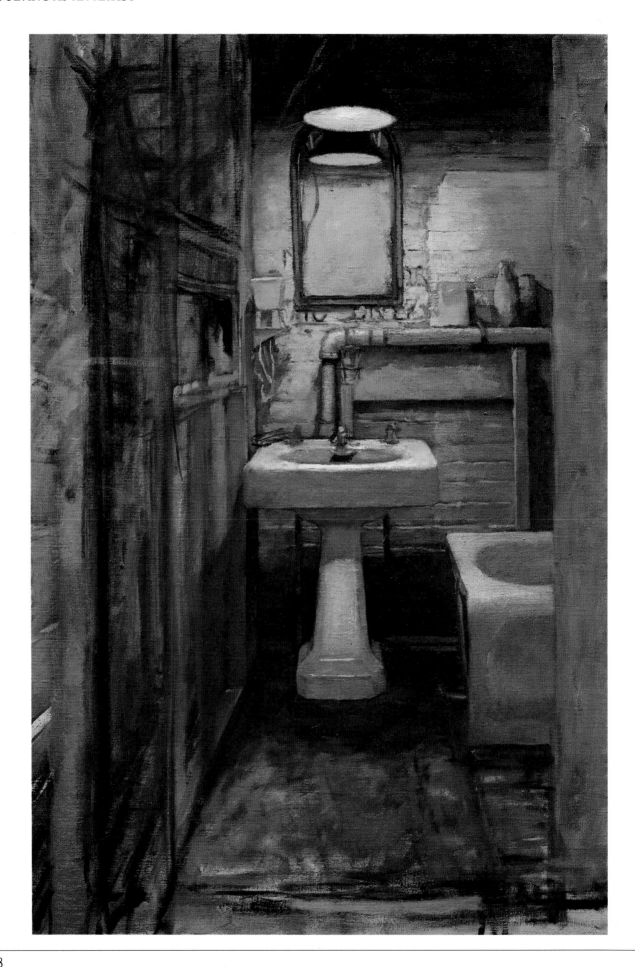

He was also a link for me with the great tradition of painting. He had such wonderful stories about artists he had known personally or had had some contact with, such as John Singer Sargent, Frank Vincent DuMond, and many of the German artists, like Wilhelm Leibl and Adolf von Menzel—people I could only read about. Up until the time he died (at eighty-seven) he still painted almost every day. Being around him made me realize that painting is a way of life; and the faith he showed in me also encouraged me to believe in myself as an artist.

A friendship of this sort can be very important when you first start to paint on your own. Without a teacher or the constant feedback from the other students in a class, painting can be a very lonely prospect at first. Models are very expensive, and discipline takes time to develop. I found the first few years painting on my own incredibly frustrating. In retrospect I realize that this was a necessary period for sorting things out and starting the process of trying to find myself, particularly since I had studied with several teachers who had differing and conflicting views and approaches. For a two-year period I destroyed almost everything I painted, and, I suspect, with good reason, although I might feel differently if I could see the work now.

Because I was so confused during this time, I began to study privately with Burt Silverman. He is a wonderful teacher. He helped me to clarify my thinking and also to think more about what I was painting. The class met two afternoons a week, in his studio. Seeing his own work as it progressed from week to week, in combination with studying with him part of the time and working on my own most of the time, was very helpful. The class itself was particularly exciting. I think that a certain level of energy is created by a group of very talented students; they spur each other on and learn from one another as well as from the teacher. This class was very meaningful for me, particularly the friendships I developed with Ronald Sherr, Mark Isaacson, and Sharon Sprung. We sometimes shared models and exhibited our work together in the beginning. My association with them and with another artist, Nancy Buirski, from an earlier class, helped to shape my thinking and influenced my work. About this same time I got to know two other artists whom I had admired for some time: Everett Raymond Kinstler and Harvey Dinnerstein. Both of these friendships are of special importance to me.

WORK HABITS

Most important, I think, when you are starting out on your own, is setting up good work habits. Sometimes I am very inspired and I go through extremely productive periods, but there are also times when I don't seem to have any ideas or any excitement about painting. Whatever my state of mind I try to work every day and at definite times. This is not always possible, but I find that a certain rhythm is necessary in painting. You cannot wait for inspiration. Ideas come from somewhere, they evolve, and one thing leads to other things. Once you begin painting, you sometimes find an inspiration you thought was missing. By putting something on the canvas, you give yourself something new to respond to—and, as more is added, more ideas generally start to flow. If I am really unable to get involved once I start, I don't continue but try to do something related. I may use this time to prepare boards or to stretch canvases for later use, or perhaps go to a museum or gallery. Sometimes the only answer is to get away from painting altogether for a little while.

You never stop learning, but at some point formal study should end. After you have developed your skills to a certain point, I feel that it is harmful to remain in a classroom where too many decisions are already made for you. You must begin to explore your own thoughts and ideas and to develop your own way of seeing things if you want to allow your work to evolve toward a personal style.

LOFT INTERIOR
oil on canvas, 36″ × 24″ (91.4 × 60.9 cm), collection of John Bradley.

This is a view into the bathroom area of the loft in which I live. In the chapter on pastel, there is a pastel version of this same subject.

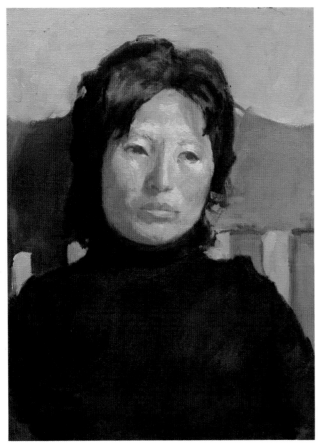

HYO CHONG YOO
oil on canvas, 14″ × 11″ (35.5 × 27.9 cm),
collection of Dr. Carole Brafman-Sharpe and Myron Sharpe.

*The model is an artist and a friend. At the time this portrait
was painted, she and I were both studying with Robert Philipp
at the National Academy of Design. We posed for each other
several times outside of class. I think it is very helpful to work
on your own at the same time that you are in a class. Working
outside of the class forces you to explore your own ideas; you
think differently in these two very different situations and
therefore will develop faster.*

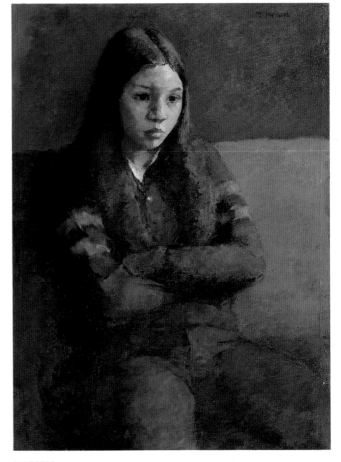

MARTHA
oil on canvas, 30″ × 21″ (76.2 × 53.3 cm),
collection of Janice Addams.

*In this picture the focus is very much on the face and head.
The model is the ten-year old daughter of a friend. I set up a
television set for her to watch while she was posing. This
made the painting possible because it held her attention for
long stretches of time.*

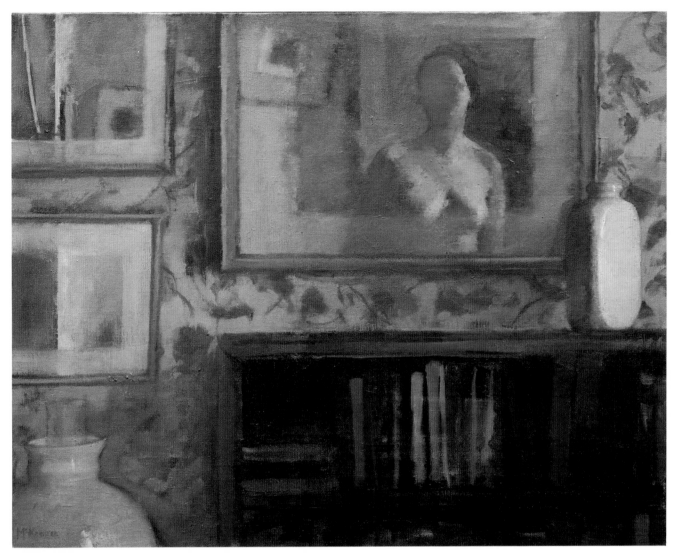

REFLECTIONS
oil on canvas, 24″ × 30″ (60.9 × 76.2 cm),
collection of the artist.

*This corner of a room was fascinating to me because of the
abstract relationships among the many rectangular shapes
and the reflections within them. I was able to work on this
painting only in the early morning; after that the sun came in
and obscured the reflections.*

MY FATHER ASLEEP
oil on canvas, 16″ × 12″ (40.6 × 30.4 cm),
collection of the artist.

I finished this painting fairly quickly, in only two sessions, while visiting my parents in Ohio. Painting people in their own surroundings has always appealed to me. The things that people chose to have around them generally say something to me about those people.

MY MOTHER AND FATHER
pencil on paper, 5¼″ × 4¼″ (13.3 × 10.8 cm),
collection of the artist.

This is a study of my mother and father. At the time, my father was very ill.

MY FATHER DURING AN ILLNESS
pencil on paper, 7¾″ × 4¾″ (19.7 × 12.1 cm),
collection of the artist.

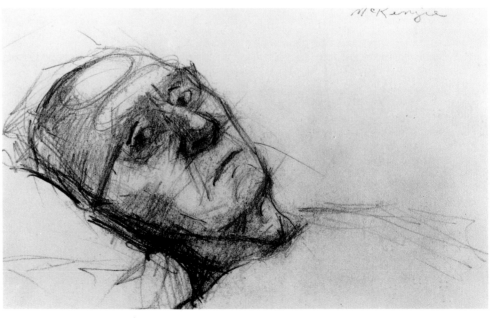

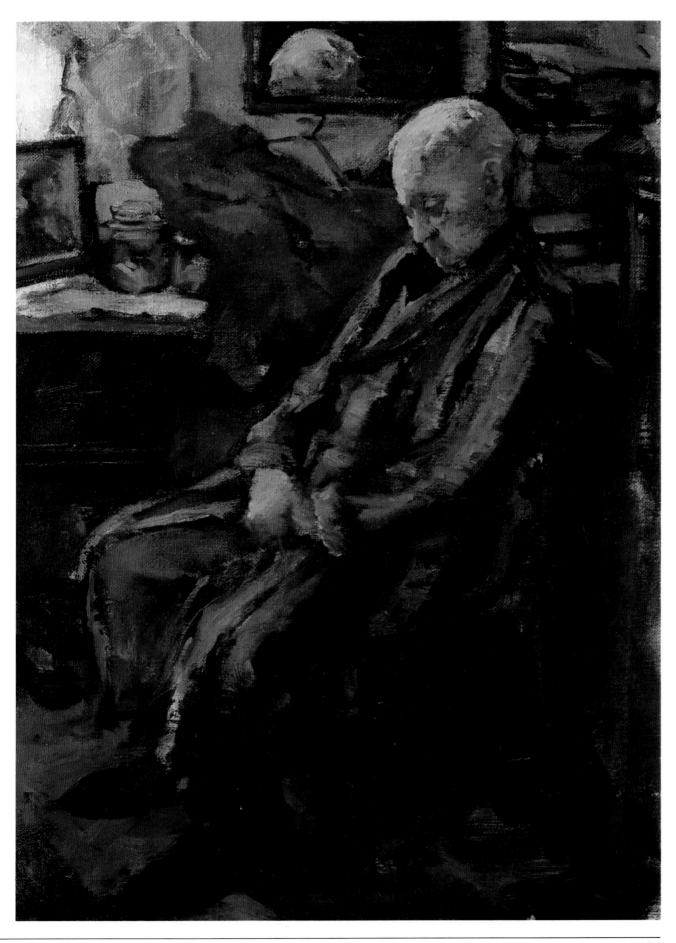

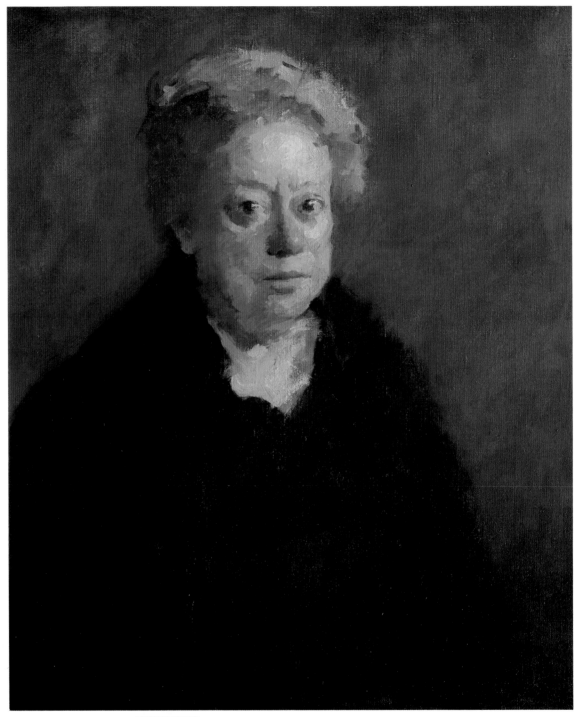

MY MOTHER
oil on canvas, 24″ × 20″ (60.9 × 50.8 cm),
collection of the artist.

*Of the many paintings I've done of my mother, this is my
favorite because I feel that I've caught something of her very
strong character. This painting was done very quickly, in only
three sittings, during a visit she made to New York. Before
starting this painting, I had worked for five days on a different
canvas but had become dissatisfied and discarded it. Looking
back, I'm sure this earlier effort was not wasted. Through it I
had gained insight and was able to approach this painting
with a clarity and directness I did not have in the first one. At
times it is much easier to start over than to struggle with a
painting that is not working.*

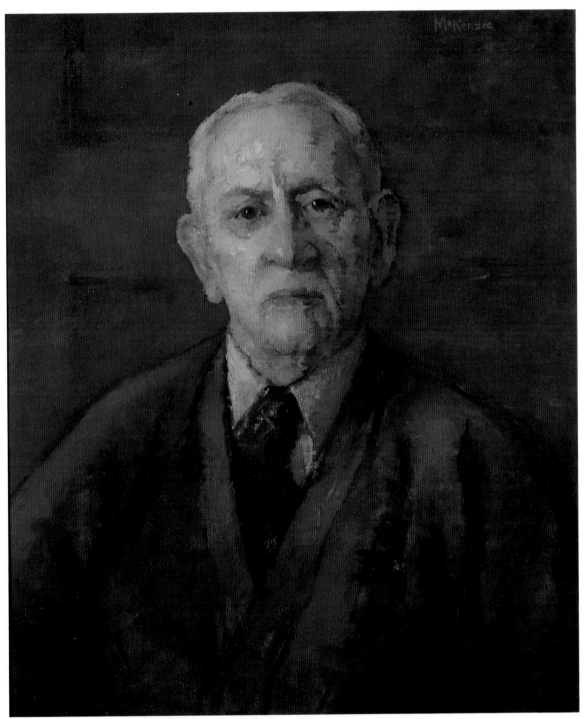

MY FATHER
oil on canvas, 24″ × 20″ (60.9 × 50.8 cm),
collection of the artist.

Like the portrait of my mother on the opposite page, this is a very early painting. Many of the portraits I did at this time have very dark backgrounds and more contrast than I use now. In my more recent work I am more concerned with color. At that time I was very influenced by Rembrandt and by Velasquez, particularly by their dramatic use of light and dark.

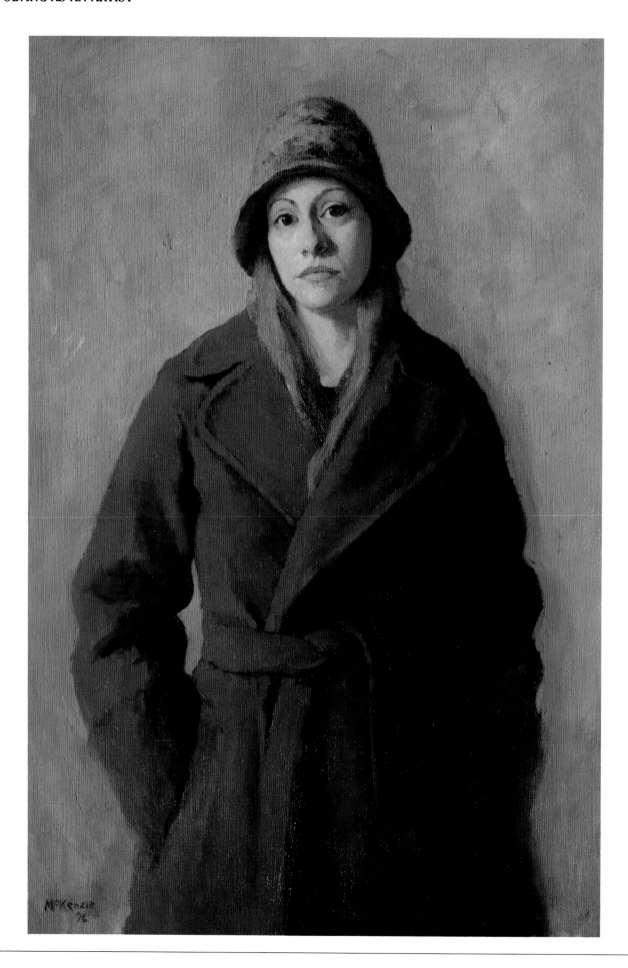

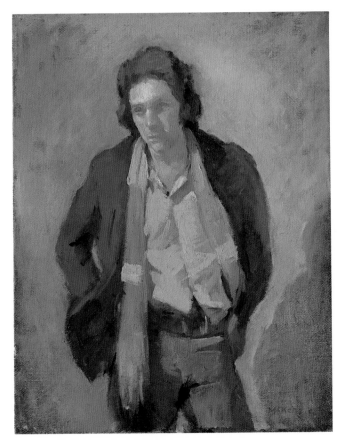

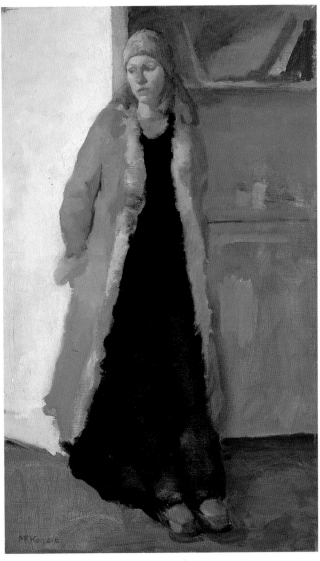

YOUNG MAN IN A PINK SHIRT
oil on canvas, 14″ × 11″ (35.5 × 27.9 cm),
collection of Bette and Howard Fast.

Young Man in a Pink Shirt *and* Waiting *were done during the time I was studying with Burt Silverman. The shapes are modeled very simply with almost no detail, and this is something I associate with and like very much about Burt's work. Both paintings are small in scale and were completed in two or three sittings under artificial light.*

WAITING
oil on canvas, 20″ × 12″ (50.8 × 30.5 cm),
collection of The Art Students' League.

SELF-PORTRAIT WITH HAT
oil on canvas, 36″ × 24″ (91.4 × 60.9 cm),
collection of Dr. Carole Brafman-Sharpe and Myron Sharpe.

Sometimes circumstances are an important factor in the selection of a subject. I wanted to paint, but it was too cold in the loft for me to ask a model to pose so I used myself as a model. The overall lack of detail and the simple shapes help to focus attention on the face. The coat and hat act as structural supports.

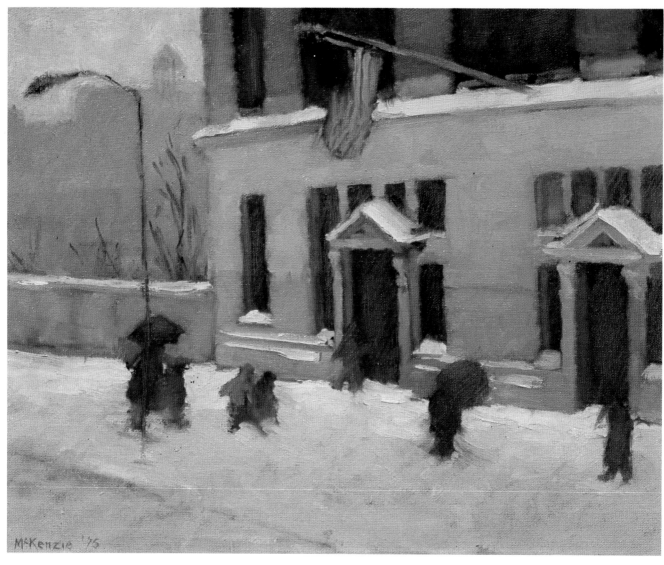

A WINTER DAY
oil on canvas, 16″ × 20″ (40.6 × 50.8 cm),
collection of Connie and Dr. Peter Ewald.

*The first snow of the year always means a certain excitement
for me; there is something magical in the way even the most
familiar scene is visually changed. This painting was done
from my window, all on the same day, in about five hours. I
was able to complete it in such a short time partially because I
was working on an already built-up surface. I often paint over
an old canvas when I know my time will be very limited.*

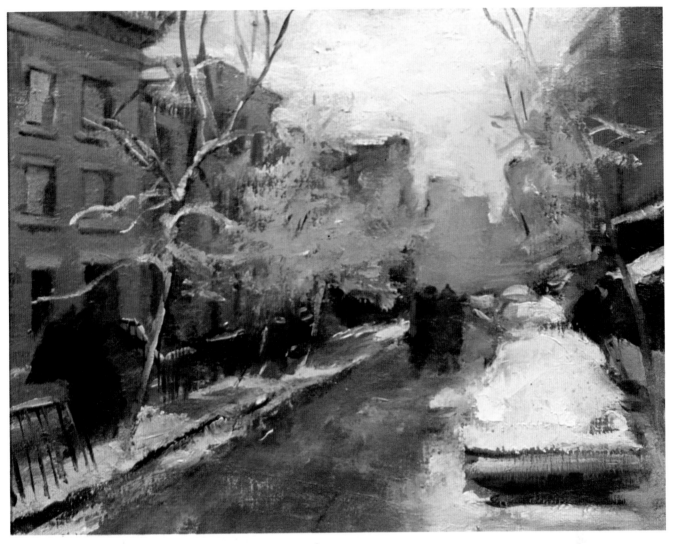

WINTER STORM
oil on canvas, 16″ × 20″ (40.6 × 50.8 cm),
collection of Sharon van Ivan.

*I did this painting outdoors in the middle of a snowstorm.
Although it is obviously difficult to work outdoors for long in
winter, I have managed to do this several times because I love
to work directly from life. To paint under these conditions, it is
necessary to work very fast and get things down right away.
Standing on cardboard or on a piece of wood gives some
protection from the cold.*

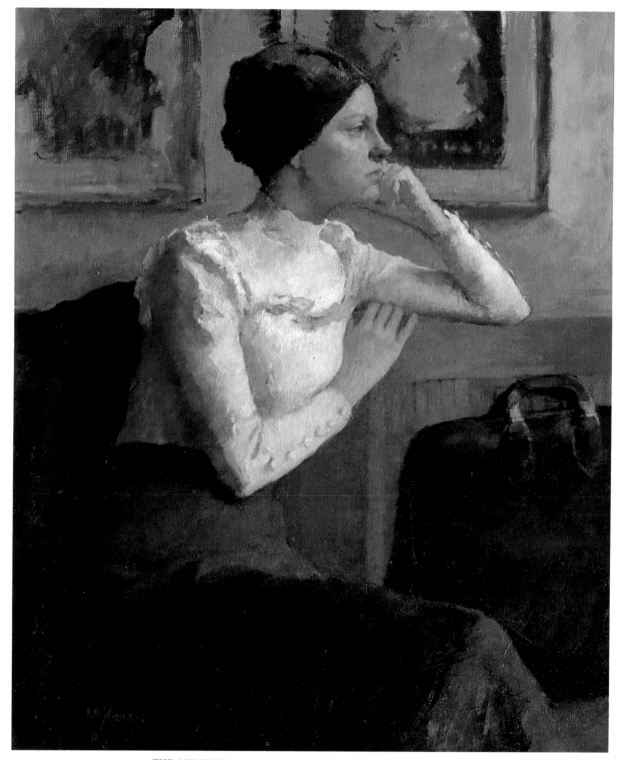

THE AUDITION
oil on canvas, 40″ × 30″ (101.6 × 76.2 cm),
collection of Kathleen Conry.

*The model is an actress. She made the mistake of visiting my
studio on her way to an audition while dressed in period
clothing, and I persuaded her to pose. The theater and
everything associated with it, including the tension of audi-
tions, fascinates me. As a painter I do most of my work in the
studio and acceptance or rejection come later; performing
artists constantly face rejection while they are working, which
is something I can't imagine.*

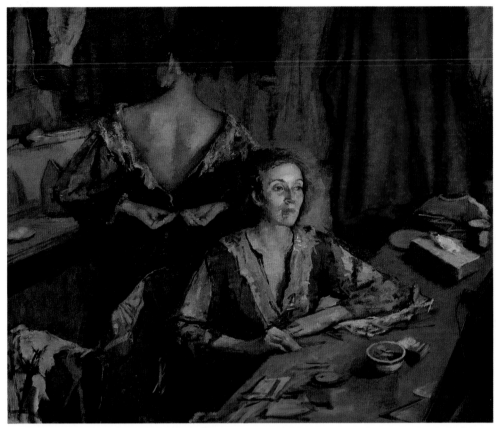

CHOICES
oil on canvas, 40″ × 48″ (101.6 × 121.9 cm),
collection of Jessica Richman.

This painting was done in the dressing room of an off-Broadway theater where one of the models, both of whom are actresses, had appeared in a play called Choices*. As always, the pictorial possibilities in a real place outside my studio were exciting to me.*

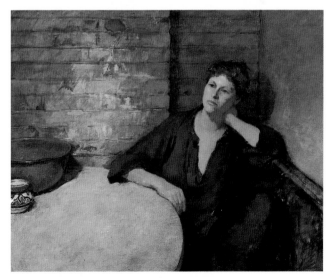

BRICK WALL
oil on canvas, 34″ × 42″ (86.4 × 106.6 cm),
collection of Marion and Sidney Richman.

Looking at this painting, which was done years ago, I find that I still feel very good about it. I like the solidity and movement created by the strong abstract patterns.

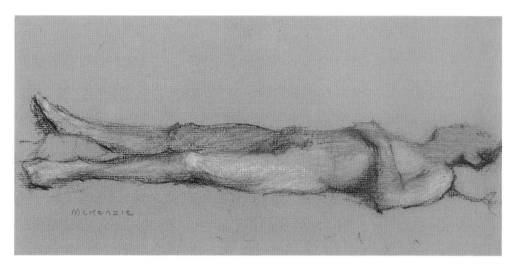

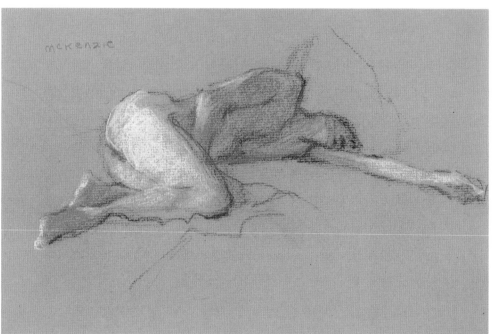

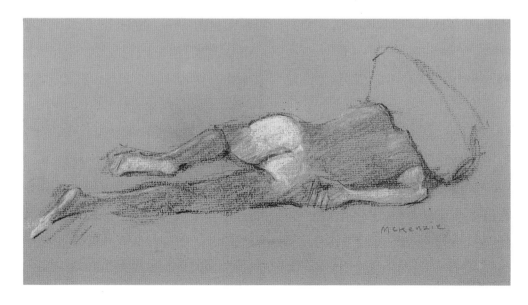

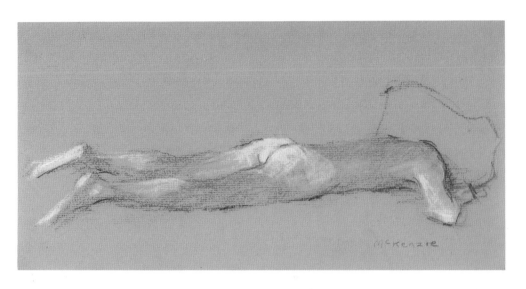

SLEEP
pastel on paper,
collection of the artist.

I did this series of five drawings of my husband while he was sleeping. I did them all on the same morning, one after the other. They were done quickly, and I think that perhaps the scratching noise made by the pastel sticks as they moved across the paper disturbed him and caused him to change positions frequently. In this way, without his even knowing about it, I was able to get a whole series of natural looking poses.

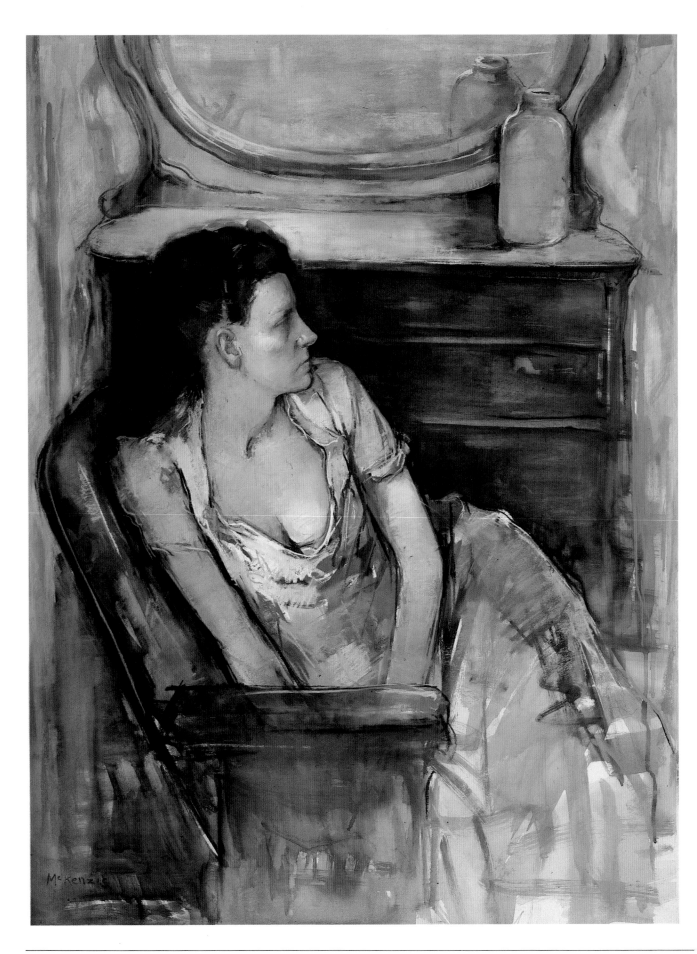

PASTELS

Pastels are not inferior to oils. As long as it is properly cared for and protected from damage, a pastel painting has great permanence. Although many people have a concept of pastel as being a very delicate and limited medium, this is not the case. A full range of expression is possible, and pastels can have rich darks and brilliant color. The pastels of Odilon Redon, for example, are especially bold in color. Manet used black very effectively in his pastels. I love Degas's pastels and find them particularly strong and beautiful. There is no limit to the strength, depth, and brilliance that pastels can have.

ADVANTAGES
Pastel is both a drawing and a painting medium and combines the use of line and color beautifully. Technically, pastel is a simple and very direct medium. Because it is always dry, colors can be worked into it at any time, and areas can be reworked immediately with no concern for drying time or colors "sinking in." Pastel has a matte surface; therefore, you can work in all lighting situations without being disturbed by glare. Because you can work so rapidly, it is also a convenient medium for sketching or doing small preliminary studies for painting.

SOFT PASTELS
Initially, I used pastel more as a drawing medium, but now most of the pastels I do are fully realized paintings, and, for that reason, I find that I use soft pastels most of the time. Soft pastels are dry pigments loosely bound with gum; they impart a heavy deposit of chalk to the surface. I have a large set of Rembrandt soft pastels and also many individual soft pastel colors made by Le Franc and by Sennelier. Since, with pastel, you can't mix the colors you want from a few basic ones, as you can with oils, you must have as many different colors available as possible. Therefore, you might as well buy the largest set you can afford and build around it. Rich darks are particularly hard to find. In general, sets contain far too few of the dark and full-strength colors, so I purchase these separately to supplement the colors I already have.

HARD PASTELS
Hard pastels are not so powdery, and this makes them more suitable for drawing. I have a set of semihard pastels made by Henri Roche that I bought in the beginning when I was more inclined to draw with pastels. This set contains an assortment of particularly beautiful and subtle colors. I also use hard pastels (Nupastel brand) that I buy individually—mostly black and white and a selection of warm and cool browns and grays. I find them useful in the beginning stages and also for drawing.

LAYING OUT THE COLORS
Before I begin working, I place the trays of pastels on a table in front of my easel. The table is large enough to hold all my pastels, so that all the colors are visible. Since you must search for each color you need, you might find it helpful to sort your pastels into related color groups, at least from one painting to the next.

YOUNG WOMAN IN PROFILE
pastel and gouache on board, 40″ × 30″ (101.6 × 76.2 cm), collection of Dominic E. Visconsi.

The model is a long-time friend. As I usually do when I work in pastel I first did a gouache underpainting and then applied pastel over it. Since in this case I really liked the way the underpainting worked out, I left a great deal of the gouache exposed, adding pastel only in those areas that I felt needed it. I often like to leave a certain amount of gouache showing, as I like the effect of the two textures together in the same painting.

PASTELS

While I am working on a painting I take the colors I am using for that specific picture and separate them from the others until it is finished.

Not being able to find the color I need—immediately—is my greatest frustration when working with pastels. I find that I have too many colors at my disposal, and hunting for lost colors adds significantly to my working time. Because pastels break very easily and turn to powder, they quickly become difficult to tell apart. Their true color is concealed. Some of the dust that hides the color can be eliminated by lining the trays you keep them in with baking soda.

SURFACES
Pastel will adhere to many surfaces but works best and can be manipulated most easily on a rough surface, one with a slight tooth. More layers of pastel can be applied to a rough surface, allowing you to work longer, while a smooth surface will fill up too quickly. However, the problem with a surface that is too rough is that your sticks of pastel will be ground down very rapidly. An extremely rough surface is also difficult to work on.

Of the many types of pastel papers, I prefer the Canson Mi-Teintes line, which is available in many tones and colors and may be bought by the sheet, in pads, or in sizable rolls. Either side of the paper may be used, but I like the side with a slightly rougher tooth. The paper should be clipped to a board for support, with several sheets of paper beneath the top one, for padding. I also enjoy working on sanded papers or boards.

PREPARING YOUR OWN SURFACES
In fact, I do most of my pastels on a board I prepare myself with gesso and finely ground pumice. Marble dust can also be used. I use 100 percent rag illustration board (a heavy ply, so that it will not warp when gesso is applied to it). Smooth or rough board may be used, depending on the texture most suitable for your work. I favor the medium-rough boards.

First, for additional support, I tape or staple the board to canvas stretchers of the same size as the board. I leave the board attached to the stretchers until the pastel is finished and ready to be framed. The mixture I use for preparing the pastel surface is: 2/3 cup of acrylic gesso, 1/3 cup of water, and 4 level tablespoons of extra-fine pumice (or marble dust). I mix well, until the solution has an even consistency. This amount will cover three or four 30″ × 40″ (76.20 × 101.60 cm) boards, so I usually prepare several at one time. This mixture is easily applied with a fairly large house painter's brush. I move the brush in several directions, so the brushstrokes overlap and are not visible. One coat is usually enough. Immediately after I apply the gesso-and-pumice mixture to the front of the board, I apply a coat of plain gesso to the back to prevent it from warping. When the board is dry, it can be sanded, if I find that the surface is too rough.

By preparing my own pastel surfaces I can control the texture, and this particular surface seems to hold color exceptionally well. Because this surface is firmer than paper, more corrections are possible. I am also not so restricted in size as I was with commercially prepared boards. A mixture of this sort can be applied to boards of any size and also to unprimed canvas, but I have not personally tried it on canvas. Commercially prepared pastel canvas is also available in most art supply stores.

HOW TO APPLY PASTELS
Pastels can be handled with a great deal of freedom. Although it is true that colors cannot be mixed beforehand, a type of mixing is often done on the picture itself, either by applying individual strokes of color alongside or over (crosshatching) the previous color or by working one color into another. A lighter color can be scumbled (lightly dragged) over a darker color in such a

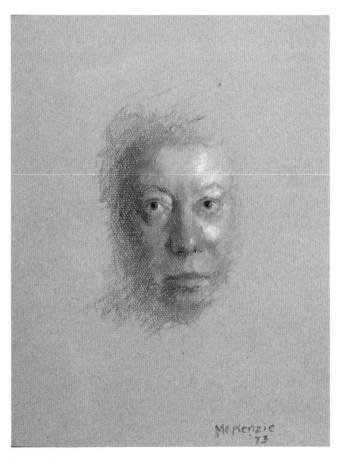

MY MOTHER
pastel on paper, 14½″ × 11″ (36.8 × 27.9 cm), collection of the artist.

This is a very early pastel study of my mother. I've included it here because it shows how I initially worked in pastels, more as a drawing medium than as a painting medium. I allowed the paper to come through and play a major role as the middle value.

way that the latter is not completely hidden. I often break the pastel sticks in half and use the side of the stick to spread the color more broadly over large areas. By applying pressure, you can build up a thick deposit of chalk, giving the surface an added richness. Once pastel is applied, I sometimes blend the colors by rubbing them together with my finger or with a charcoal stump—particularly to mass the shadow areas together or to blend one area into an adjoining area. It is very easy to lose an edge but just as easy to re-establish one.

Depending on the angle or the amount of pressure applied, the side or tip of a pastel stick or hard pastel stick can be used to produce a clean line or to place a strong accent. By working in this way I am able to get as much detail and clarity as I want. Although pastel pencils (hard pastels in pencil form) are available, I stay away from them because they tend to make me focus too much on details and lose sight of the overall picture.

ISOLATION
gouache on board, 40″ × 30″ (101.6 × 76.2 cm), collection of the artist.

This is one of the few times I've ever done a painting entirely from memory. It was done over a pastel of another subject that I had worked on for months and couldn't resolve. After covering the pastel with gesso, I completed this gouache painting in one session. I had planned to continue using pastel over the gouache, but I liked the painting as it was and decided to leave it alone.

Pastel can also be combined with other media, such as oil (by working the pastel into wet turpentine washes), watercolor, gouache, casein, and acrylics (applying pastels over a thin underpainting). Unless only a thin wash is used, I would discourage the use of acrylic paints; if applied too heavily they destroy the surface, and it will no longer accept pastel. Degas, who was always experimenting with new methods and techniques, is said to have sprayed his pastels with boiling water, dissolving the chalk into a paste, which he then applied with a stiff brush. He also worked over monotypes with pastel. Clearly, there are many different ways of using pastel, so I suggest that you experiment freely. The important thing is not to be timid or afraid to make mistakes. You will gain confidence and a thorough understanding of the medium with experience.

WORKING METHODS
Because the dry colors are so opaque, it is easy to bring up light colors against a dark background. Therefore, it is preferable to work over a toned ground or a tinted pastel paper. When I work on board, I often tone the entire surface with a thin wash of acrylic or gouache (usually a cool gray tone). The tone I choose is dictated by the subject. The paint is diluted with water and applied with a large brush, and a rag is used to wipe away the excess. If I use paper, I usually choose a color that is middle tone in value and also one that relates to the main tone of the painting or drawing. I've found that what you leave out or leave to the imagination in a drawing (what is left as the paper) is often the most interesting part. Whatever tone you choose, keep in mind that a different palette will be required for each background tone or color of paper. The same colors used on a rose-colored background, for instance, will look entirely different when applied to a blue background.

Before I start, I generally do several rough sketches to determine the composition and sometimes a color study or a drawing to further familiarize myself with the subject. I begin with vine charcoal, applying it lightly. This is not an accurate drawing. I am only concerned with placement, and all of these lines will eventually be covered. Next, I use the harder pastels and very light pressure at first, as I want to keep the rough surface as long as possible. I apply pastel more heavily as I go on. As I develop the painting, I allow the tone of the board or paper to serve as the middle-tone value. I immediately establish my darks and also at least an indication of the lights. I work very broadly at first and all over the painting. As it progresses, I work in both directions, back and forth, going both lighter and darker, building toward the lightest lights and darkest darks, which I save until last.

Lately, I work most often on a white board and start with an underpainting of gouache rather than just an overall tone. This allows me to begin in a more fluid

manner and to quickly establish my light-and-dark patterns. This is not a careful underpainting but is done roughly and quickly. I concentrate on basic form, color, and gesture. The gouache colors get considerably lighter in color and tone as they dry, so it is necessary to make allowances, particularly with the darks. Sometimes with the gouache colors I am able to state a color that would be difficult to achieve with the pastels by themselves. I establish my darks and middle tones and preserve the white board as the light pattern. When the underpainting is completely dry (in less than an hour) I apply pastel over it, working from dark to light. Once the darks and middle tones are correct, I am better able to judge the lights. If there is not enough color in the lights, they will appear chalky. To obtain richer lights, I use a strong, pure color and apply white over it. Again, as in the first method, I use lighter pressure in the beginning and build up layers of pastel. I tend to build up a heavy deposit of chalk in the lights. I think that I am comfortable with this approach because it is initially more fluid and also very similar to the way in which I usually start my oil paintings: on a white surface rather than a toned surface.

FIXATIVE

Fixative is sprayed over pastel in order to bind the pastel particles to the surface and to protect them from smearing. It should be used carefully. After testing the spray on a scrap piece of paper, I spray lightly from about two and a half feet away, moving the can in a circular motion so that no one area gets too much. When sprayed with fixative, a pastel actually changes in appearance; the relationship of the color particles changes (they stick together as well as to the surface, resulting in a definite loss of brilliance).

As the painting develops I use the fixative quite a bit. The spray not only binds the pastel to the surface at each stage but isolates that stage and creates a new surface with slightly more tooth. This new surface enables me to continue working. New colors can be applied over those isolated with fixative, allowing the color underneath to come through. Mixing on the surface, in this way, can create very luminous and vibrant color.

I sometimes intentionally spray an area very heavily with fixative. The object is to restore the surface and to darken that particular area for corrections. This must be done carefully or the surrounding areas will be affected or even lost. I usually mask the areas around the one I wish to spray, to protect them from damage.

In the final stages I rarely use fixative, for fear of disturbing the color or value relationships. If I use any fixative at all, I spray very lightly and from a greater distance. At this time I flick the surface with my finger to dislodge the loose particles of color. It is better to dislodge them now than to have them fall off after the painting is framed.

RESTORING THE SURFACE

Although it is possible to work very rapidly with pastels, my pastels do not necessarily go any faster for me than my oils. Inevitably one area becomes a problem, and eventually I lose the surface in that area because of overworking. The surface fills in and will no longer accept the pastel. Knowing how to restore the surface is often a question of experience, but it can be done in a number of ways.

A heavy application of fixative will to some extent supply a new tooth on which to work, but after continual reworking this alone is not sufficient. I often spray the disturbing area heavily with fixative and sprinkle marble dust over it while the spray is wet. After the fixative dries, I tap the side of the board on the floor a few times to dislodge any excess dust.

Sometimes I repaint a small area with gouache, which also renews the surface slightly. I first try to wipe off as much pastel as I can from the area I wish to repaint, being careful not to harm the surface. This is done in order to remove the build-up of pastel, which would smear and turn into a mess were gouache applied over the pastel surface.

I have also, in desperation, covered a problem area with a fresh mixture of gesso and pumice (removing the build-up of pastel first). Because you can easily lose more of the image than anticipated, this is not a practice that I recommend except as a last resort.

One advantage of painting with pastels is that the surface never looks overworked, because, in effect, you start over on a totally new surface, keeping a freshness that is hard to maintain after continual reworking with oil paints.

FRAMING

Because pastels are so fragile, a great deal of care must be taken with them. Most of my pastels are done on board and remain attached to stretchers until they are framed. They can be stored in a standing position. Those on paper I separate from one another with a clean sheet of pastel paper. I store them in print cabinets, so that they can lie flat. When I want to transport these pastels I tape them between two pieces of cardboard; this prevents any movement that could smear the pastel.

Ultimately, a pastel must be framed and sealed behind glass to protect it from being smeared or damaged. In order to prevent the glass from touching the surface of the painting, pastels require a spacer inserted between painting and glass. This spacer is designed not to be visible once the pastel is framed. A mat, provided it is of sufficient thickness, may also be used to separate the painting from the glass. However, as I have already determined the size and shape of the picture, I prefer to frame a pastel as I would an oil painting, with the frame right next to the edge.

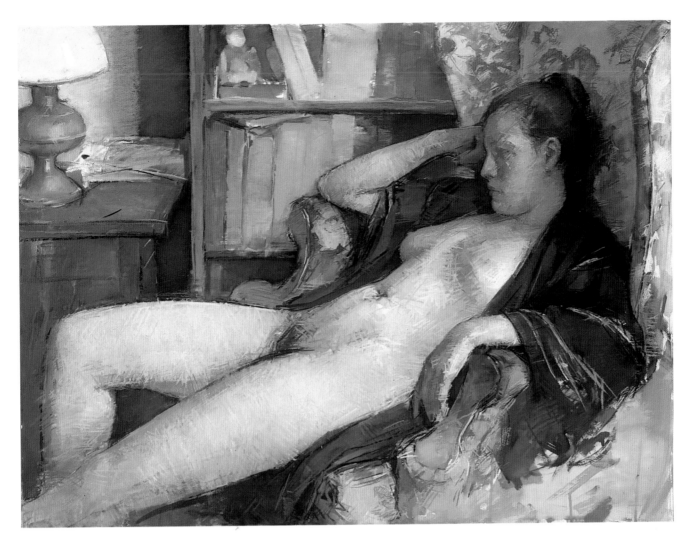

NUDE STUDY (wingback chair)
pastel and gouache on board, 30″ × 40″ (76.2 × 101.6 cm), private collection.

I often choose certain elements for paintings because they contribute to the design. In this case I chose the black robe because it offset the forms of the figure and emphasized the strong diagonal aspect of the composition.

THUMBNAIL SKETCH FOR NUDE STUDY (wingback chair)
pencil on paper, 2″ × 3″ (5.1 × 7.6 cm).

NUDE STUDY
pastel and gouache on board, 40″ × 30″ (101.6 × 76.2 cm),
collection of Judy and Ted Goldsmith.

*Much of the background in this painting was invented. I used
myself as a model, which considering the pose, was extremely
difficult. An interesting thing: I left an area of board unpainted
intending to cut it down later; but without my realizing it, that
area became an integral part of the painting and a necessary
part of the composition. Fortunately, I took a careful look at the
painting before cutting the left side off, realizing that I had
been relating everything in the picture to everything else,
including the area on the left. If I hadn't studied the painting so
carefully, I might have ruined it.*

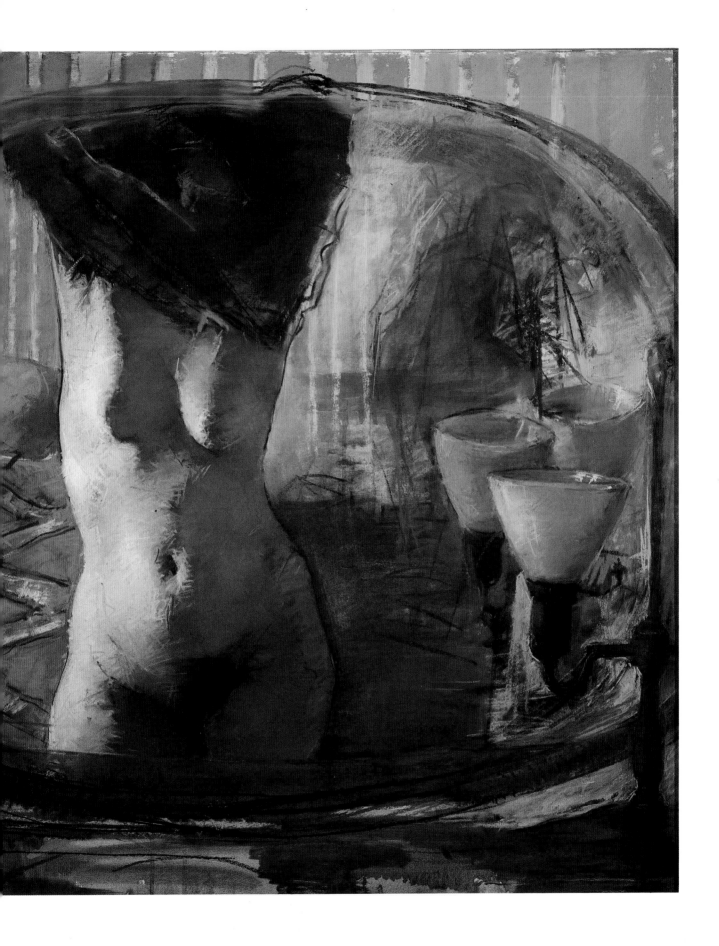

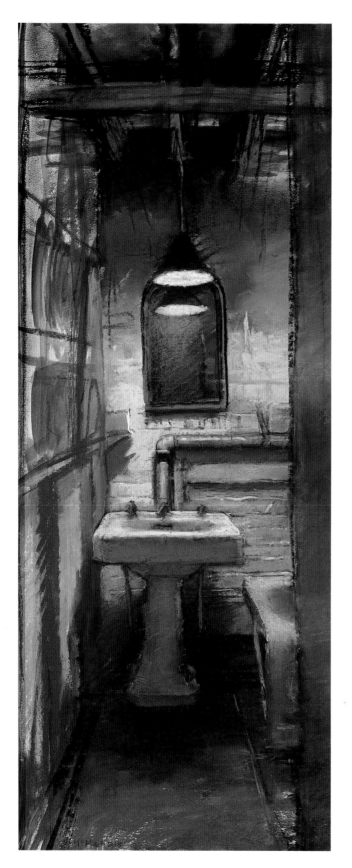

LOFT INTERIOR
pastel and gouache on board, 27″ × 11″ (68.5 × 27.9 cm), collection of Patricia Lysinger.

This is the pastel/gouache version of the oil painting reproduced on page 18. After doing the first painting, I decided to try a second, more vertical format, which would include the ceiling beams. The first picture was painted entirely under artificial light, while the second includes both artificial light and daylight, making the color generally cooler.

CHERI
pastel on sanded paper, 20″ × 16″ (50.8 × 40.6 cm), collection of Cheri and Simon Dratfield.

By initially using gouache, I was able to set the mood of the picture almost immediately by establishing the color relationships first, especially the pink areas. This pastel is characteristic of many of my earlier pastels. It was done on a type of sanded paper (mounted on board) that I have since stopped using. I had problems with this paper because the surface filled in too quickly. I also wanted a firmer support for my gouache underpaintings; so I began to use the gesso/pumice mixture (described in the text on page 36) to prepare the board's surface.

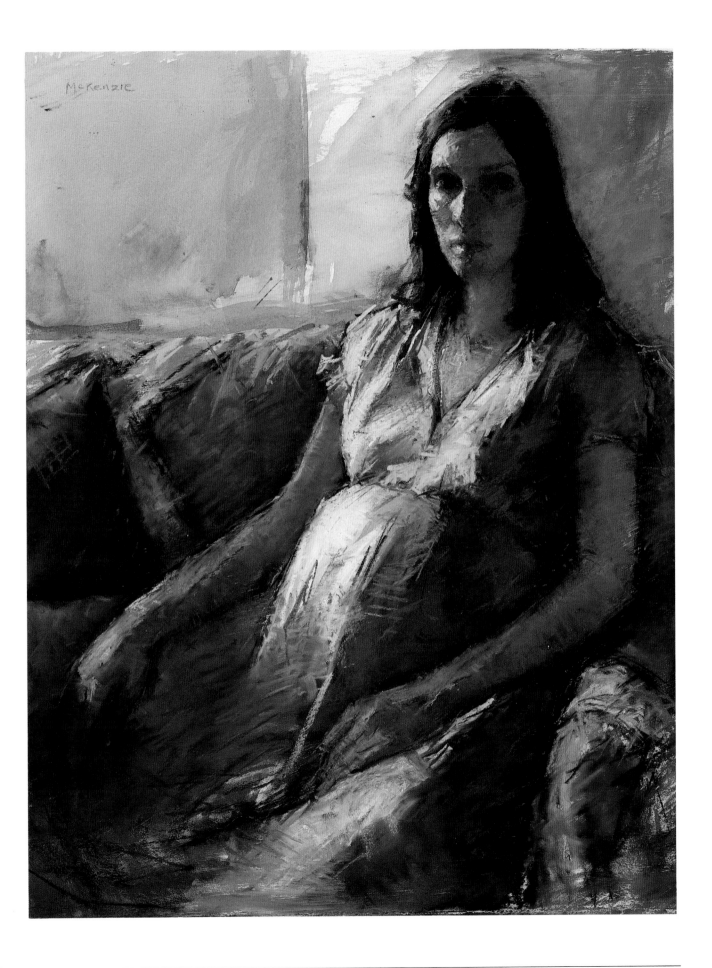

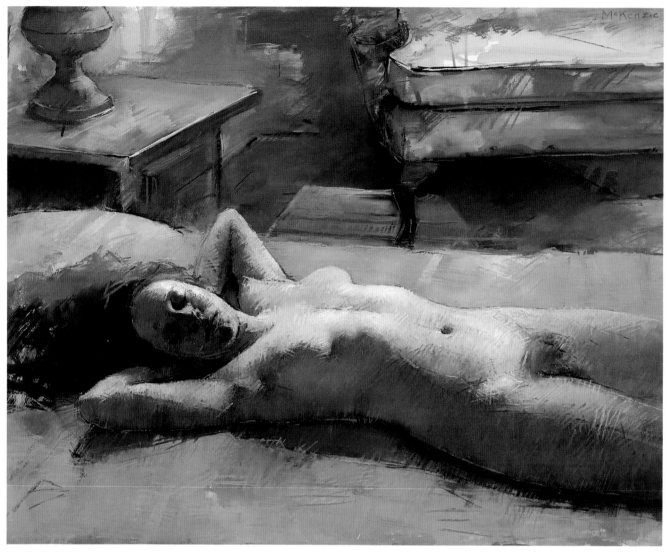

RECLINING NUDE
pastel and gouache on board, 30″ × 38″ (76.2 × 96.5 cm),
collection of the artist.

*I had many problems with this pastel. At one point, I was so
dissatisfied that I covered the entire head and arms area with
a mixture of gesso and pumice and then reworked it. Even
though that area had already been reworked many times, the
surface still looks fresh because it was renewed.*

BACK NUDE
pastel and gouache on board, 40″ × 30″ (101.6 × 76.2 cm),
collection of Beverly and Jerome Scheer.

*This painting shows how I use strokes of color to define and
unify form. I also used the side of a pastel stick to cover
broader areas throughout this painting and massed large
areas together by blending them with my finger.*

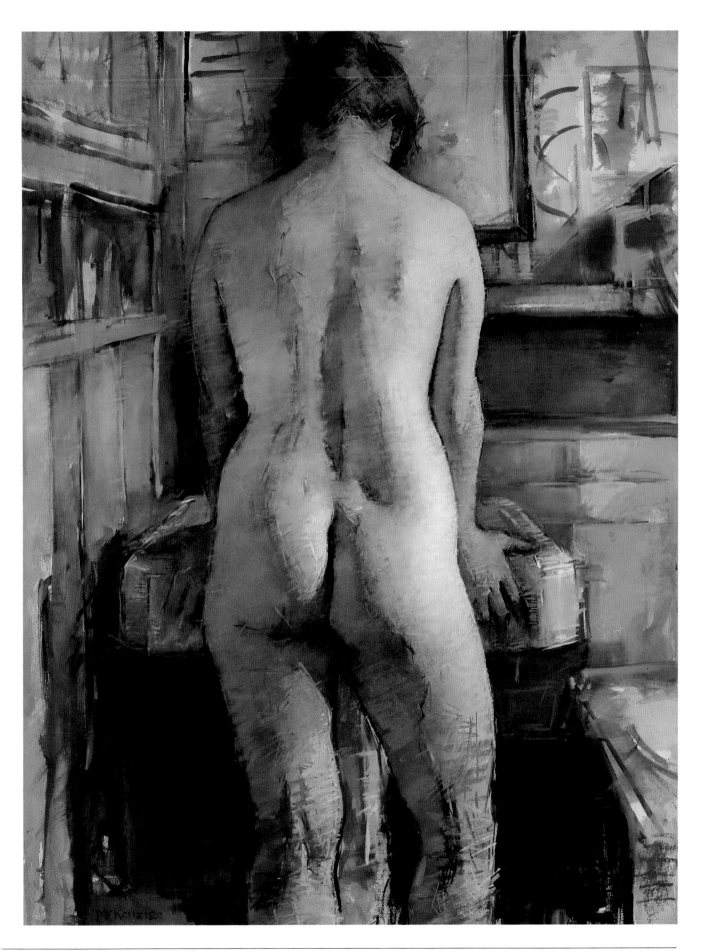

PASTEL DEMONSTRATION
The following demonstration shows how I apply a
painterly approach to pastel. Notice that the gouache
underpainting provides an initial layer of color without
affecting the grain of the paper. Also note the layering
process: gouache base, initial pastel layer, then a spray
of fixative between this and all subsequent layers.

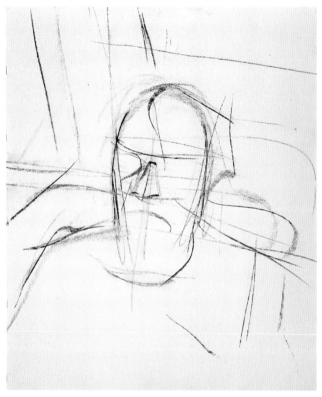

STAGE 1. *I placed the shapes in roughly and quickly with vine
charcoal. I tried several other possibilities, using charcoal and
wiping it off, before deciding on this composition.*

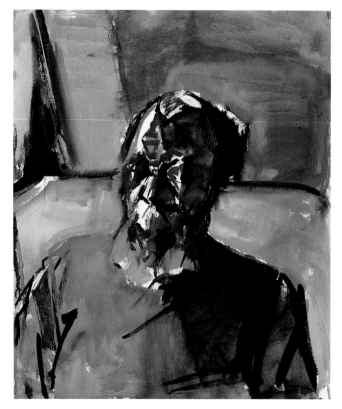

STAGE 2. *I began with an underpainting in gouache, working
in a very fluid manner. Using a large brush, I quickly
established broad areas of color in relation to one another,
working from dark to light. I completed this stage in less than
an hour, trying to cover as much of the white board as I could
(leaving only the lightest lights), so that the pastel could be
applied to a toned surface. It's much too difficult when working
with pastels to get started on a white surface; there's just too
much area to fill in.*

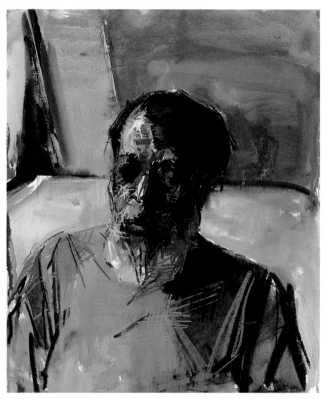

STAGE 4. I continued working from dark to light, focusing on the exact shape of the shadows and placing color wherever I saw it. I was also looking for the right tones to make the transitions from dark areas to light areas.

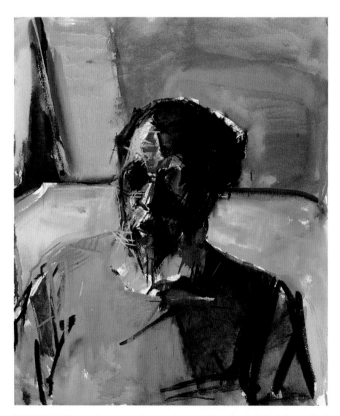

STAGE 3. When the gouache underpainting had dried, I applied pastel colors over the gouache colors, trying to block in the large simple masses of shadow. I blended these shadow areas together with my finger to give a strong simple shape to the dark pattern. At this point, I started to use rich color, particularly in the middle tones. I also began to suggest the lights with strokes of color. I couldn't find strong enough greens for the color of the shirt, so I bought some individual sticks of color—a selection of very intense greens specifically for this painting.

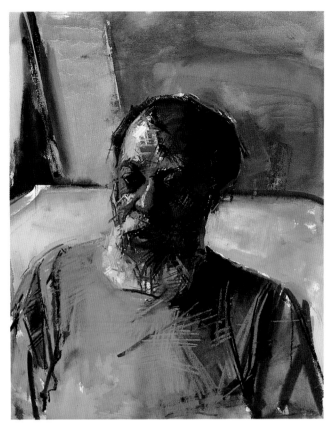

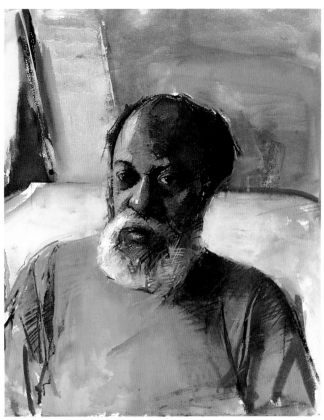

STAGE 5. The pastel was sprayed with fixative before I began this stage. I continued to work all over the surface, placing strokes of color where I saw them in a crosshatched manner, slowly pulling areas together and into focus. At this stage, the head was starting to take shape, and I felt it seemed to be going well.

STAGE 6. I sprayed the surface again with fixative and continued to work in the same way, but I seemed to be in trouble. I couldn't pinpoint when it happened, but suddenly something about the whole painting bothered me—the energy and visual excitement that was there in the initial stages was missing. Somehow the painting had become too literal and looked overworked.

DAVE MOORE
pastel on board, 24″ × 20″ (60.9 × 50.8 cm),
collection of Margarete and Dave Moore.

After I had put this pastel aside for a while, I realized that, for one thing, I had used too much fixative, and thus lost much of the contrast. Both the lights and the darks had no life. There was an overall sameness to the painting. The shoulders were too high and too narrow, and the left shoulder was actually higher than the right one. It was obvious to me that I had been focusing too much on the face.

To correct this problem, I lightly wiped off some of the pastel and sprayed the head area heavily with fixative and sprinkled marble dust on the surface to restore texture. At this point I was basically starting over, having lost most of the face area with just enough of the image to guide me. I then re-established my dark pattern throughout and worked from dark to light, but in a much looser and freer manner—as I had done in the beginning. I also redefined the features at the same time. The face seemed to be going well again and I felt that I was back on the right track. I moved the shoulders down and redrew them, this time following through to the other side. I was pleased with the shapes in the background, so I left it alone.

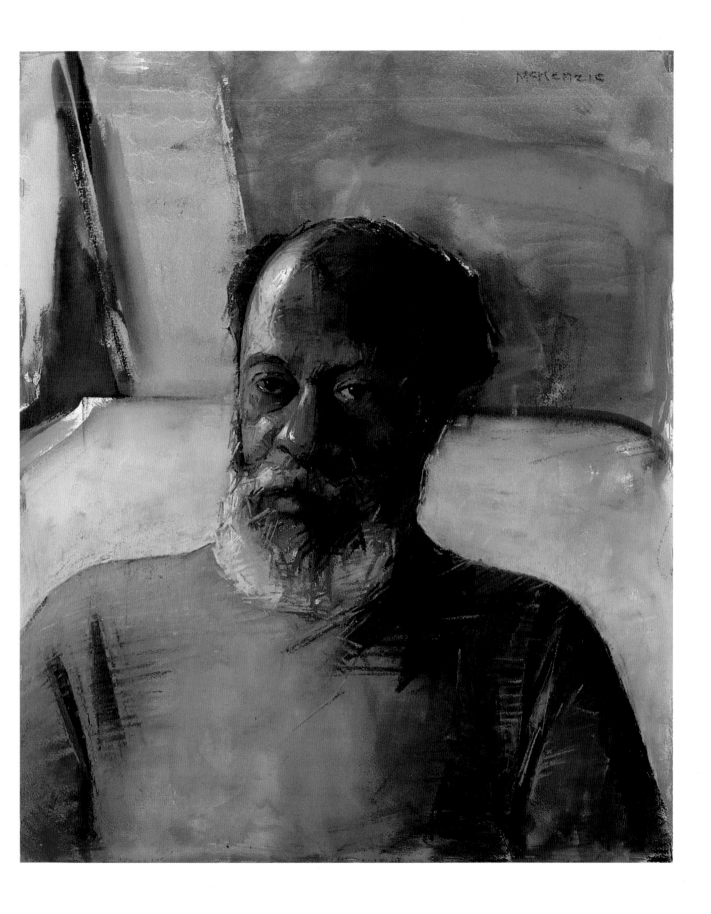

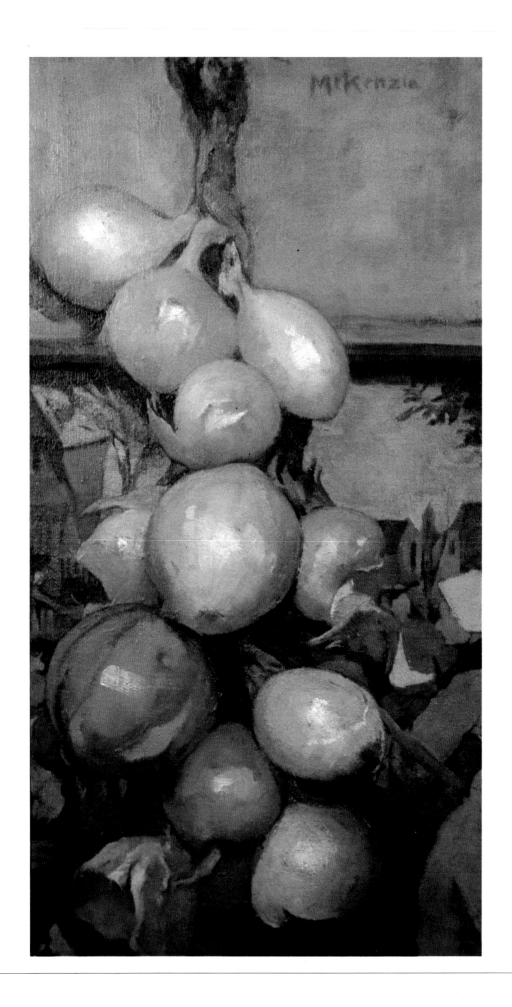

CHOICE OF SUBJECT MATTER

I t is not so much what you paint as how you perceive things—how you see the things you choose to paint and the excitement you feel in them. Even if you choose to paint in a representational manner, you must look for abstract patterns and relationships in nature. Try to see things in an abstract way first, before you see them as specific objects. Squint and try to lose the details until you see only the large, simple shapes and the overall color harmony. You have to look at nature with a real awareness of color and form and see it so clearly that you can convey it to others. Something so simple as the color of a building silhouetted against a gray sky, seen as beautiful color relationships and forms for their own sake, can motivate you enough to begin a painting.

It is not just the visual excitement that is important, it is also important that you record your personal interaction with the subject. I don't mean just recording, but responding, reacting—most of all, interpreting the image in front of you. There should be a confrontation with the subject. You have to put something of yourself into a painting—transmit something to the viewer. One hundred years from now an exact likeness will not matter. What will matter is what the entire painting says to the viewer. The paintings I respond to most are those in which I feel a strong sense of the artist.

When I have a class of twenty students, all working from the same model, I'm always amazed by how different each painting is from the others. Different things are significant to each individual; each records a personal reaction or response not only to the subject, but also to the shapes and colors. The proportions of the canvas, how it is composed, the use of line and color—all of these things are different. A lot of what goes into painting is done instinctively and unconsciously and is simply a matter of following your own preferences.

When I paint someone, I am not concerned so much with likeness as with the character or spirit of that person. Certain objects and places can also have their own character, and what I hope to convey is a sense of that object or place. I want to say something on a deeper level about whatever I paint, or maybe even about myself, but this is not altogether a conscious aim while I am painting. I don't think an artist can be aware of what the painting says to someone else while it is being painted. I may see something of the psychological content later or if someone points it out to me, but I'm not conscious of anything like that while I'm painting.

I seem to do my best painting when I am able to abandon myself totally to the activity itself, when I am most lost in it, not worrying about technical matters, just responding to what is in front of me.

WORKING FROM PHOTOGRAPHS

I enjoy painting directly from life, having a direct interaction with the subject. With the subject in front of me, I can see what's actually happening and determine the exact colors, values, and shapes. Not only does the camera have a tendency to distort, but it takes that direct contact away. Many artists have used photographs successfully, but they did not simply copy them. They used them for the information they contained. Both Eakins and Degas took photographs and used them as a means of studying composition and lighting effects as

ONIONS ON A STRING
oil in canvas, 17″ × 9″ (43.2 × 22.8 cm), collection of John Calver.

These onions were hanging in front of a Breughel print in my kitchen, and I liked the way they looked with the complex pattern of the print behind them. The relationship between the print and the hanging onions was the impetus for this still life.

well as the subject. If you choose to use photographs, I suggest that you take your own so that you have some control over them. If it is not possible to work from life on part of a painting, I prefer to use either sketches or studies that I have done from life or to work from my imagination.

SELECTING A MODEL

My paintings stem from my everyday experiences. My subjects are the people with whom I come in contact and the objects and places that are a part of my surroundings. I have always been preoccupied with the human figure—people alone, or in relation to other people or objects.

Selecting a model is very personal. Although some people have extremely expressive features or body characteristics, they may not necessarily appeal to every artist. I'm not always sure why a particular subject interests me. Someone evokes a feeling in me, but I don't always know what it is and cannot verbalize it. Sometimes it is, in fact, a subtle contradiction that intrigues me. The contradiction may be between the person and the environment, or it may be within the person. Or, I may select two people because the relationship between them seems contradictory.

I rarely paint professional models. Friends or members of my family, people I know or happen to meet and respond to, are generally more interesting to me. I've probably painted in my mind over and over again the faces of all the people I care about, and I find it very exciting when I actually get the opportunity to paint them. Although many hours of posing were involved, I think that both my father and my mother enjoyed spending the time with me and being a part of my work. It's not always easy to persuade friends and family members to pose, but I think you often have more to say about people you know.

My friends sometimes pose in exchange for a small painting or drawing. This sort of faith in your work is, in itself, very rewarding. One friend, Victoria Prewitt, has posed for me for years, enabling me to explore many ideas. Because she has been so generous with herself, I have been able to undertake several ambitious paintings that would otherwise have been impossible. You seldom get the opportunity to work with a person over a long period of time in a variety of surroundings. I've been able to follow her through different phases of her life (and mine).

While I'm doing one painting, I at times see something that excites me from a different angle, or something about the person that I wasn't as aware of when I started the painting, that makes me want to paint that person again. If I do another painting, it is usually very different. I am never totally satisfied with a painting, and this may also add to my desire or need to paint someone again.

I talk to my models while they are posing, because I like to work in a relaxed atmosphere. If they are comfortable they tend to open up more than they would otherwise. I usually get to know my models better as I work.

SELF-PORTRAITS

I often use myself as a model. Many artists studied themselves throughout their lives. Rembrandt left an amazing number of very revealing self-portraits, as did Van Gogh, Käthe Kollwitz, and Egon Schiele. Some of these are among my favorite paintings or drawings.

I think a self-portrait is extremely personal. Most people tend to look for an exact likeness and make comparisons on that level. I paint myself as I see myself, but it is my view, not necessarily reality. You see yourself differently from the way that anyone else does anyway. For that matter, everyone sees everyone differently; that's why it's so difficult to do portraits for other people.

I think that it is very hard to paint a self-portrait. The tendency is to stay right on top of the painting, never getting any perspective on it. You have to allow a model to take a break, but with yourself it's easy to continue painting long after you can see what you're doing. Also, it's impossible to step back and study the subject and the painting at the same time. Objectivity is a real problem. On the other hand, you allow yourself to take chances more freely, because the model will always be available.

WORK SPACE

I have a large studio, with high ceilings and windows on the north wall. The walls of my studio are painted a neutral gray so that the color of the walls doesn't interfere with whatever I'm painting. Although I work in many different kinds of light, depending on what I want

SHARON
oil on canvas, 19″ × 15″ (48.2 × 38.1 cm),
collection of Sharon van Ivan.

This portrait is of a very close friend. I am pleased with this painting because I feel it succeeds in conveying a certain intensity and strength of character that is very much a part of this person.

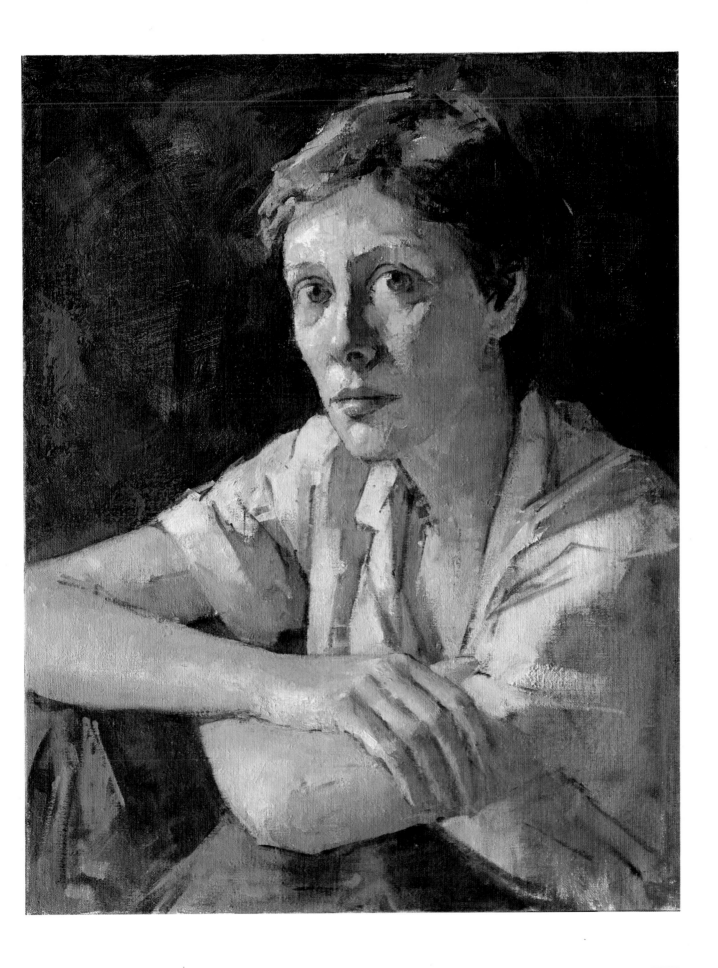

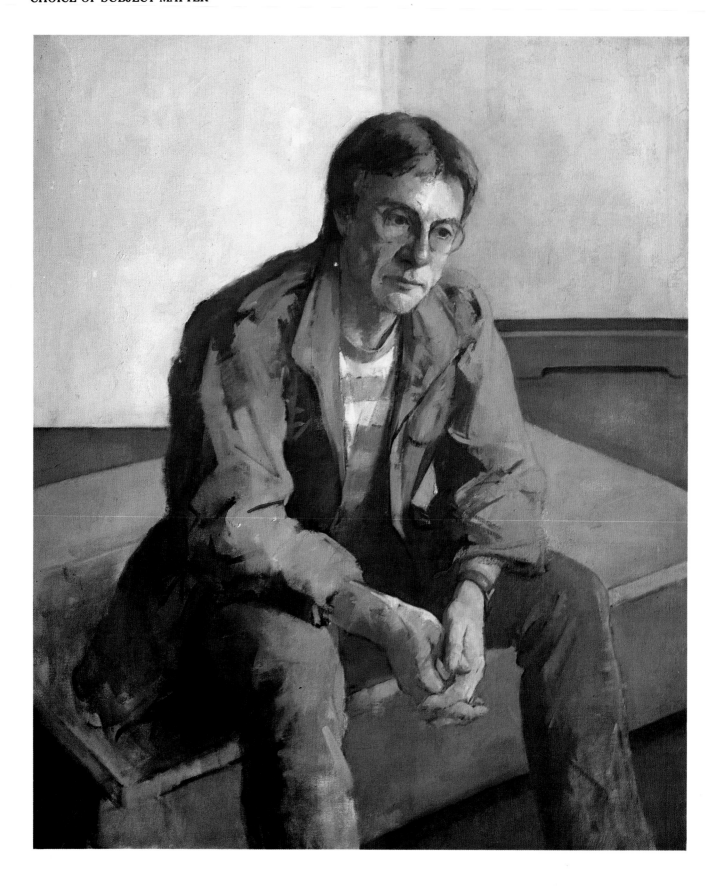

to convey in a painting, I prefer natural light. North light is best, because it is constant and allows me to work on the same painting at any time of day. In order to feel the freedom to paint, I find that a studio of my own is absolutely necessary. I need to be able to work in peace, without being interrupted, and leave unfinished work without any fear that it will be disturbed.

Although I have a studio, I have also worked in many parts of the loft in which I live. The loft appears in many of my figure paintings, and I find many parts of it interesting in themselves. I love it when I get the opportunity to work in new places (the home of a friend, for example). In a new place I am always confronted with new shapes and colors and different and sometimes exciting possibilities.

WORKING OUTDOORS

I really enjoy working outdoors. Working outside gives me a certain feeling of freedom, a release. I usually come back fresh with new ideas and options. Several times I've gone away for a month or two or for the summer to paint in the country. It always takes me a while in a new place before I am ready to paint. I can't just arrive, set up, and start painting. I have to be in a place long enough to get a feeling for it. As a student, I went to Connecticut several summers with another painter and friend, Bobbi Adams. We put ourselves on a very rigid schedule, setting out before dawn to catch the early light and working all day. It was a wonderful learning experience. Lately, however, when I work outdoors I am more drawn to the city than to the country.

For painting outdoors I use a French easel, because it is both sturdy and portable. It folds into a compact box that has a carrying handle and provides storage for paints, brushes, and other equipment. Several canvases can be attached to the front. The only problem with the French easel is that it can be very heavy to carry around, so it is essential to pack only what is absolutely necessary. For outdoor work I recommend canvas separator clips, which enable you to put two wet canvases face to face. This device protects the paintings from being smeared while they are being transported. In order to see your canvas while working, it's a good idea to bring some sort of backing for it, such as a piece of cardboard, to keep the strong outdoor light from coming through. Bright light tends to make you paint in a higher key than you normally would. A painting may not look so strong as you thought it was once you get it inside, and it helps to be aware of this while painting. You might also find it helpful to wear a hat or visor to keep the sun out of your eyes and to minimize glare.

Light is extremely important. I usually like to paint early in the morning or in late afternoon. The shadows are longer and the light is more dramatic. A place may not look particularly interesting until a certain time of day. In my own neighborhood something I pass everyday will all of a sudden be exciting to me: The light is different because of the time of day or a change of season. I particularly like the subtle variations of color in early spring and the cool quality of the light in the fall.

Because light changes so rapidly outdoors, it's difficult to work for very long on the same painting, unless it happens to be cloudy. If it's sunny the light will be totally different in two hours or less, so I usually bring several canvases to work on. Also, weather is completely unpredictable. If you're working on a painting in sunlight and the sky becomes overcast, all the colors change. At that point, it's better to stop working. A partly cloudy day is probably the worst, because conditions are constantly changing, and it's hard to stop working, so the painting becomes a mixture of both. When you look at a painting you shouldn't have to wonder what time of day it was painted or what the weather was.

Whatever you choose to paint, it is most important to paint what excites you and to paint for yourself. The problem with painting what you think others want, or what you think will make you successful, is that you probably will fail at it, because you will become inhibited by these considerations. Subject matter is merely a point of departure, and I think you have to search for a personal way of expressing your own responses to life. If you follow your own direction and stick to your own convictions, you are more likely to achieve something meaningful in your work.

DAN
oil on canvas, 36″ × 30″ (91.4 × 76.20 cm),
collection of the artist.

Although I was very interested in the movement created by the abstract shapes surrounding the figure, this painting is very much a portrait of a specific person, an artist friend, Dan Gheno.

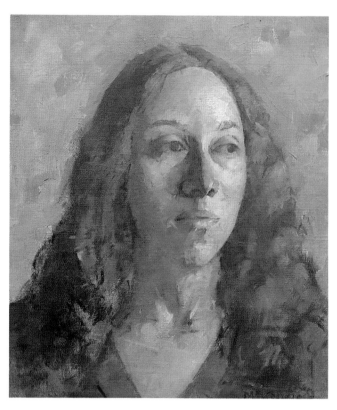

RACHEL
oil on canvas, 14″ × 12″ (35.5 × 30.4 cm),
collection of Lois and Harvey Dinnerstein.

The model is a friend and artist, Rachel Dinnerstein.

EARLY SPRING
oil on panel, 9″ × 12″ (22.8 × 30.4 cm),
collection of Lois and Ronald Sherr.

*This landscape is one of the few that I've done since my
student days when I spent summers painting in the country. I
painted it very early in the morning, directly from nature, and
completed it in one session. At that time of year, early spring,
variations of color are very subtle, and I tried to capture them
and also a sense of the light.*

SELF-PORTRAIT (green coat)
oil on canvas, 18″ × 14″ (45.7 × 35.5 cm),
collection of Everett Raymond Kinstler.

*In this self-portrait, my head is seen against a strong backlight.
It was a challenge to paint this and still retain enough detail
on the face because against this kind of light, objects appear
almost as silhouettes and the value changes within them are
very subtle.*

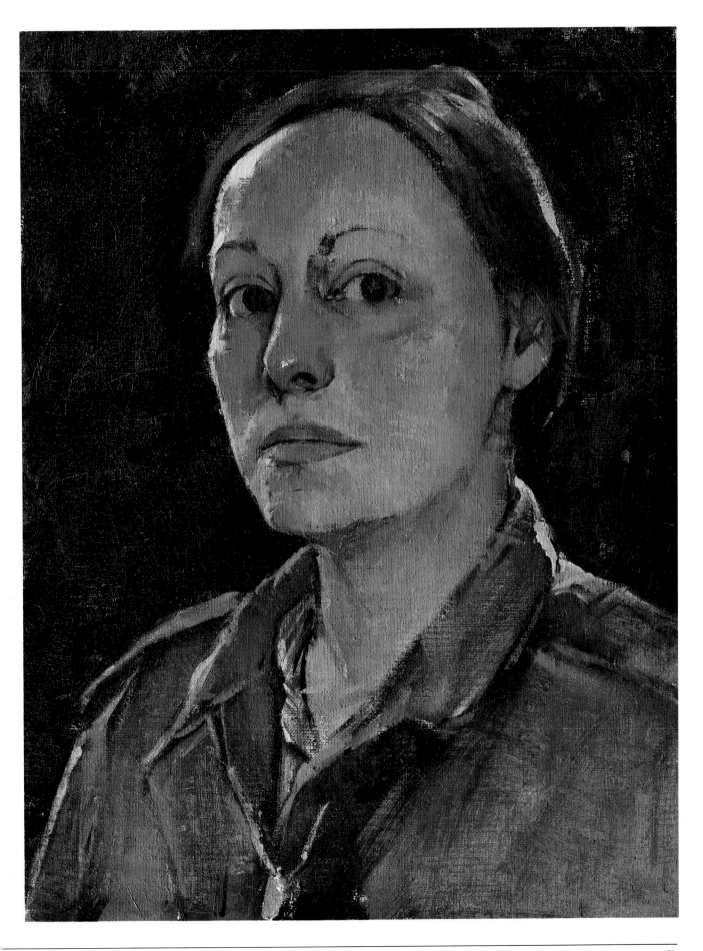

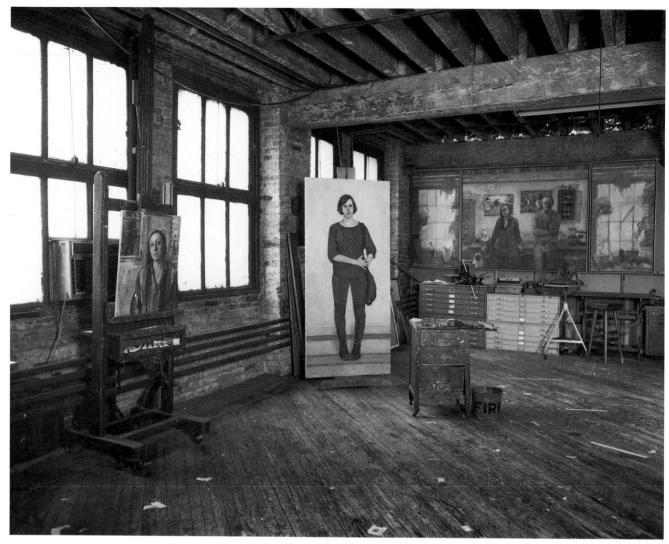

MY STUDIO

This is a photograph of my studio. The windows are on the north wall and opposite them, not shown, are storage racks for canvases and shelves filled with books and catalogs. Also, a number of my completed paintings are hung on the same wall. Although I do own works by other artists whom I admire (including several of my instructors), I keep those in the living area of the loft rather than in the studio. Under the triptych, you can see the shallow drawered metal cabinets in which I keep monotypes, drawings, and paper. If you look closely, you can also see tape markers on the floor. These are used to mark the positions of my easel and subject, so that I am free to rearrange things from day to day and work on several paintings at once.

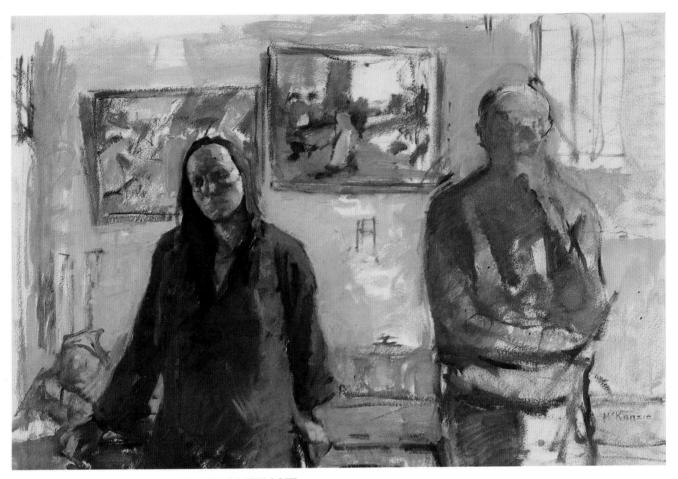

STUDY FOR THE LOFT
oil on board, 19¼″ × 29¼″ (48.9 × 73.3 cm),
collection of the artist.

*This study was done to help me visualize the center panel of
the triptych on the next page. But once I began it, I got more
involved than I had intended. I feel that the study itself is a
complete painting.*

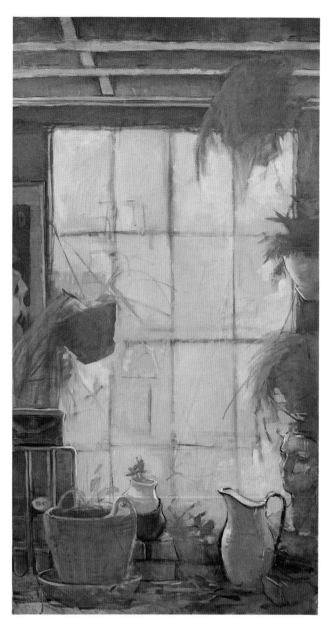
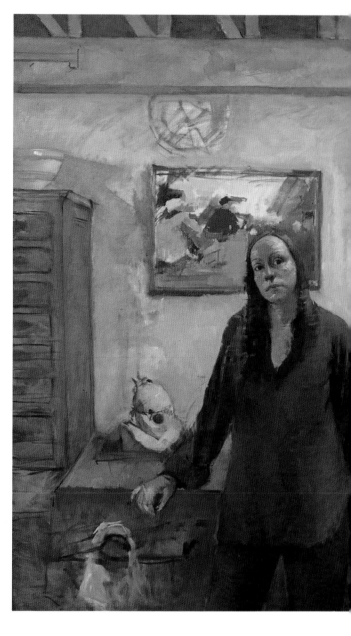

THE LOFT (triptych)
oil on canvas, center panel: 60″ × 74″ (152.4 × 187.9 cm),
side panels: 60″ × 32″ (152.4 × 81.2 cm),
collection of the artist.

This is a painting of me and my husband, but it also conveys a sense of the space we live in. Our loft is an entire floor of an old factory building. It has a wonderful character: old heavy beams, brick walls, wooden floors with the planks set diagonally, and many large windows on two sides.

The Loft posed many technical problems. Because the canvas was so large, I found that I couldn't paint in the kitchen, which is the area of our loft that is the background for the center panel. I had to actually move a whole section of the kitchen into my studio in order to have enough space and light

for working. I posed us under artificial light because I wanted to show the same kind of light that is in my kitchen, but I didn't want to work under it; therefore, I positioned the canvas so that only natural light fell on it. Since Tony and I obviously couldn't pose together, I used the objects around us to judge color and relative size. I found that we both had to pose in the same spot in order to compensate for the fact that my image was reversed by the mirror. In this way, I was able to have the light (which was directly overhead and between us) appear to come from the correct direction.

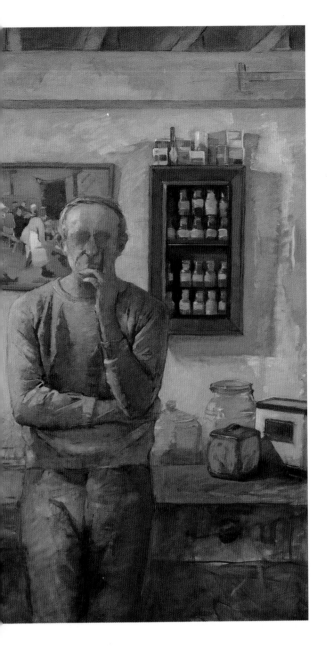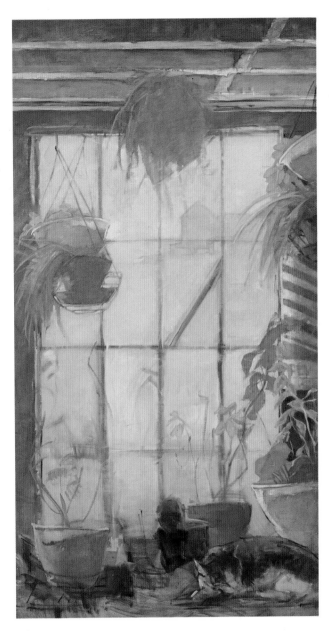

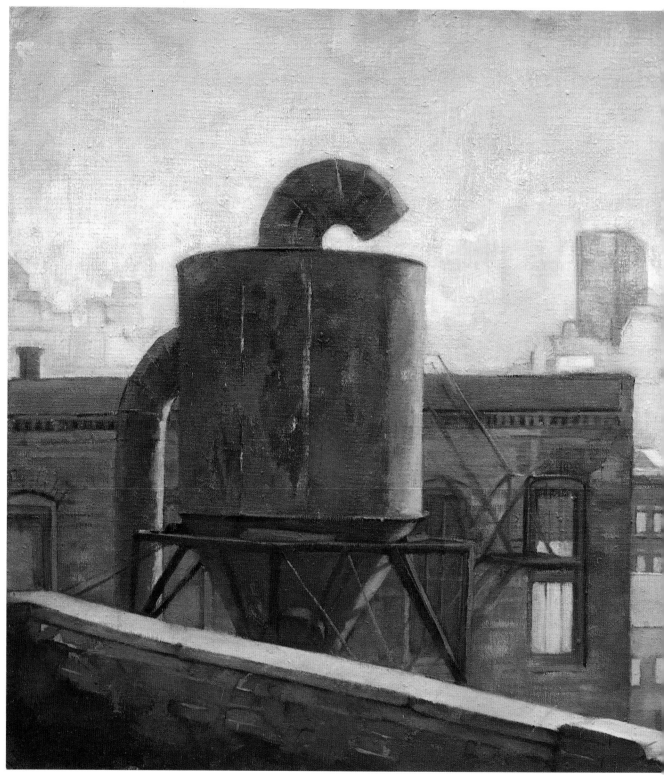

WATER TOWER
oil on canvas, 24″ × 30″ (60.9 × 76.2 cm),
collection of the artist.

This is a view of and from the roof of the building in which I live. Watertowers are very much a part of the New York landscape. I particularly liked this one on my building because of its interesting shapes and the variations of color. The scene as you see it does not exist exactly as I present it here.

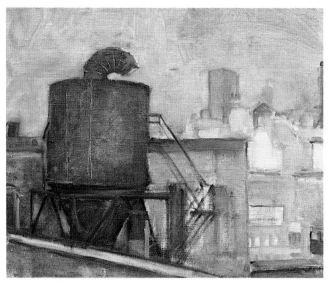

WATER TOWER (small version)
oil on canvas, 12″ × 14″ (30.4 × 35.5 cm),
collection of Fran Quinoness.

Although this was painted before the larger one opposite, it was not done as a study. I liked the looseness of the painting and left it, deciding that it was complete. However, I did use this painting for reference while I was working on the larger picture, specifically for the buildings on the right in the background.

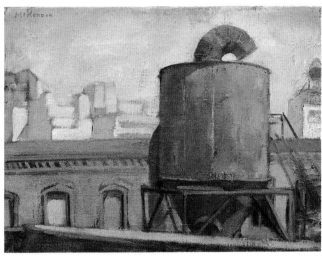

WATER TOWER (sunlight)
oil on canvas, 9″ × 12″ (22.8 × 30.4 cm),
collection of the artist.

This is a closer view of the same water tower but because I painted it later in the morning, the light is different and the tower itself appears as less of a silhouette.

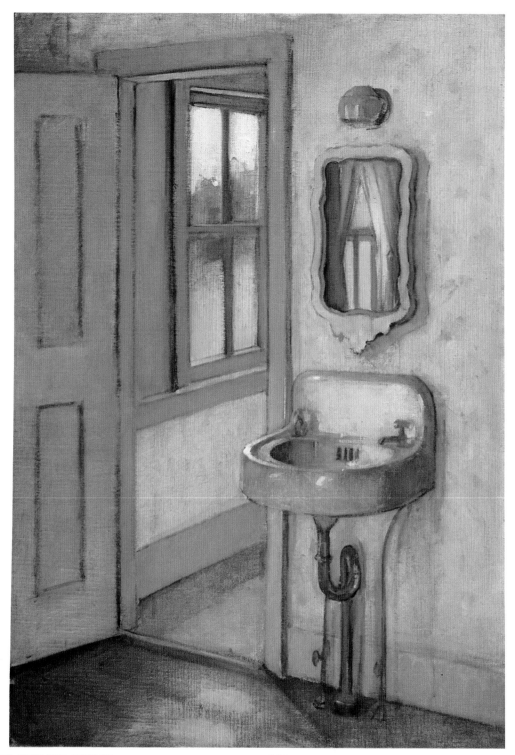

INTERIOR WITH SINK AND MIRROR
oil on canvas, 24″ × 16″ (60.9 × 40.6 cm),
collection of Connie and Dr. Peter Ewald.

The somewhat odd perspective in this painting is due in part to the age of the building, a country inn in New Hampshire. As a building ages, it settles and various things, such as angles of walls and floors, change. I found this intriguing. I was also drawn to the combination of indoors and outdoors, as well as by the reflections.

COUNTRY INN
oil on canvas, 20″ × 16″ (50.8 × 40.6 cm),
collection of the artist.

This inn, which is part of a 1785 farmhouse, has a sink in every bedroom. I found the inn itself very exciting. Its interiors were so interesting in themselves that I painted very little outdoors, because there were so many things to paint inside. This particular oil was done quickly, in almost one sitting.

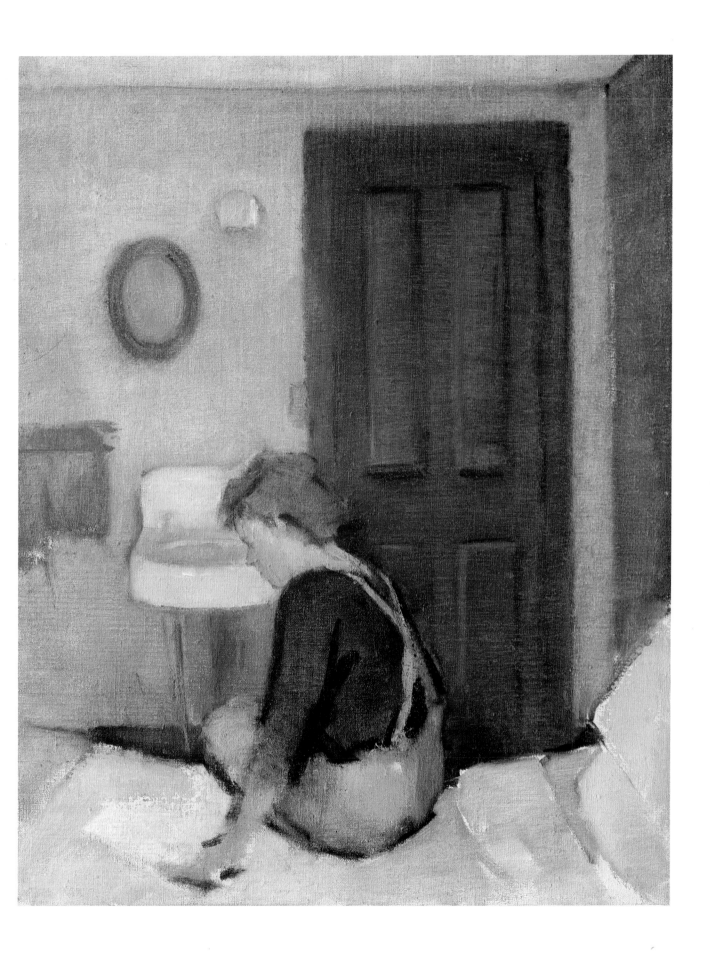

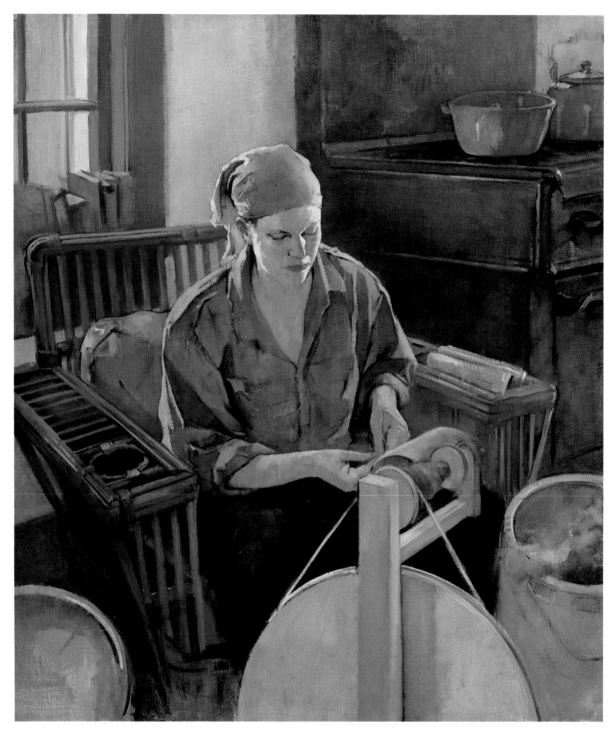

STONEWALL FARM
oil on canvas, 42″ × 36″ (106.68 × 91.44 cm),
collection of the artist.

Stonewall Farm *was painted in a room with light on three
sides. I used two of the three light sources, blocking off one
window and therefore eliminating one light source. Although I
found this light interesting, not only was it very different from
the cool north light that I'm used to in my studio, but I also
found it difficult to see the form with the light coming from two
directions. The model is a woman who recently changed her
life by moving from the city to a farm. At Stonewall Farm she
has animals, spins wool from her own sheep, and has turned
part of the house into a country inn.*

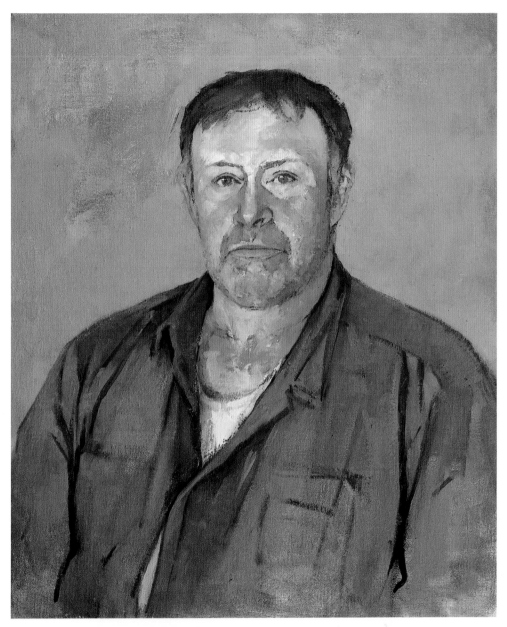

NEW HAMPSHIRE MAN
oil on canvas, 24″ × 20″ (60.9 × 50.8 cm),
collection of the artist.

*This portrait was done last summer during a stay on a farm in
New Hampshire. The model, Bob McCallister, worked there as
a handyman. He has spent his entire life in that area and is
very much a part of it. Because he is very different from
anyone I've had the opportunity to paint, I found him a
fascinating subject.*

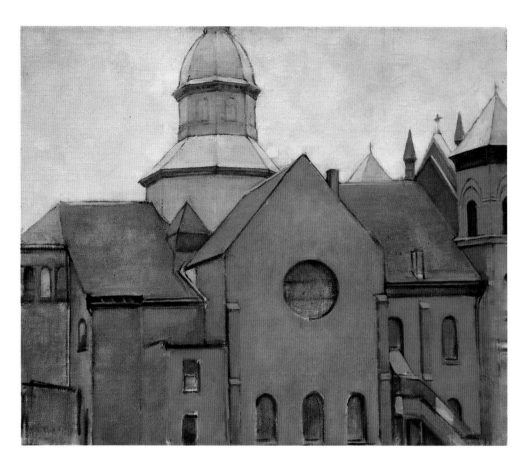

HOLY CROSS CHURCH
oil on canvas, 24″ × 30″ (60.9 × 76.2 cm),
collection of the artist.

Holy Cross Church is in my neighborhood, and I was aware of it for a long time before starting a series of paintings on this subject. I was drawn to the flat geometric shapes of color and to the shades of red and green themselves. Because I wanted to avoid sunlight, which I felt would break up these shapes, I painted the church only very early in the morning or on cloudy days. (I was given permission to work in the parking lot next to the church, so I was able to work without interruption.) In this first painting, I wanted to draw attention to the shapes of the church by showing space around them.

HOLY CROSS CHURCH
oil on canvas, 20″ × 18″ (50.8 × 45.7 cm),
collection of Kathleen Conry.

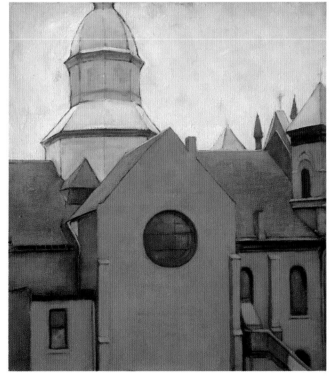

As the first painting progressed, I felt I wanted to focus more closely on the shapes of the church by coming in closer. I began a second painting. In this one, handling the color became a problem: Color areas started getting too flat and too saturated. Red can be a very difficult color to use, particularly in large areas. When mixing red with other colors in order to lighten it, I find that I can maintain its intensity if I mix it with Naples yellow, cadmium yellow, or zinc yellow rather than white. Because I had experienced this problem, I was able to return to the first painting of the church and make it work. I was able to vary the reds and achieve a feeling of more air.

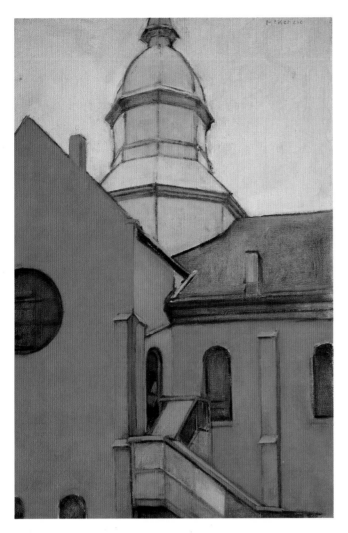

HOLY CROSS CHURCH FROM FORTY-SECOND STREET
oil on canvas, 18″ × 14″ (45.7 × 35.5 cm),
collection of Privatbanken, N.Y.

*While I was working on the first two canvases, I became
excited about how the church looked from an entirely different
angle. Unfortunately, this view forced me to set up in the street
in the very busy Times Square area and the amount of activity
that centered around me made it extremely difficult to
concentrate. In situations like this it is often better to paint with
another person. I've found that when I'm working alone,
people think me much more approachable and are inclined to
disturb me.*

HOLY CROSS CHURCH IN SNOW
oil on canvas, 12″ × 19″ (30.4 × 48.2 cm),
collection of the artist.

*As the weather got colder, I would take all three paintings of
the church with me but usually only work on one. On cloudy
days, because the light was constant, it was possible to do
some work on each of them. Just being able to see all of them
at the scene gave me more clarity. Although I did not think of
these paintings as a series, each one influenced the others
because they were all done at the same time. I found it an
interesting way to work. This fourth painting was conceived
the day after a major snowstorm. I was already very familiar
with the geometric shapes of the rooftops, and seeing them
covered with snow was very exciting to me. Because I knew
my time would be limited due to the weather, I composed the
painting at home, working from the other three versions. I
stretched a canvas to the appropriate size and roughed in the
design with charcoal. I was able to complete this painting
within a few hours because I was already so familiar with the
church. Now when I look upon this painting, I feel a certain
fondness; I was so absorbed in the painting process, that even
when the snow turned to sleeting rain I was unable to stop
working.*

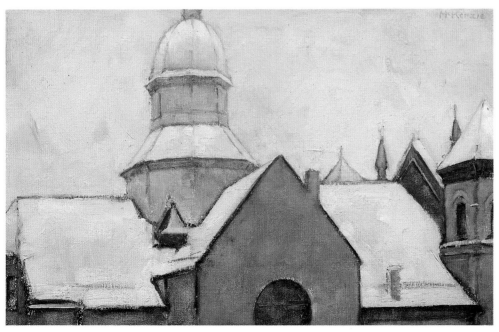

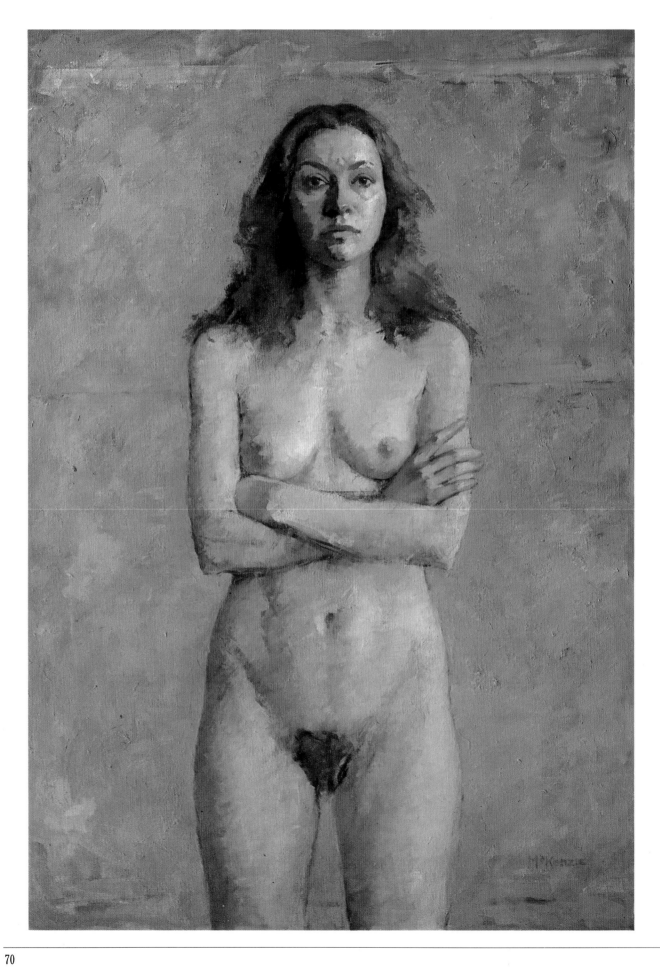

OILS

As you develop as an artist, you will evolve your own personal painting methods, according to need, but it is important that this be an on-going process, that you continue to search for new ways to express ideas, and that you keep making discoveries. Being tied to any fixed technique will only stop you from growing. Technique is a means of expression and should never be thought of as separate from expression or as an end in itself.

MATERIALS
Since you will constantly be using all sorts or materials, it is important to know how they work. Experiment, and discover the nature of your materials, their potential and their limitations. Try not to be afraid of your materials or of making mistakes. Take risks. Certain facts can be acquired by reading, but a real understanding and feeling for your materials can be gained only through experience.

PALETTE
I use mostly Winsor & Newton artists' oil colors, although I also like some of the colors made by Blockx, particularly burnt sienna deep and compose green. My regular palette includes: ivory black, raw sienna, yellow ochre, cadmium yellow, zinc yellow, cadmium orange, cadmium red, alizarin crimson, light red (Winsor & Newton only), burnt sienna, viridian, cerulean blue, cobalt blue, and French ultramarine blue. Because it has the greatest opacity and a consistency I like, I use flake white number 2 by Winsor & Newton. I can usually get whatever colors I need by mixing these colors, although

I sometimes add additional colors for a specific painting or because I feel like trying a new color. I often use Naples yellow, which by itself is a weak color but mixes well with other colors (when mixed with red, for example, it lightens the red without changing the intensity of the red as white does). It doesn't matter how you lay your colors out on the palette, but they should always be in the same order so that you are not repeatedly searching for colors.

I use a large rectangular wooden palette. Paint can be mixed on many surfaces, but I prefer wood, because I like the feel of it. Whatever surface you choose should be middle tone in value. After the first few hours even a white canvas will have a middle tone, so you have a better chance of mixing the right color on a middle-tone surface. You must remember, however, that any color you put on the canvas will be influenced by the colors next to it and you may have to make modifications.

The mixing area should be kept clean if the colors you mix are not to be affected. I often scrape and clean my palette several times during a painting session as well as after I've finished for the day. Each day I lay out fresh colors, with the exception of the reds and yellows, which stay fresh longer. You should use plenty of paint. If you are afraid to waste paint and feel restricted in your use of colors, the painting will suffer. Each time I begin to paint, I have a complete set-up of colors laid out in front of me. This is more important than you might think. If a color is missing from your palette you may find yourself substituting colors for the ones you really want to use, unconsciously gearing the painting to false color.

I stand while I work, frequently stepping back to look

STANDING NUDE
oil on canvas, 46″ × 32″ (106.8 × 81.2 cm),
collection of the artist.

There was something very confrontational in the stance of this model, and I tried to convey this feeling by putting her in the center of the canvas. Most of the background was done with a palette knife, using a heavy buildup of paint.

at the painting from a distance. My palette rests on the top of a taboret. This small cabinet on wheels has drawers, which hold my brushes and tubes of paint, making them easy to get at while I'm working. Occasionally I will sit down to paint if from that point of view my subject becomes more interesting, but, in general, I prefer to stand.

I think it is important to set up properly, before you begin painting, so that you are comfortable. To avoid distortion in your drawing, the canvas should be perpendicular, and the easel positioned so that once the canvas is covered with paint there will be no glare to contend with. The easel should also be sturdy. Painting itself presents enough problems; you shouldn't have to fight a canvas that is not held firmly in place. I sometimes use a spring clamp to attach the crossbar of a large canvas to the easel for more stability. Ideally, you should be able to see the canvas and the subject at the same time, with plenty of room behind you for stepping back and comparing both from a distance. In my experience however, the most interesting view seldom allows for ideal working conditions. I too often find myself boxed into a corner, forced to work with inadequate light, because I find a certain subject or angle very exciting.

MEDIUM

In the beginning stages of painting, I use only turpentine to thin and extend the paint. Since it is going to interact with the paint, I always use the best grade of turpentine because it has fewer impurities. I use two separate containers, a large one for cleaning my brushes and one that contains clean turpentine for mixing colors. Once the painting has been completely blocked in, if I use any medium at all it is a very simple one: a mixture of half linseed oil and half turpentine. I prefer a matte surface, so I use very little oil. When I do use oil, I use linseed oil, which is the binding medium that is already present in the composition of the paint. Be careful not to use excessive amounts of oil, since it has a tendency to yellow and darken with the passage of time. Drying time must also be considered. It is recommended that you use very little oil in the beginning stages of a painting and more oil as you go along. The rule is "fat over lean," fat referring to the oil content.

BRUSHES

Brushes depend on personal preference. The brushes I use most often are called filberts. They are long-haired bristle brushes, similar to flats but somewhat rounded at the end (sizes 4 through 12). I also use rounds and brights. I may use a house painter's brush or a rag if I want to cover large areas of canvas. Occasionally I will use a flat or pointed sable brush. Although I don't use it for painting, I often run a fan-shaped brush lightly over the surface of the painting at the end of a painting session. By doing this I am able to eliminate glare without interfering with the brushstrokes. I use good-quality brushes and keep them in good condition by washing them immediately after I finish for the day, first in turpentine and then with soap and water. Once I am sure that all the soap has been removed, I reshape them.

PAINTING KNIVES

I enjoy using a painting knife and do so frequently while I'm working, but I like to use both a brush and a knife, not just the knife by itself. A knife can be used for laying in large flat areas of color, for building up thick paint, and for losing edges. It is possible to get purer, more intense color by using a knife instead of a brush, particularly when you are working back into a wet painting. A knife also allows you to control the painting surface somewhat. Areas that become too thick can be scraped, allowing you to make changes or corrections in the painting. Scraping and repainting can give you a certain richness of surface that I find exciting.

A painting knife should not be confused with a palette knife, which is used for mixing colors and for scraping paint off the palette. Painting knives are made of thinner, more flexible steel. They are usually trowel-shaped, but can be bought in various shapes and sizes. The better quality painting knives have thicker, stronger handles that are less apt to break when the knives are used forcefully.

As you progress, you will develop your own preferences for certain materials, but it is important to experiment. I often have my class do one-day studies, using only a painting knife, to acquaint them with its capabilities. This also forces them to use stronger color and to concentrate on the large shapes of color in relation to one another, as the knife makes detail

VICTORIA

oil on canvas, 56″ × 40″ (142.2 × 101.6 cm),
collection of Ellen and Dr. Martin Stern.

This large canvas was painted at the model's apartment. I still remember the frustration of working without enough space to step back and really see such a large painting. I found it helpful to elevate the canvas while working on the lower portion; raising the canvas in this way helps to avoid distortions of perspective. The light was inadequate, which became another source of frustration.

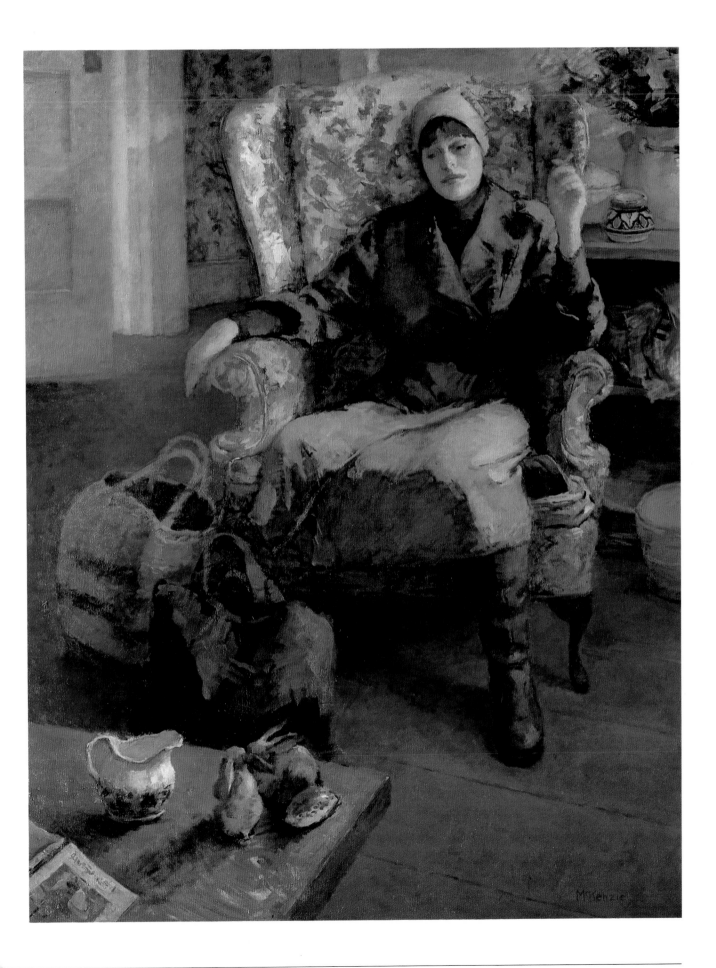

impossible. In these studies, paint is not applied thickly, but in flat areas of color.

The use of a painting knife can easily be seen in the work of Edwin Dickinson and Abbott Thayer. Many of their paintings have beautiful knife passages. When paint is applied vigorously with a knife, it can add a sensuous, lively quality to the surface and strengthen the image, but inexperienced painters are often seduced by superficial effects, and this can be a danger.

SURFACES

Canvas should be of good quality, linen if possible. I use a commercially prepared linen of medium-rough texture, double primed with acrylic. Canvas should be tightly stretched taut, like a drum. A canvas that is not taut has no resilience and is difficult to work on. If the canvas becomes too loose or slack in the middle of painting, I remove the staples and restretch the entire canvas. Paintings larger than 30 inches require heavy-duty stretchers, with crossbars for additional support. The larger sizes are usually warped or pieced together (which may cause them to snap under pressure), so it is important to inspect stretchers carefully before purchasing them. Some art supply stores, like David Davis in New York City, make their own stretchers. I prefer these because they are sturdier and easier to fit together.

For smaller paintings I sometimes work on quarter-inch untempered Masonite, which I prepare with several coats of acrylic gesso. Masonite can be purchased and cut to size at most lumberyards.

I also enjoy painting on paper. It has a matte surface, is more absorbent than canvas, and feels very different to work on than cloth surfaces. Arches makes a cold press (medium rough) 100 percent rag paper, mounted on board, which I use frequently. Because oil may eventually destroy the fibers of the paper, it is advisable to apply a thin coat of glue size, or shellac diluted with alcohol (half and half), to the paper before painting on it. You can also apply several thin coats of acrylic gesso to the paper to isolate it from the oil paint.

VARNISH

Varnish forms a protective layer over the paint. This keeps it free from dirt and chemical reaction, but it should not be applied for at least six months (some people say a year) after the completion of the painting. Although a painting may appear to be dry, the underlying layers may still be wet, particularly if thick paint has been used. Varnish should never be applied when humidity is high. Before varnish is applied, I dampen a clean rag and wipe it lightly over the surface of the

painting to remove any dirt that may have accumulated. I use a synthetic varnish, Kamar, which will not yellow with age and which can be safely removed without causing harm to the paint underneath. Kamar varnish comes in a spray can, so the application is very simple and allows for a lot of control. The surface is built up by

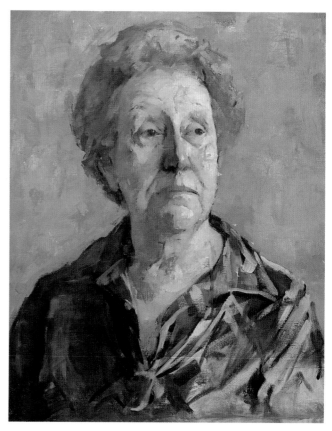

JANE PERIN
oil on canvas, 20″ × 16″ (50.8 × 40.6 cm),
collection of Jane Perin.

In this portrait I worked quite a bit with a palette knife on the face in an effort to simplify and bring out the modeling of her features. The pattern of light on her dress acts as a visual support for the head. Without this pattern, the bottom half of the canvas might have lacked interest.

YOUNG WOMAN SEWING
oil on canvas, 24″ × 30″ (60.9 × 76.2 cm),
collection of Jane E. Rice and Michael W. Rice.

I kept the background pattern soft and undefined in order to emphasize the face. I did this painting sitting on the floor because I liked the view, and the model was able to continue working while I painted.

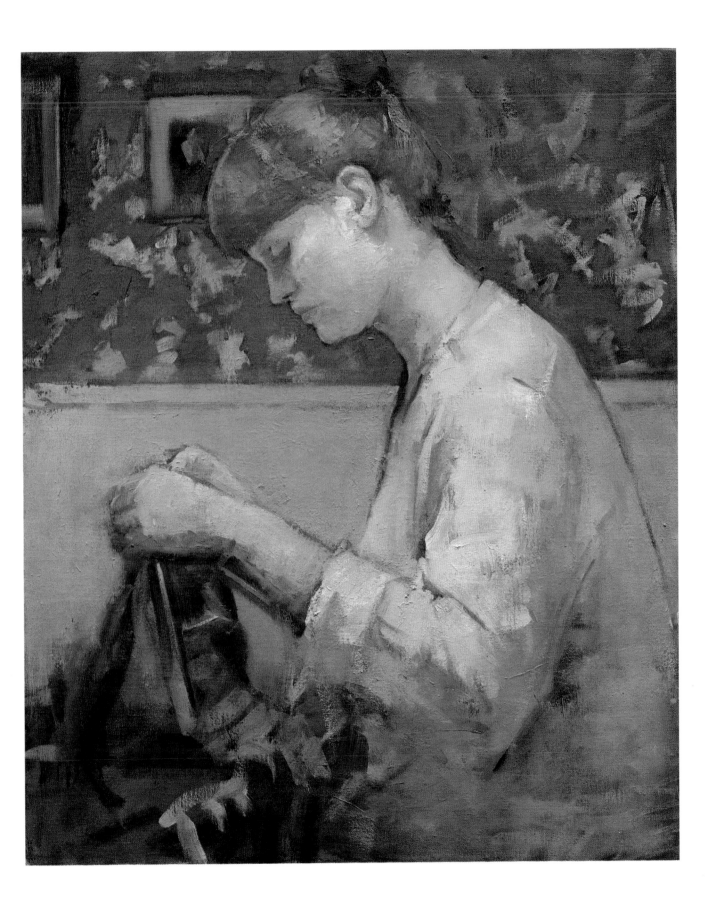

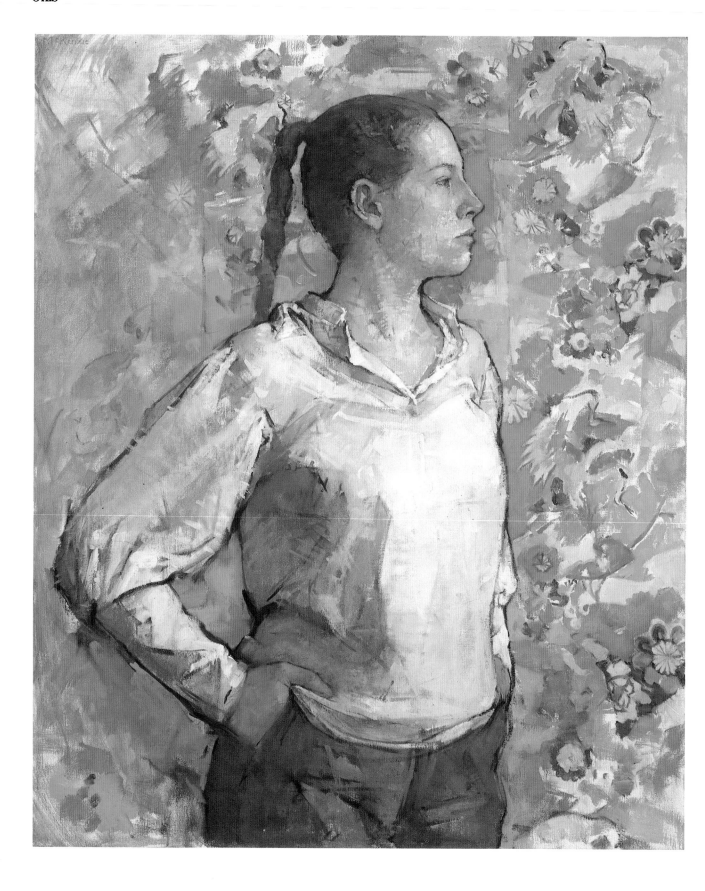

applying several coats; you should wait at least twenty minutes between each application. Since I prefer a matte surface, I am able to control the amount of gloss by using fewer coats.

Oil colors have a tendency to "sink in" and lose their brilliance as they dry. Varnish can restore this brilliance. Retouch varnish may also be used for this purpose, but it is not permanent. I sometimes spray my paintings with retouch varnish once they are completed to restore the color until is is time for a final varnish. An application of retouch varnish will also revive color while you're working on a painting, but it will leave a tacky surface that I find unpleasant to work on.

COMPOSITION

You can't depend only on being excited by your subject. You must use your imagination as well and spend some time exploring ways to best express what you feel about your subject. Possibilities for composing the same space are unlimited, and the way you choose to divide this space can be either very exciting or dull. Any number of artists working from the same spot would arrive at entirely different compositions. Although some artists are intellectual about composition, for most the process is more intuitive. Every artist has a personal sense of balance and order, and the act of painting is guided by this sense. A certain placement will simply feel right, be more satisfying. I think you must develop your own feeling for, or sense of, design by actually making compositions. Certain principles can be learned, but there are no absolute rules. Looking at and studying the way other paintings are structured and being aware of the theories or systems used in the past, will make you more conscious of other possibilities.

PRELIMINARY STUDIES

At times I have an immediate response to my subject and a clear concept of what I wish to paint, and I begin freely on the canvas without any preliminary studies. Sometimes, however, in my eagerness to paint, I make mistakes and then, disappointed by the results, spend days changing things established in the first few minutes. With some preparation, I could have avoided these problems.

More often now, I spend time determining the composition, particularly with a larger, more complex painting. I usually do several preliminary sketches in an attempt to familiarize myself with the subject. These are small compositional sketches. I concentrate on the break-up of space within a format, being very conscious of the bounding edges. I also concentrate on gesture, and on light-and-dark pattern. Details are of no importance. It helps to see the subject within an enclosed space, that is, to frame it by looking through a rectangle formed either by the thumb and forefinger of both hands or by two corner pieces of a cardboard mat, which can be adjusted to make the opening larger or smaller.

If I have a model, I look for poses that are most natural or characteristic of that person. I try to be sensitive to gestures that express something personal about the model. I usually try several ideas, looking from different angles but try to stay open to new possibilities. Sometimes, during a break, the model will take a pose that will suggest something quite different to me, and this may lead me in an entirely different direction.

As I develop a composition, I find it helps to think in terms of positive and negative space. With the simple subject of a figure against a background, the figure is the positive space and the background is the negative space. The amount of space around the figure is part of the composition and says as much about the figure as the figure itself does. The spaces in between are also part of the composition and create shapes that can help in drawing the figure. For instance, if the area between the arm and the body is perceived as a shape and seen correctly, it will help you to draw both arm and body.

JAPANESE ROBE
oil on canvas, 35″ × 29″ (88.9 × 73.6 cm),
collection of the artist.

In this painting I wanted to stress the bold stance and simplicity of the figure by opposing it to the intricacy of the Oriental pattern. The model has a beautiful profile, which led me to develop the painting in a more linear way than usual. The background pattern, which is itself very linear, also influenced my approach to this painting. I worked out the pattern slowly as the painting progressed, suggesting all of the colors from the beginning, rather than starting with a general tone.

During this process I sometimes see possibilities for a painting, although they are somewhat vague at first. I am often confused during this period. Small color studies are very helpful. Occasionally, these studies will turn into paintings. With a large painting, I sometimes spend a few days simply allowing a visual image to form in my mind. Working from memory or from the original sketches done from life, I often do new sketches to explore other possibilities. Design is my primary concern. I seem to know intuitively when the image is right.

I used to feel that if I did preliminary work I would lose much of the excitement of the painting. However, now I find that the concentration I put into the studies helps me to express myself more clearly and more forcefully, because I am familiar with the subject.

TRANSFERRING THE SKETCH
If I am working small, I usually work out my composition on the canvas itself; or, if I do compositional sketches, I may have several different-sized canvases on hand to choose from, and then I will transfer the sketch to the canvas by eye. With a large painting, I generally stretch my canvas after I have decided on the composition. The canvas must have the same proportions as the sketch. I measure the sketch and enlarge it however many times it takes to bring it up to the size I want.

I use a very simple method for blowing up the sketch (see diagram). First I tape tracing paper over the sketch and outline the outer edges. With a ruler, I draw a line from each corner to the opposite corner, making an X in the enclosed space. The X marks the center, and I make lines through the center, horizontally and vertically. The space is now divided into fourths, with each fourth divided in half diagonally, and I complete the X in each fourth. By drawing lines through the centers of the X's, horizontally and vertically, I can make further divisions. The process may be repeated any number of times, but I

rarely go beyond what I've just described. I am only interested in a rough placement of the large shapes and in finding their basic proportions. The sketch from which I am working is itself rough and inaccurate.

Working with vine charcoal, very lightly, I divide the canvas in the same way and place the basic forms, referring to the sketch. Once I am satisfied, I lightly flick a rag over the surface several times, leaving only a ghost of the charcoal. It is important to remember that when a small sketch is blown up into a large painting it will look very different, so you can't stick rigidly to the sketch. I always go back to the subject, work from life and make adjustments. Although this process may sound time-consuming, I find that I actually save an enormous amount of time. Enlarging a small sketch by eye onto a large canvas can be very difficult. You can be easily deceived.

STARTING AND DEVELOPING A PAINTING
Strong light on the subject from one direction can create beautiful well-defined patterns of light and dark. Some set-ups have very little light-and-dark pattern but instead present flat shapes of color, one next to the other, with very little change in value. Every set-up is different and presents its own problems, and you may have an interest in a particular aspect of it, such as light or color. The important thing is that you approach each painting as a totally new challenge.

I prefer to work on a white canvas or one with a very light tone, although many times I will switch to a toned canvas or even work over old paintings. A toned canvas must be approached somewhat differently from a white canvas because you are starting with a middle tone and working in two directions, both darker and lighter. Although I still establish my darkest darks first, I find that at least an indication of the lights is necessary fairly early on. What follows is not a formula but a basic approach that allows me to set up value and color relationships and stay in control for a while in the beginning, when I am working on a white or very lightly toned canvas.

Initially, I may spend time thinking and planning my composition, but once I begin work on the canvas itself I like to react directly to my subject. I begin with vine

MAYA (model stand)
oil on canvas, 18″ × 14″ (45.7 × 35.5 cm),
collection of the artist.

I liked the way Maya looked when she walked into my studio, and I painted her just as she was. I had her sit on the edge of the model stand so that I could include the abstract shapes behind her.

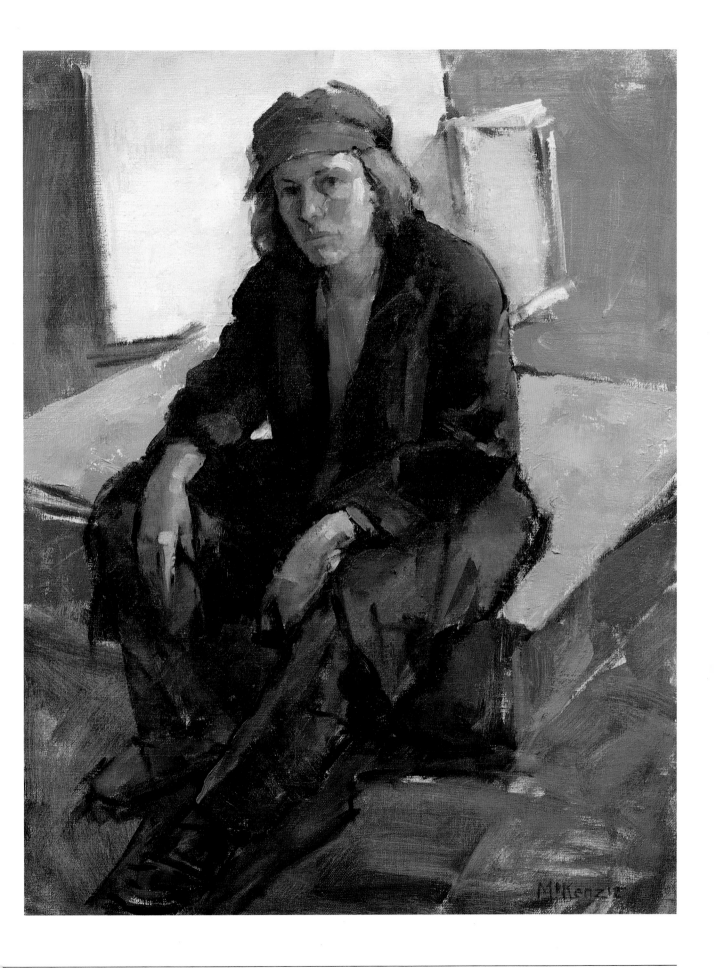

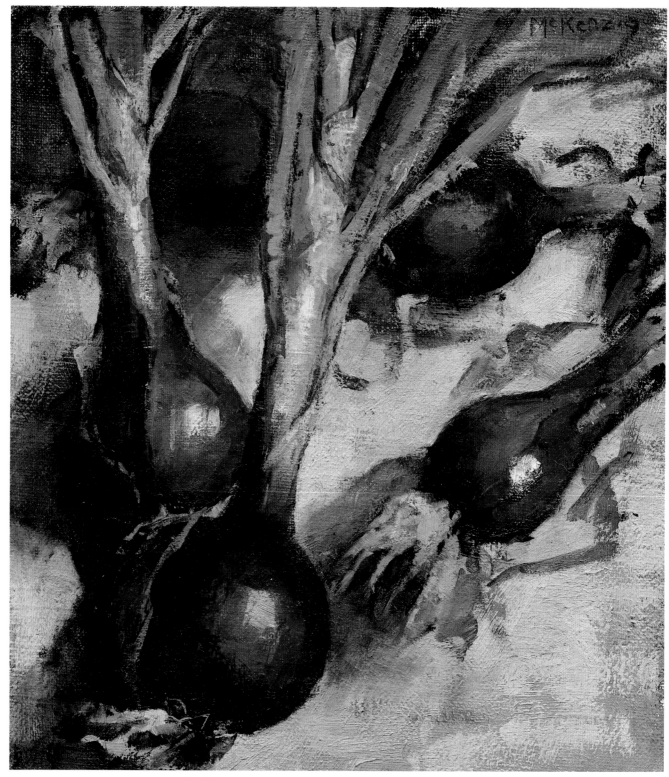

RED ONIONS
oil on canvas, 10″ × 8″ (25.4 × 20.3 cm),
collection of Gitte and Dr. John Blass.

*Although I often work on large canvases for an extended
period of time, I also like to paint smaller, less formal
paintings that can be approached very simply and directly. In
this painting and in the one opposite, I was interested in the
relationships of color and shape.*

charcoal, boldly scaling the forms to the canvas, working only for placement. I spend only a few minutes and I don't try to be accurate. It is a mistake to do a careful drawing in the beginning and have it serve as an outline. You can't be afraid to lose lines that have been established. The basis of painting is to make the form happen with color. The drawing should evolve as the painting progresses.

Do not be misled by my saying that this process should take only a few minutes. The charcoal sketch itself is rough and quick, but I may wipe it off and start over any number of times—no matter how long it takes—before I am excited by the composition. If the way the space is broken up is not exciting there is no point in continuing, so you should spend as much time as it takes.

When I am happy with the placement, I hit the canvas with a rag and leave only a slight indication of charcoal to guide me. Using a light, neutral color with a dry brush (very little turpentine), I construct the forms, not by going

over the charcoal, but by making new lines freely, trying to find my way. Detail is of no importance. I am looking for the large shapes in relation to one another, considering the entire canvas at once. I am trying to capture the action or overall movement. I sometimes find it helpful, using a brush with my arm extended, to measure the angles against the straight edges of the canvas. I may reconstruct several times with a slightly darker color (dry brush), each time continuing to re-examine the subject and each time becoming a little more accurate. These lines will all be covered eventually, so I keep them as elusive as possible. I construct both sides of the figure at once, looking for fluid lines and emphasizing the large movements, never working on one side without considering its relationship to the other side.

By squinting I can see the light and shadow patterns more clearly. I start with the darkest darks throughout the canvas, still using a dry brush, and mass in the shadow areas, looking for the value, color, and shape of each shadow, working in an almost abstract manner. I am concerned with the overall dark pattern, void of all details, and the warm and cool variations within the dark pattern. Using a very large brush, I almost scrub the paint into the canvas, not building up any paint on the surface. The more simply or abstractly you visualize these patterns, the stronger the resulting image will be. I stay away from the lights, allowing the canvas itself to work as the light pattern.

You should establish the color relationships in the beginning. The first color you put on the canvas is important. If you put a color on the canvas that is wrong, everything will follow from it, and then the whole painting will be wrong. I work broadly, all over the canvas, relating the large areas of color. I judge each area by its relationship to the surrounding areas (it helps to look in the center of these areas rather than at the edges). If I change one area, the areas around it may have to be adjusted. It helps to step back and compare each area to the others. It's really important to be able to see these relationships and to get the impact of these large areas of color in relation to one another. I try to develop the painting as a whole and to have all areas of the canvas at the same level when I stop for the day. The tendency is to work only on the figure and not to consider the background until later, but the figure must be seen from the beginning in relation to the background, not as an isolated object. Often, painting the background will create the forms of the figure, as well as create the distance between the background and foreground. Once I have established the main elements I may spend more time in one area, but I think that basically the painting should be complete at each stage.

I continue to work all over the canvas, constantly relating value, color, and shape: placing color freely where I see it. In order to prevent the shadow areas from appearing dull or flat, I try to keep the darks transparent

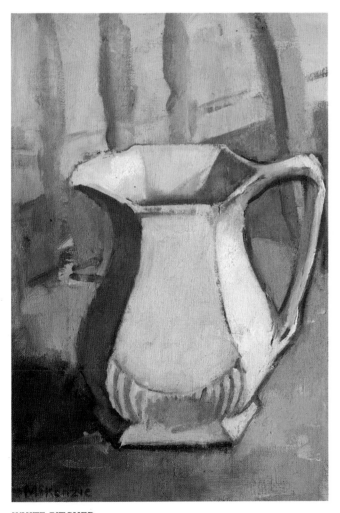

WHITE PITCHER
oil on canvas, 12″ × 8″ (30.4 × 20.3 cm),
collection of the artist.

and the shadows luminous. I build up more paint in the lights. Sometimes I will run my painting knife lightly over a dark area to keep the paint from building up. I continue to strengthen the drawing. I sometimes choose to leave some areas less finished or more out of focus than others, allowing the imagination to finish them, giving more importance to the more detailed parts. You have to decide where you want the viewer to look—what you want to emphasize or lose. You can intentionally direct the viewer's eye to specific areas of the painting. Hard edges, bright colors, and strong contrasts generally come forward. Soft or blurred edges and cool colors usually recede. However, they don't always, and while it helps to know these "rules" and to be conscious of them, you can't rely on them. I see so many students reasoning that things should be a certain way, deciding in advance instead of really looking at what's in front of them. This often blinds them, stopping them from

making valid decisions that may seem to them to contradict these rules.

I apply strokes across rather than along the form; this brings the planes together, making a more solid form. For example, the tendency with a long form, such as an extended arm, is to apply strokes that follow the length of the arm, a technique that should be avoided. Try to think sculpturally and perceive the form as existing three-dimensionally, in space.

While an initial concept is important, you must allow a painting to take its own course. It will grow in stages, and each stage, or your reaction to it, influences the next. A painting has its own existence and reality, and you have to follow its needs, making changes freely. Often these changes take you in another direction, opening up new possibilities that are sometimes more interesting than your original idea. You have to allow a painting to evolve.

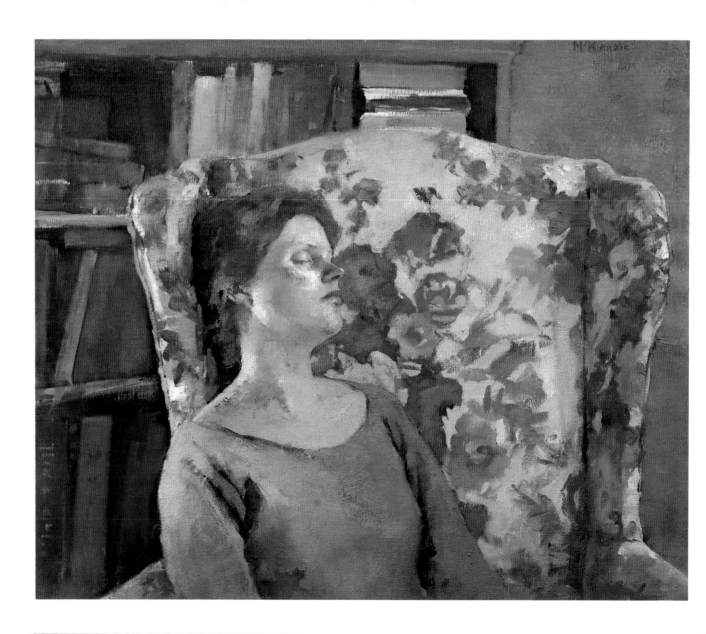

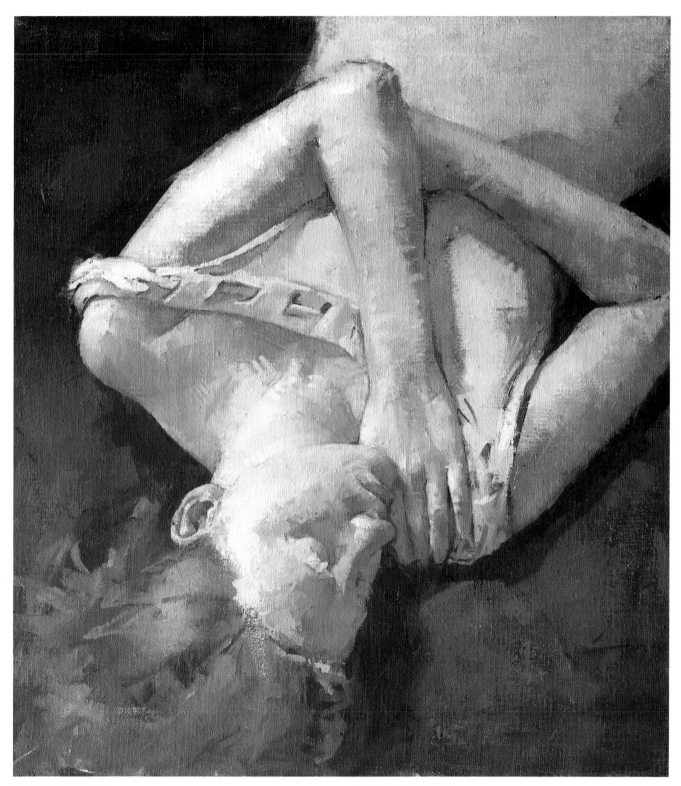

WINGBACK CHAIR
oil on canvas, 24″ × 30″ (60.9 × 76.2 cm),
collection of Victoria Prewitt and Robert Harte.

*The central focus of this painting is the relationship between
the woman's face in profile and the pattern on the fabric of the
chair. I kept her clothing simple in order to maintain the focus.
Of particular interest to me as I worked was the play of the
two light sources on her face.*

INVERTED FIGURE
oil on canvas, 20″ × 18″ (50.8 × 45.7 cm),
collection of Ellen and Dr. Martin Stern.

*This was a very interesting but difficult angle. As I painted, I
stood directly over the model; I found that if I moved my
position even slightly, everything changed dramatically.*

As the painting progresses I am more concerned with detail, but at the same time I am thinking in terms of losing edges and pulling areas together, simplifying to make the strongest statement. A painting should work not only close up but from a distance. The forms have to "read." Clarity is one of the most important elements of design. As I did in the beginning, I try to see the painting at this stage in terms of the large, simple shapes and how they relate to one another. I am looking at the simple masses of light and dark. When a painting looks spotty and colors jump out rather than stay within a larger pattern, it is usually because the values are wrong. Every color also exists as a value, and the colors that form the shadow pattern should hold together. The lights should also hold together and form a pattern.

You must be aware of the importance of the whole picture. All parts of the painting must be related. People tend to put too much into a painting; try to eliminate what is not important. Sometimes an area that is beautifully painted must be reworked or taken out entirely, or something new must be added, because it will strengthen the overall image. To clearly express anything, a painting must be unified.

COLOR

Every artist sees color differently. Vuillard saw the world in extremely beautiful, subtle variations of color. Artists like Bonnard or Munch viewed color in a much bolder way. A painting may be high key (mostly light colors), low key (mostly dark colors), or have a full range of values. Also, the overall color in most paintings generally leans toward cool or warm. Piero della Francesca and Botticelli painted cool pictures; Rembrandt's paintings are very warm. Color is also an element of design, and the way it is distributed can move your eye through a painting. This way of using color is very evident and very effective in the paintings of Pieter Brueghel.

The use of color is very personal, and only the technical aspects of it can be taught. As a student you must develop the ability to see color and color relationships. Students seem at first unable to see color at all and after a while see far too much, missing the large areas of color in relation to one another. The ability to see and mix colors comes with experience. William Merritt Chase said, "One becomes in time so sensitive to color harmony that the instant one puts on a false spot of color it hurts, like the wrong note in music."

I never premix colors but try to mix exactly what I see in front of me. I try to determine whether the color is cool or warm and what the value is. Every color has a value, and if the color is right the value will be right. There is no way to judge the effect of any color you mix until you actually put it on the canvas and step back and look. Every color must be seen in relation to the other colors, and then modified until it seems right.

In this book I purposely don't discuss the specific colors I've used in any of the paintings, or how these colors were mixed. There can be no formula for mixing colors, and that sort of discussion encourages people to rely on formulas. The colors of the subject are affected by the light in which they are seen and by every surrounding color and will be different in every painting. Preconceptions about color limit your ability to see what's actually in front of you. Learn to trust what you see with your own eyes. Every time you mix a color you should look closely and never take anything for granted. Inexperienced painters are often afraid to actually use color. It's better to be bold and overstate a color rather than put down something indefinite and weak. For color not to lose its strength, you must put it down and leave it alone. It's not that you can't mix paint into wet paint, but you must remember that the colors will lose their intensity. When you're working into wet paint, you might try using a painting knife if you want to get stronger or cleaner color.

Hawthorne on Painting is a wonderful book about color and painting in general, and I highly recommend it to you. Charles Hawthorne's sense of excitement about painting is vividly expressed in this collection of remarks he made to his students. His wife collected their notes and published them after his death. *The Art Spirit* by Robert Henri (compiled by Margery Ryerson) also conveys an excitement about painting.

I also recommend *Brackman: His Art and Teaching* by Kenneth Bates, first published in 1951 by Noan Publishing Studio, and revised and enlarged in 1973 by Robert Brackman and the Madison Art Gallery Publishing Company.

SELF-PORTRAIT (striped shirt)
oil on canvas, 27″ × 21″ (68.5 × 53.3 cm),
collection of Joan and George Wallace.

The painting on the wall behind me is a self-portrait by Robert Philipp. He was my teacher and very important to me.

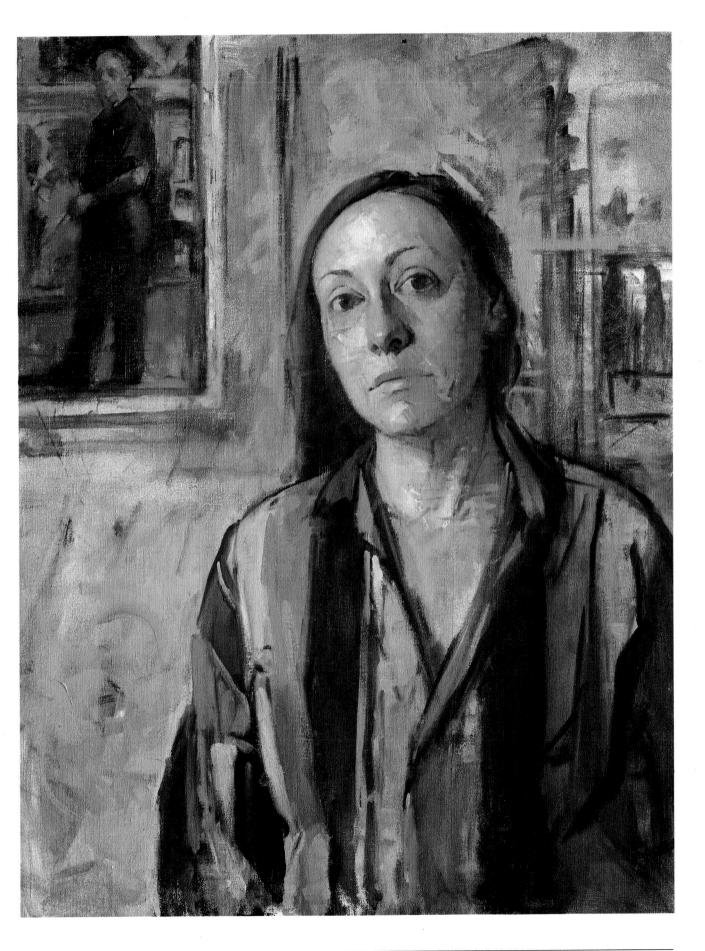

BOB MERRIT
oil on canvas, 20″ × 16″ (50.8 × 40.6 cm),
collection of the artist.

This very loosely painted portrait study was actually done slowly although it appears to have been done quickly. The shapes of light on the face function both as compositional elements and as a means of building up the structure of the head.

SELF-PORTRAIT (blue shirt)
oil on rag board, 29″ × 22″ (73.6 × 55.8 cm),
collection of Gitte and Dr. John Blass.

This self-portrait was done in my studio. Although there is a great deal of activity in the background, I kept the detail to a minimum in order not to detract from the figure. Also, the figure is strongly lit, creating a feeling of solidity.

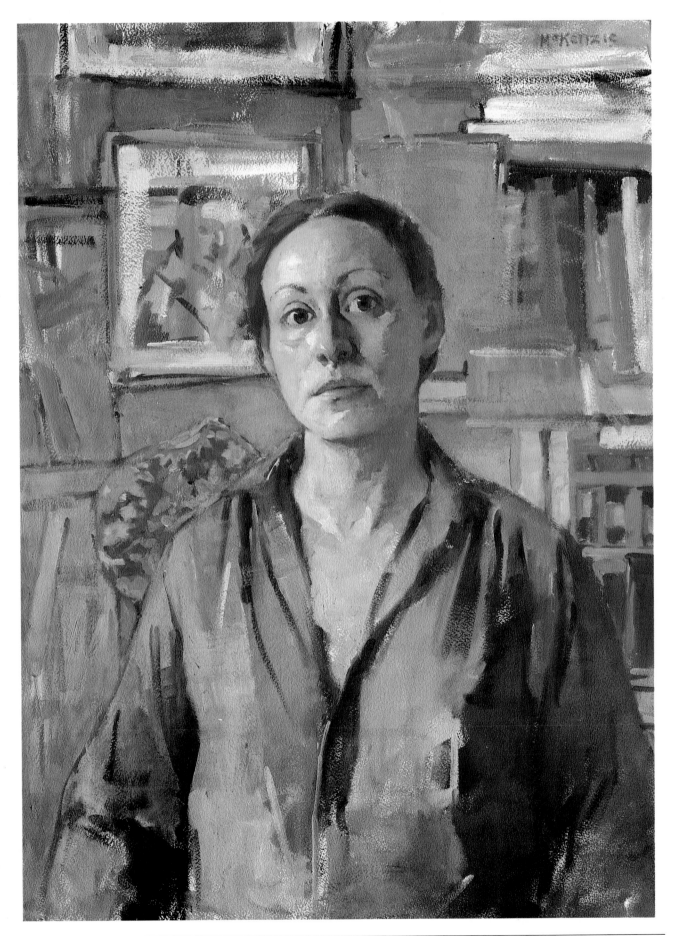

COUPLE

oil on canvas, 36″ × 50″ (91.4 × 127 cm),
collection of Henri and Marcelle Danan.

This painting is something of a favorite of mine because—for once—the painting itself seemed to just flow and I was able to handle the image in a summary way. The man is basically in silhouette, in front of a strong backlight, with the light around only the edges of his body. Although the woman's figure is flooded with light, it assumes a secondary importance in the composition. While working on this canvas, I always had the models pose together, except at the very end.

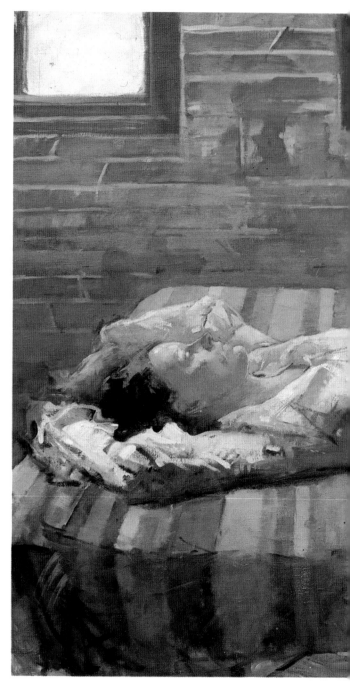

THUMBNAIL SKETCH FOR COUPLE

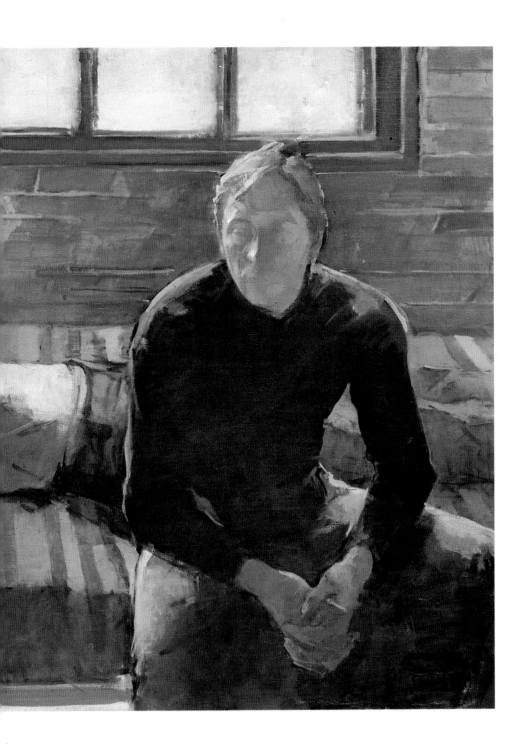

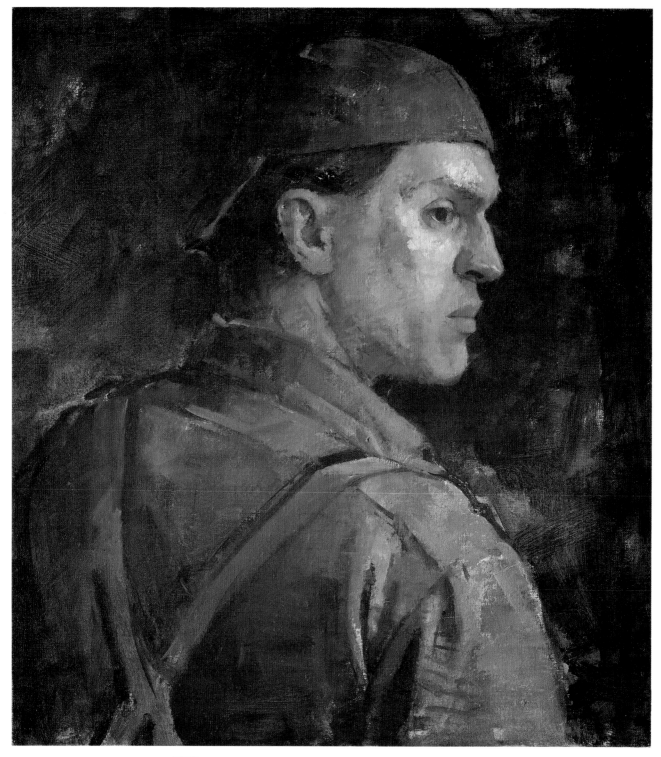

NICK
oil on canvas, 20″ × 18″ (50.8 × 45.7 cm),
collection of the artist.

*Because of the strong contrast between the dark wall and the
model's profile, I had to make the head very strong. In this
way, I was able to avoid a cut-out effect. I also had to pay
special attention to the edges, bringing them in and out of
focus, especially around the head. The model is a friend, an
artist, Nick Palmisano.*

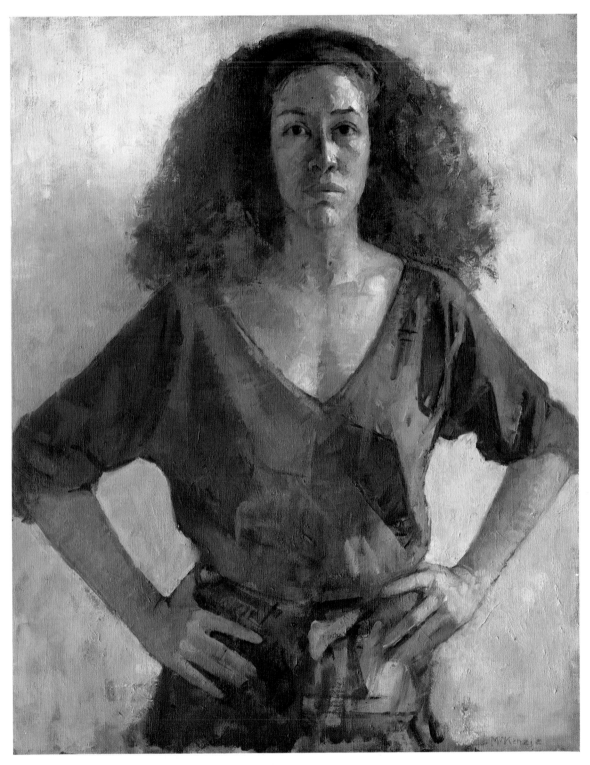

TERESA
oil on canvas, 30″ × 24″ (76.2 × 60.9 cm),
collection of the artist.

Teresa *was done over an old painting. Working over an old
canvas can be exciting: it is similar to painting on a toned
canvas, but you must work very rapidly to cover the old image
before you can see the new one (it helps to turn the canvas
upside down). Some of the excitement comes from combining
the old shapes and colors with the new, taking advantage of
accidental relationships. I also find it pleasing to work on the
already built-up surface texture of an old painting.*

STUDY FOR BASS PLAYER
oil on board, 21½″ × 14″ (54.6 × 35.5 cm),
collection of the artist.

This was done on Arches 100 percent rag board, as a study for the larger painting (opposite). This particular board seems to absorb the paint faster than other surfaces do; therefore I was able to work quickly and then immediately work back into what I had just painted. I find this type of rag board ideal for preliminary color studies.

BASS PLAYER
oil on canvas, 64″ × 51″ (162.5 × 127 cm),
collection of the artist.

I saw a bass player standing on the street with his instrument and immediately wanted to paint him. I always find it difficult to approach a stranger, but eventually I found the courage to ask this man to pose. I posed him in artificial light but had natural light on the canvas. While he was posing he sometimes played, which I found very enjoyable, as I had never before heard the bass alone. I had tried, at first, to have him hold his hands in a playing position, but they started to look stiff and posed. I found it very helpful to be able to paint his hands while he was actually playing.

THUMBNAIL SKETCH FOR BASS PLAYER

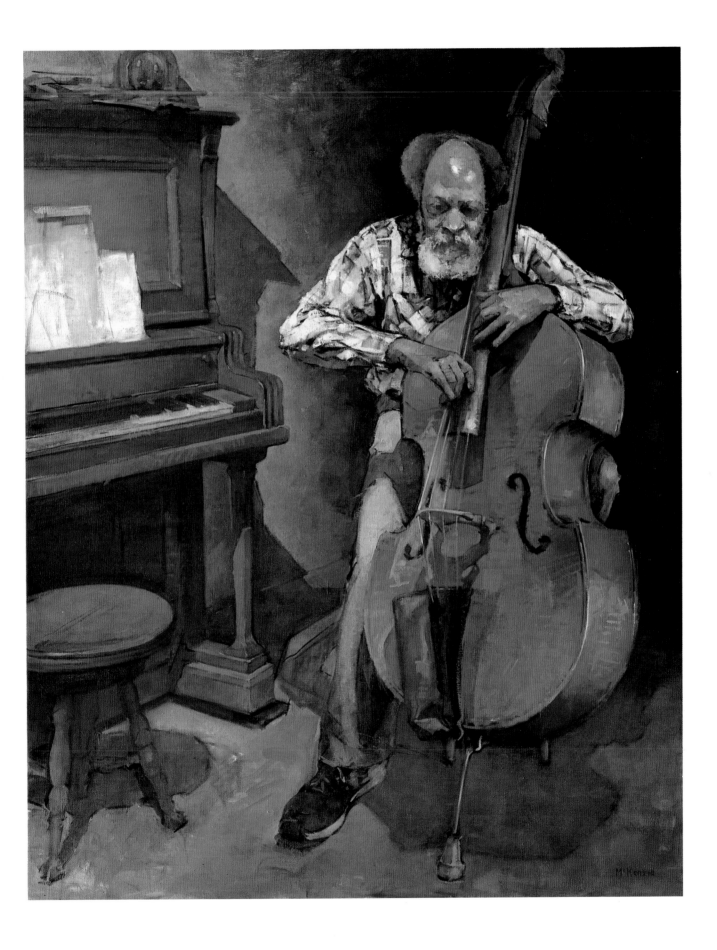

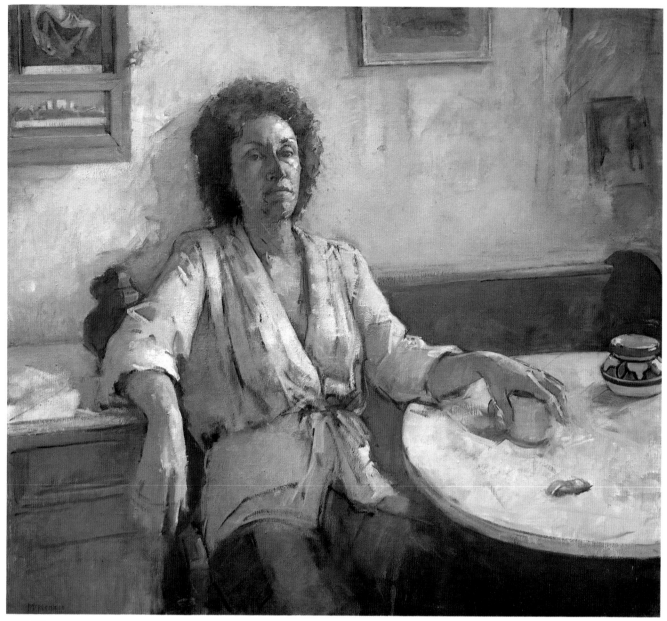

CHRISTI
oil on canvas, 38″ × 42″ (96.5 × 106.68),
collection of the artist.

*The light shapes are important here: the table, the wall, the top
of the cabinet, the woman's shirt. These elements move you
through the painting. This is an area of my kitchen; however,
because the kitchen is small, everything was moved into the
studio in order to make it possible for me to work.*

FIGURE IN FRONT OF CLOCK
oil on canvas, 60″ × 26″ (152.4 × 66.04 cm),
courtesy of Sindin Gallery, New York City.

*This very vertical canvas was done in my living room. Because
of the strong south light, the posing sessions had to be very
early in the morning. I kept the reflections on the clock very
simple and vague in order to focus on the profile.*

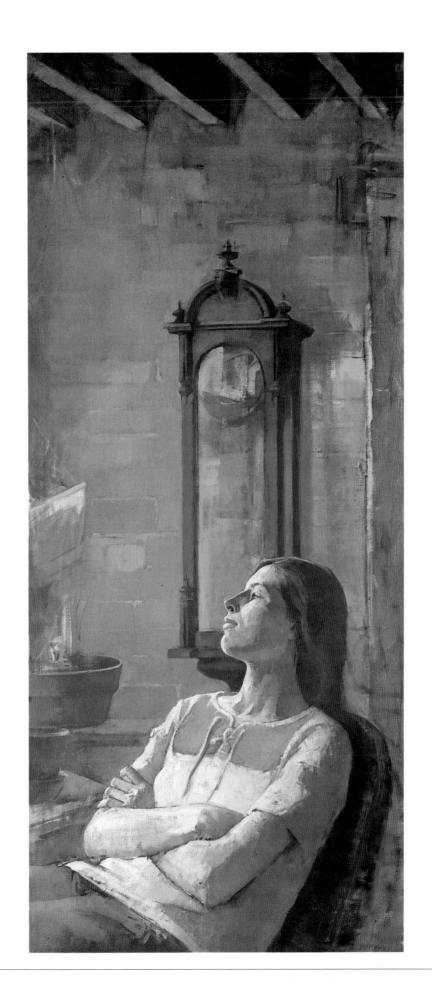

OILS

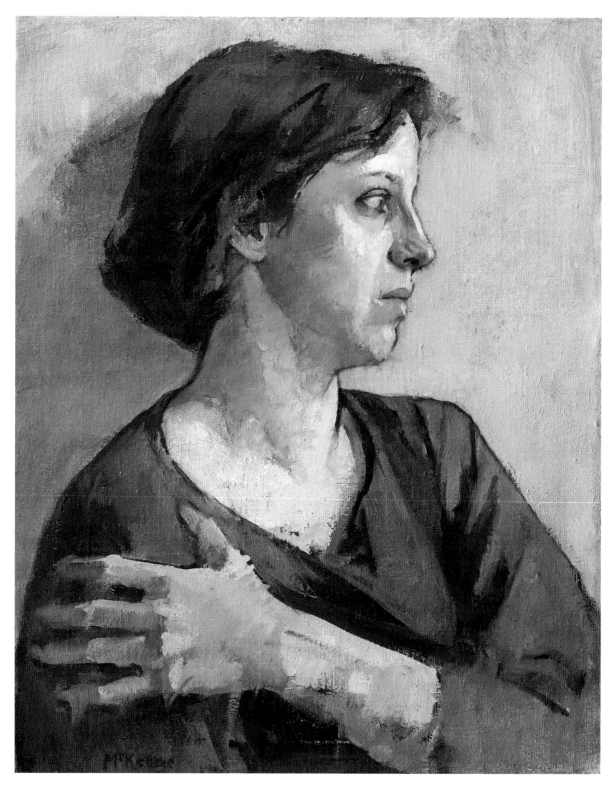

LAUREN (in profile)
oil on canvas, 18″ × 14″ (45.7 × 35.5 cm),
collection of Lauren Goodrich.

*I recently painted this portrait. The model is a young artist, a
student of mine.*

LAUREN
oil on canvas, 78″ × 36″ (198.1 × 91.4 cm),
collection of the artist.

*I wanted to try something different with this painting. I liked
the way Lauren looked in full light, without any strong
shadows. The shapes were kept very simple, with very little
detail, and the form is more implied than rendered. I tried to
communicate a sense of this young woman's character through
her posture; the way she stands here is very typical of her.*

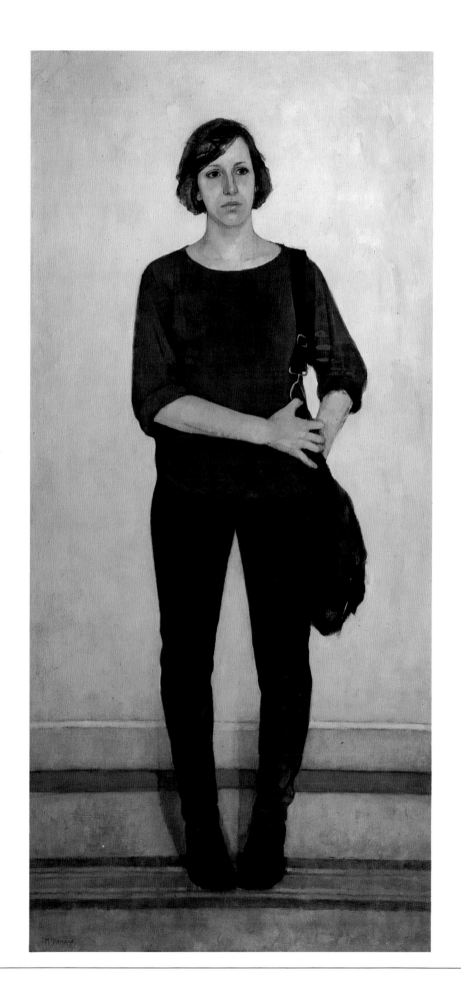

OIL DEMONSTRATION 1
This simple oil portrait will show you my painterly
approach to the medium. Notice how tentatively I begin,
lightly scrubbing paint into the grain of the canvas,
seeing the painting in terms of abstract shapes and areas
of value and color rather than as the profile of a specific
person.

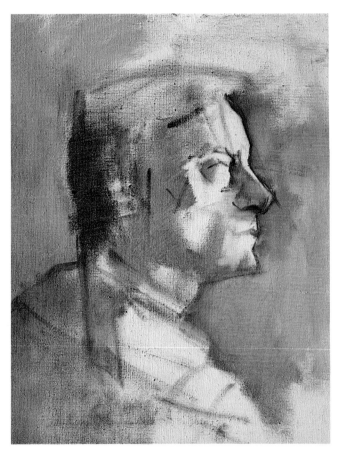

*STAGE 1. This is a very rough sketch made with vine charcoal.
I was only concerned with the placement of the head and the
general proportions.*

*STAGE 2. I began with the darks and massed-in the shadow
areas, trying to see these areas as simple abstract shapes. I
used a large brush and worked in a drybrush manner (very
little turpentine), scrubbing paint into the canvas rather than
building up any paint on the surface. I then put in a tone for
the background; the white canvas worked as the light pattern.*

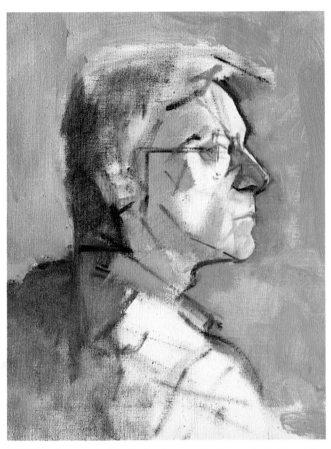

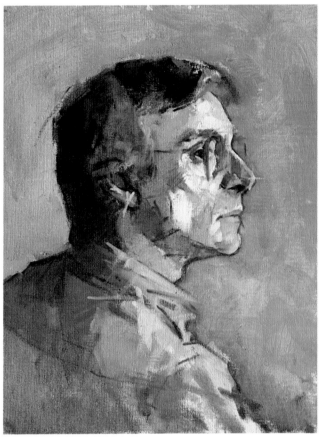

STAGE 3. I started with the background color and tried to state it more accurately than I had before. I could see immediately that the shadow pattern needed to be stronger, so I further developed the shadow areas as they related to the background. At this stage I began to pay more attention to the shape and actual color of the shadows as well as the warm and cool variations within them. It also helped to step back and compare these relationships from time to time. I tried to determine the actual shapes and make them specific. I didn't want to lose them as the painting progressed. I was thinking in terms of planes and angles and trying to find the underlying structure of the face. With a few lines, I indicated the glasses to help me accurately locate the features.

STAGE 4. I redrew and strengthened the darks here and began to paint more directly, freely placing colors where I saw them. I also started to initiate rich color, but the reds on the nose and cheekbone may be too strong. At this stage, I left the lights alone; I wanted to keep the contrast of the white canvas as long as possible while I set up the darks and middle tones. I continued to work all over the canvas, trying to keep everything at the same stage of development.

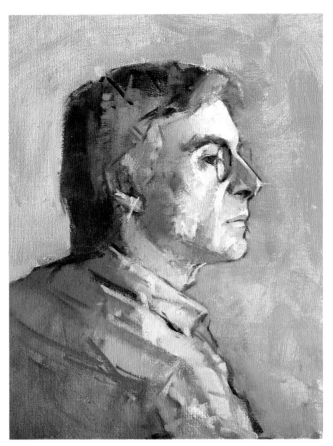

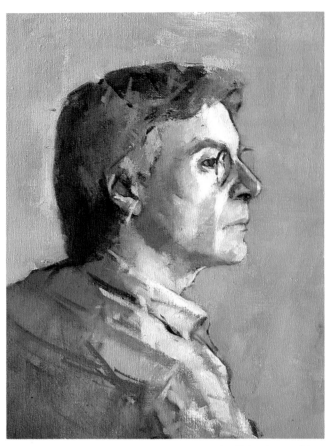

STAGE 5. By this stage the darks and middle tones were developed, so I was better able to judge the lights. I began to apply paint in the light areas, painting across the form. Somehow I couldn't get the lights strong enough, and the painting seemed to have lost something—some of its impact. The contrast wasn't as strong with most of the white canvas covered, but it generally takes time to build up the lights. I also thought the shirt needed simplifying.

STAGE 6. I continued to build up paint in the lights by working back and forth, strengthening both the light and dark patterns. I redefined the features and jawline. I liked the expression, but still felt something wrong with the transitions. The head didn't hold together the way I wanted it to.

DAN (in profile)
oil on canvas, 18″ × 14″ (45.7 × 35.5 cm),
collection of Dan Gheno.

At this stage I refined the drawing and paid more attention to details like the glasses, but at the same time I was very aware of the overall image. (I used a mirror to determine how the head read from a distance.) I wanted to simplify the forms to make a stronger image. The value of the neck (right under the chin) was too light. I toned it down so that the shadow areas held together. I also brought more light into the area between the eye and the cheekbone and softened the transition to make the form fuller, describing the structure underneath. I put a slightly darker tone on the right side of the forehead to make it appear to turn, and I softened the harsh line of the forehead. I also repainted and simplified the hair. At this stage I thought the painting finished, but I still needed to put it aside for a while so that I could be completely sure.

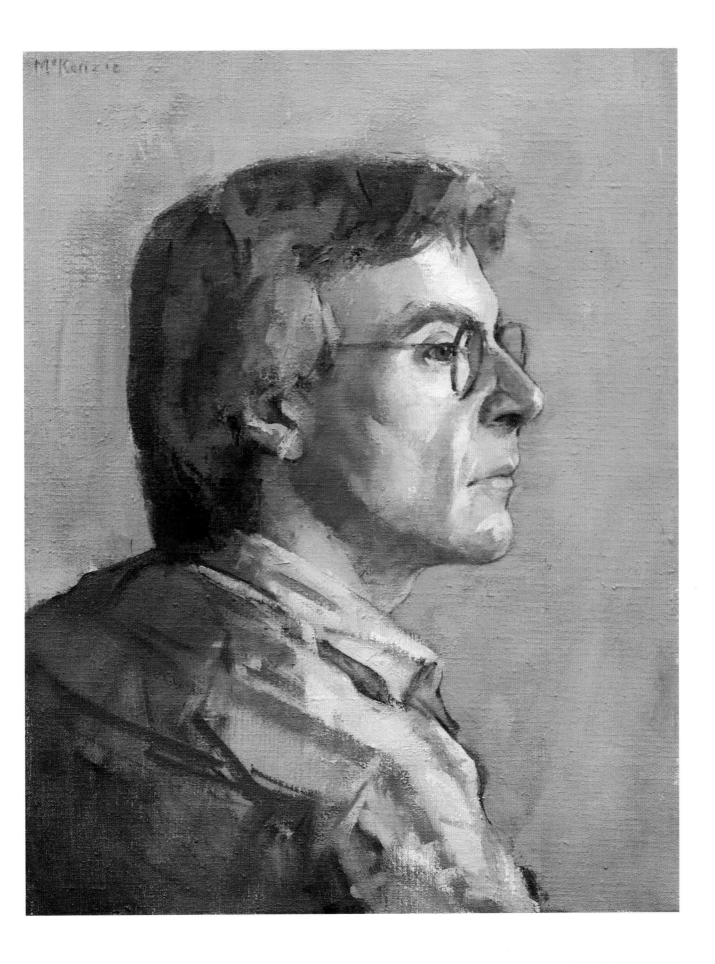

OIL DEMONSTRATION 2

Compare this demonstration to the preceding one. Notice that the buildup is similar, whether I do a portrait or a full figure. Also note that as I work, the painting is developed equally in all areas so that it always works as an abstract unit, with no one area dominating or more finished. I never lose this abstract pattern—even at the end.

STAGE 1. Because this is a relatively small canvas, I worked out the composition on the canvas itself, using vine charcoal to compose the space. This is not a drawing in any real sense; it is only for placement.

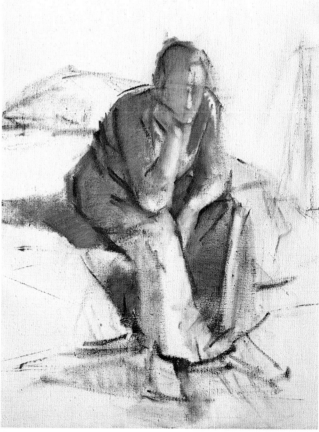

STAGE 2. To improve the composition, I moved the figure up slightly. I began with a drybrush method (very little turpentine), scrubbing paint into the canvas and indicating only the placement of the figure and the general shadow masses. I decided on the size of the head in order to have something to relate the other shapes to.

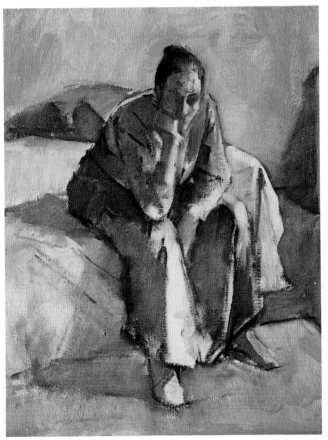

STAGE 4. *I continued to work in an abstract way, trying to develop the large relationships of color. I had to constantly step back and compare these relationships from a distance. To bring back some of the light areas that I'd lost in the face and throughout the painting, I used a rag wet with turpentine over these areas. I wanted to maintain the light-and-dark contrast as long as possible—the impact of the painting. At this stage, I was concerned only with the overall effect.*

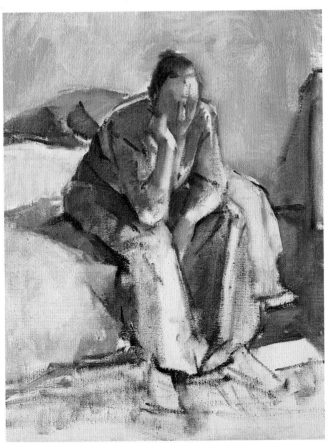

STAGE 3. *Working all over the canvas, I blocked in the large shapes of color as they related to one another. At this point I was only interested in the abstract character of the painting; I didn't care about detail. When the background was sufficiently developed, I could see that all of the darks in the figure needed to be stronger in relation to it. I kept the white canvas as the light pattern. A rag was used to apply a wash of color to some of the light areas, such as the bed.*

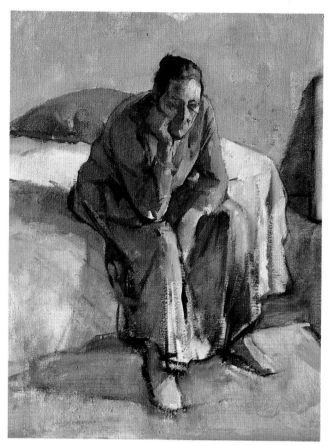

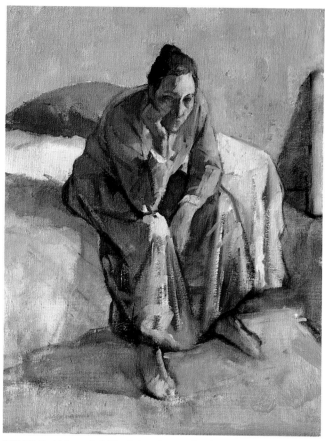

STAGE 5. *Now that the canvas was working as a whole, I started to more carefully work out the shadow areas of the sweater and skirt, and describe the forms underneath. I tried to see these areas in terms of the simple abstract shapes first, and this helped the drawing. A palette knife was used to get the areas behind the figure light enough and to create some distance.*

STAGE 6. *Although I liked the shapes in the background, I wanted to leave them indistinct so that they wouldn't overpower the figure. I also wanted them to stay behind the figure. At this stage, I redrew the features because I didn't like the expression or the shape of the head. I thought the head should be stated more simply and without any unnecessary detail. I wanted it to read from a distance.*

MAYA (pink skirt)

oil on canvas, 20″ × 16″ (50.8 × 40.6 cm),
collection of the artist.

At this stage, the paint still seemed too thin. I painted over the entire figure and built up thicker paint in the light areas. I liked the looseness of the skirt and tried to achieve a consistent looseness throughout the painting, applying paint more boldly in other areas. I repainted the shoulders. I was worried that Maya's back looked too rounded. I also had difficulty getting her left shoulder light enough, to make it read in front of the background. By deepening the tone of the background, however, I was able to solve the problem and also help the rest of the painting. Because the edge of the bed seemed to read as a continuation of the skirt, I moved the bed up and reexamined its angles. I also redefined the features and made the expression closer to what I wanted. Adding the white collar around the face also seemed to help. I think that the painting is complete, but since I am still much too close to it, I will have to wait until some time has passed.

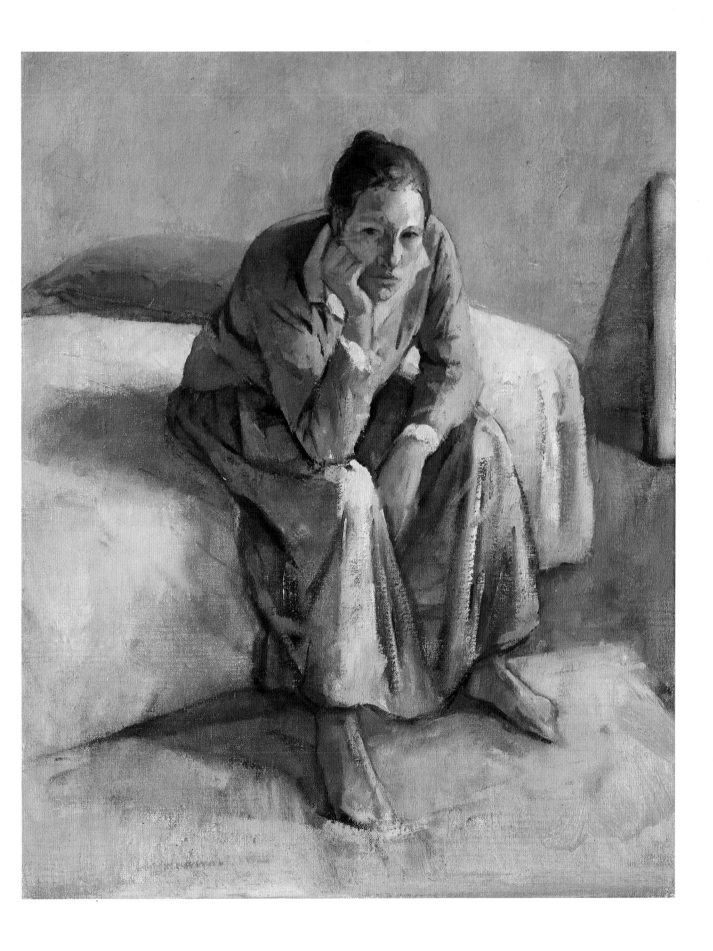

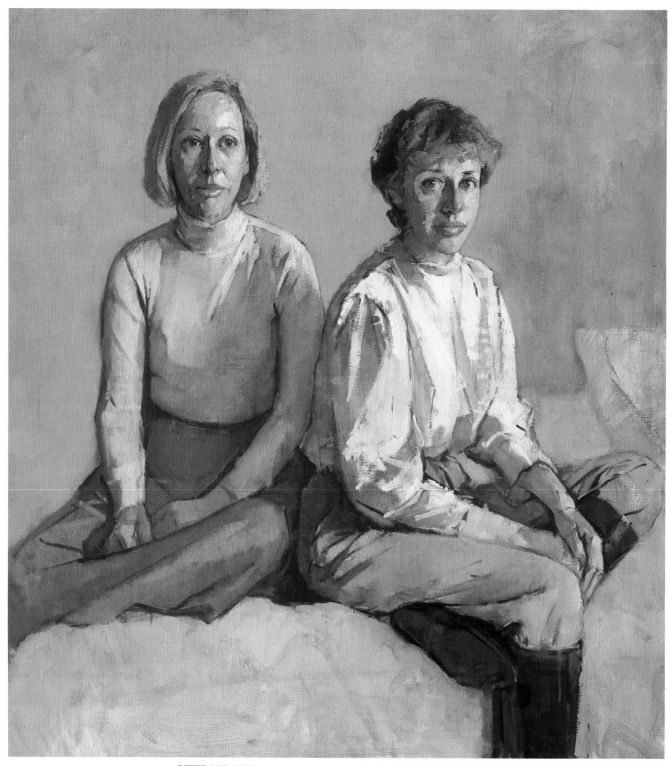

GITTE AND LISA
oil on canvas, 38″ × 42″ (96.52 × 106.6 cm),
collection of Gitte and Dr. John Blass.

*This is one of my most recent paintings. The models are a
mother and daughter and they were very comfortable posing
together. I think this painting is finished, but I'm never
completely sure until I've allowed some time to pass.*

RESOLVING A PAINTING

Almost from the moment you begin a painting, you lose objectivity and never really see your canvas clearly again—at least not until long after it has been completed. Even obvious mistakes in drawing, immediately apparent in someone else's painting, are difficult to see in your own.

SEEING A PAINTING MORE CLEARLY

There are several ways of overcoming this problem during the long and often frustrating period of resolving a painting. A mirror is extremely helpful. In my studio, I have two large mirrors, one that is stationary and one on an easel, with casters, which may be easily moved. I also have a small hand mirror that I use constantly. By looking at the reversed image in the mirror, I can study my composition for balance. Mistakes in drawing, value, or color become magnified. Because the image in the mirror is double the distance from the easel to the mirror, without actually moving I can see the painting from far away. The image is reversed, and this also gives me a fresh look at my painting.

Distancing yourself physically from a painting or turning it to the wall between sittings also helps you to see it with a fresh eye. Working on more than one painting at a time is helpful; moving from one painting to another, you get ideas. Turning the canvas on its side or upside-down helps you to see the shapes and relationships more clearly. Problems in drawing and composition are then more easily seen.

Whether or not I have a model, I take breaks frequently. This allows me to come back to the painting somewhat refreshed. Staying on top of a painting can be deadly. The time you spend stepping back from a painting and studying it is very valuable. By squinting you can see the subject more simply, in terms of overall pattern. By squinting and looking first at the subject and then at your painting, back and forth several times, that which is not yet happening in the painting becomes more clear.

RESOLVING A PAINTING

Because so many forces are at work, and because of the complexity of the relationships, it is difficult to determine how a change will affect the unity of the whole painting. If there is a compositional problem, I find that taking a black-and-white Polaroid photograph helps me see the painting in a different framework. Rather than make changes on the painting I sometimes paint on the photograph itself. I have also tried placing a piece of clear acetate over the area I want to change and painting directly on the acetate. This gives me a chance to try many different solutions without destroying the surface of the canvas. Sometimes the only way to resolve a compositional problem is to change the dimensions of the canvas: to cut it down in size (adding is not so easy). Until you have actually made the change, it is difficult to visualize the result, so this should be done cautiously.

Some paintings almost paint themselves, they go so easily—but most go through a crisis period. I often reach a point at which I'm not happy with a painting, but I don't have a clear idea of where to go with it. At that point, not only do I feel incapable of solving certain technical problems, but I also begin to question my ability to paint at all. So long as the problem is not compositional, I'm generally able to work through this. Usually something just clicks. I seem to go through this

with almost every painting and I find it very frustrating. Experience has taught me to trust that it is just part of the process.

Some paintings never get resolved. I destroy many canvases and, after much frustration, finally letting them go can be a very freeing feeling. But I've learned not to do this at a time when I'm discouraged. Instead, I turn the canvas to the wall, and when I am in a different state of mind I may find something to be salvaged. When a painting is not working, it usually requires a radical change. Accident plays a large role. Sometimes just making a change will point you in a new direction. It can be invaluable, when you are in need of help, to get the opinion of one or two friends who are close creatively, people whom you not only respect, but trust to be totally honest. However, you must not allow friends to exert too much influence. You must be the final judge and follow only what you agree with. There are many possible resolutions for any painting. You must learn to be highly critical but also to trust yourself.

I find it very difficult to decide that a painting is finished. It is easy to lose the freshness, to overwork, or to rework an area that isn't really a problem. Often I find that the problem is not in the area I keep reworking but in some other area. I think paintings tend to finish themselves—at least, if you allow them to. When I don't know how to go any further, I set the painting aside and wait to see if something irritates me or makes me feel that the painting requires more work. I like to work on a painting over a long period of time; then I have a chance to live with it a while. I don't like to be pressed to finish a painting by a certain date or for an exhibit.

EXHIBITING

I am always a little nervous before I see one of my paintings in an exhibit because the experience can be disappointing. Seeing one of my paintings outside of my studio and surrounded by the work of others alters my own perception of it. For the first time I am able to see it somewhat objectively and as a whole. The strengths and weaknesses become more apparent. For me, this experience often results in a certain clarity, followed by changes in my work (not necessarily in that specific painting but in my work in general). While it is very necessary to get a response from others to your work, I think that the real value of exhibiting is the learning process involved; your own reaction is more important than anyone else's.

A solo exhibit has even more impact. When you see all of your paintings hanging together as a group, you see them differently. Not only is it all your own work, but the work is seen under different conditions and with different lighting. This can be a very unsettling experience. Your new perspective will, however, very much influence the direction your work will take in the future.

No matter how successful, I think this sort of exhibition is always followed by a big letdown. This is only natural, since you have used up so much energy and experienced so much anxiety. I've always been left with the feeling of "where do I go from here?"—wanting some great change to occur in my paintings, but being almost paralyzed, unable to paint. I've learned that it is important to keep working; the changes happen on their own, without your conscious decision to make them, but they also come out of the work itself.

MAYA
oil on canvas, 40″ × 30″ (101.6 × 76.2 cm), collection of Marion and Sidney Richman.

This model is a friend of mine and has been the subject of many paintings. Although there was strong light on the figure, I kept the overall painting very high in key. All of the activity (and detail) is contained within the simple shape of the figure. Since each time a model moves the folds are different, I try to select what will best describe the forms underneath. I was particularly aware of this problem in this painting. I found that it was very helpful to use a mirror to see how the forms were reading from a distance.

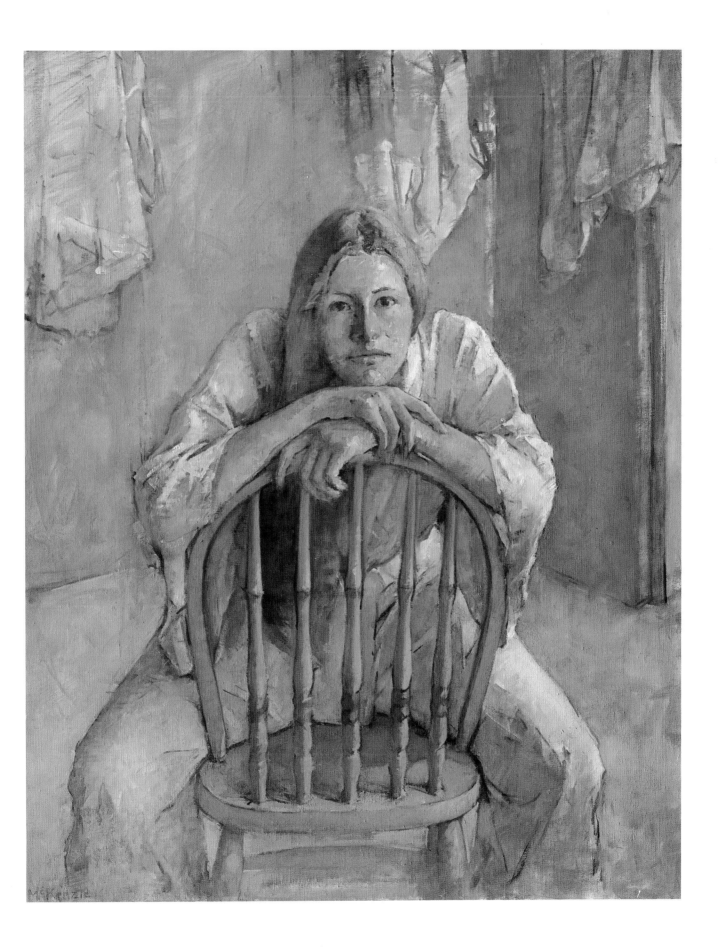

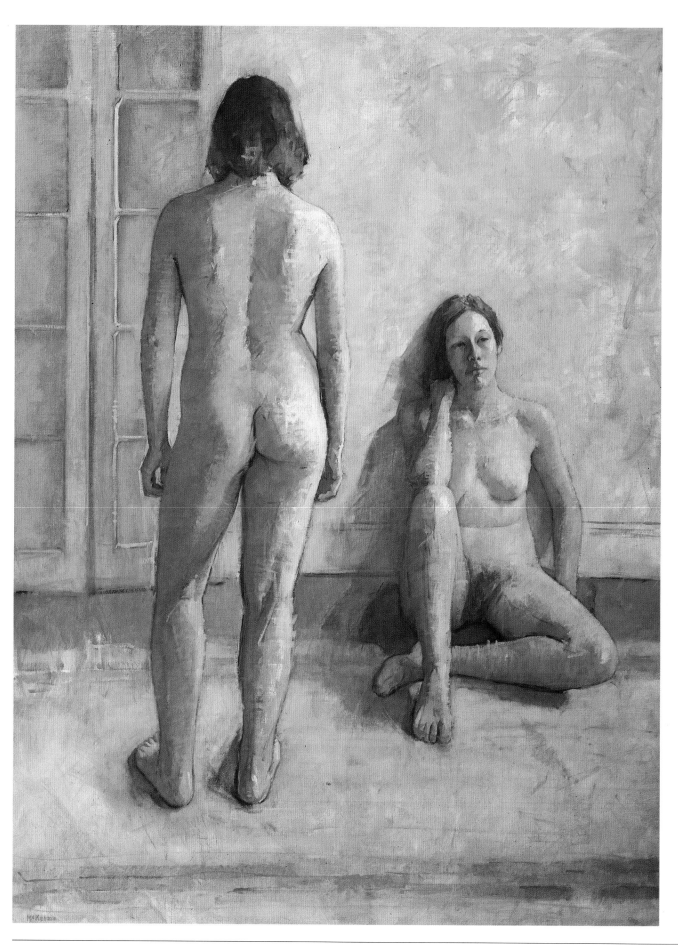

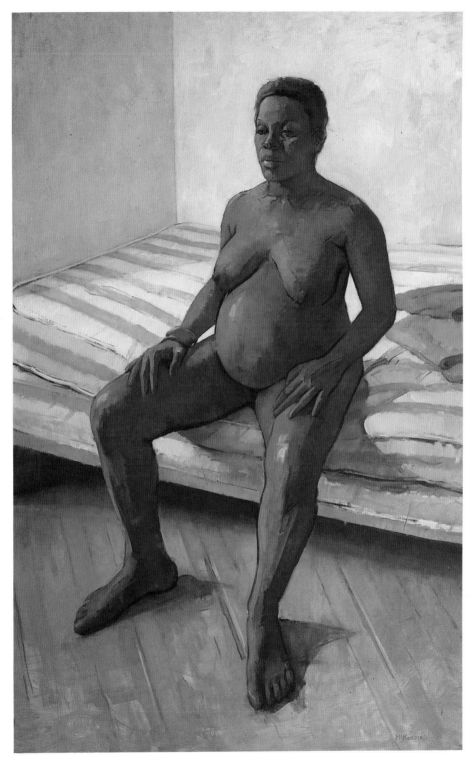

TWO FIGURES
oil on canvas, 79″ × 59″ (200.6 × 149.8 cm),
collection of the artist.

The same model posed for both figures, which made it difficult to relate one to the other. This is quite a large painting and I was very concerned with creating a feeling of space. I kept the rest of the painting rather stark to emphasize the solidity of the figures.

ROBERTA
oil on canvas, 64″ × 40″ (162.6 × 101.6 cm),
collection of the artist.

I didn't get to carry this as far as I would have liked, because the model had to stop posing (because of her pregnancy) before either of us thought she would. I haven't yet decided if it is finished; I think it is consistent throughout and has a linear resolution. Last month I cut the canvas down in size, quite drastically. Initially, the painting had an iron bed in it, which I eliminated. Now the canvas is vertical, which makes you focus more on the figure and makes the figure much stronger.

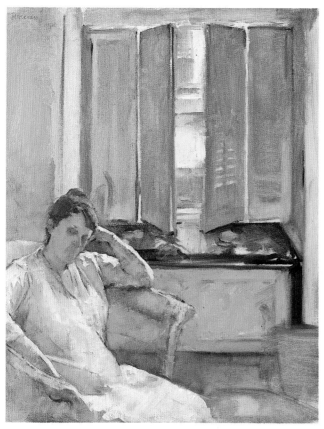

INTERIOR WITH FIGURE
oil on canvas, 20″ × 16″ (50.8 × 40.6 cm),
collection of Helen and Robert Driscoll III.

This was done in the house of a friend in only two sessions. It was not meant as a study for a larger painting, but I did refer to it later when I painted Wicker Chair *(opposite).*

STUDY FOR WICKER CHAIR
oil on canvas, 14″ × 16″ (35.5 × 40.6 cm).

This study was done as a preliminary for the larger painting opposite. I often do small studies in color to help me visualize what I want to do in a painting. For compositional reasons I wanted more room around the figure, so I removed the canvas from its stretchers and worked to the edges of the canvas.

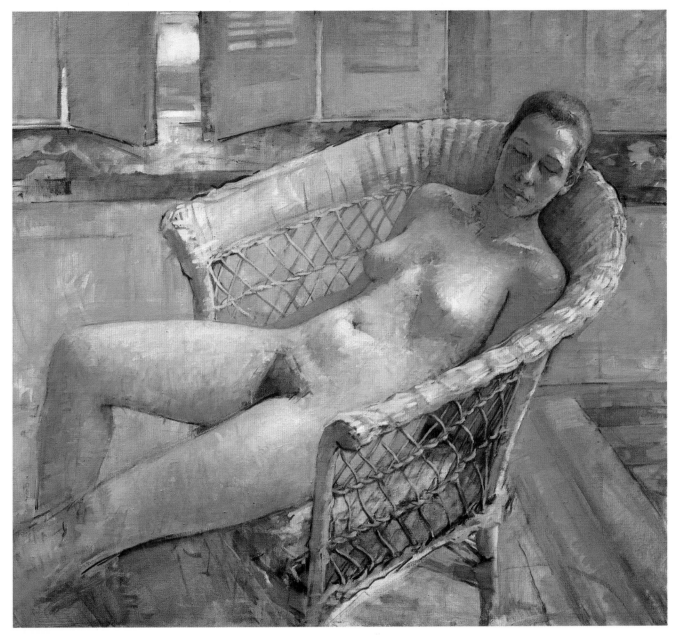

WICKER CHAIR

oil on canvas, 43″ × 47″ (108.2 × 119.3 cm),
collection of the artist.

Because I liked the small painting Interior with Figure *so much,
I decided to do a larger one, using a different model, that
would have some of the same feeling as well as some of the
same elements. Using the small painting for reference, I tried to
recreate the scene in my studio, borrowing the wicker chair
and the material from the window seats. Almost as if I were
making a stage set, I set up shutters and painted cardboard for
the wall so that I would have the colors I needed in relation to
the model. My model moved away to the West Coast in the
middle of the painting, which upset me very much at the time.
She came back, months later, and I realized that the painting
was virtually finished. This amount of time allowed me to see
the canvas objectively; without this time, I think I might have
taken the painting a lot further, repainting some of the looser
areas that I now like.*

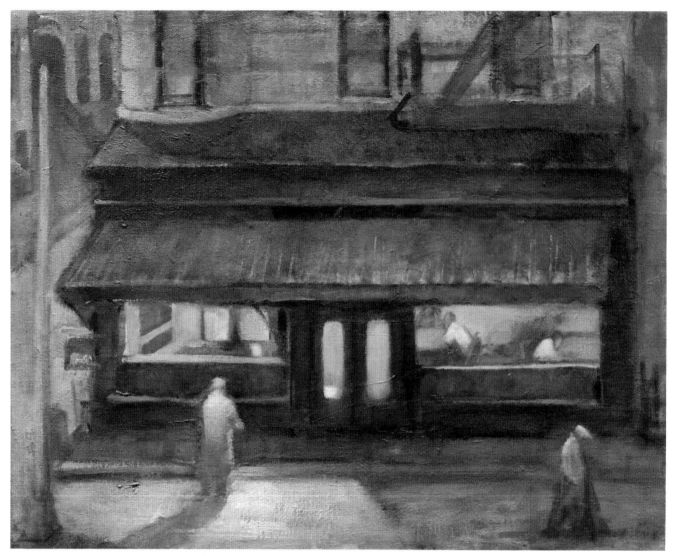

FRONT PORCH RESTAURANT
oil on canvas, 16″ × 20″ (40.6 × 50.8 cm),
collection of Ticia Kane and Peter Healey.

*This is one of the few night scenes I've ever attempted. It was
done from the window of a friend's house. Because the light
inside the house was so inadequate, I had a terrible time with
glare and experienced great difficulty. To really see the painting
I had to keep taking it in to another room while I was working.*

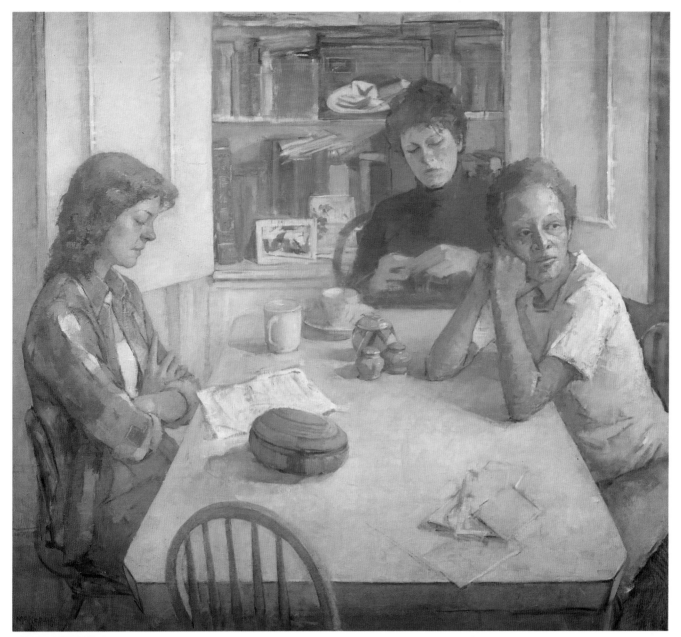

THREE FIGURES
oil on canvas, 44″ × 48″ (111.7 × 121.9 cm),
collection of the artist.

I was intrigued by the idea of painting three figures, as I had never done it before except on a small scale. This painting was done at the apartment of Emily, the figure on the left. Even though at certain stages in the painting, I could only focus on one figure at a time, all three had to be present in order for me to relate them to one another. Toward the completion of the painting, each person was able to pose separately.

I had many problems with this painting and eventually found it necessary to bring the canvas back to my studio to

study. One problem I had was that I could not resolve the figure on the left. I realized that I could make a stronger statement about her character (as well as improve the composition) by changing her pose entirely. Covering that area of the painting with clear acetate, I tried several variations before going back to Emily's apartment and working on the actual canvas. To strengthen the composition, I removed a red chair that dominated the foreground. I also cut the canvas down a few inches to its present size.

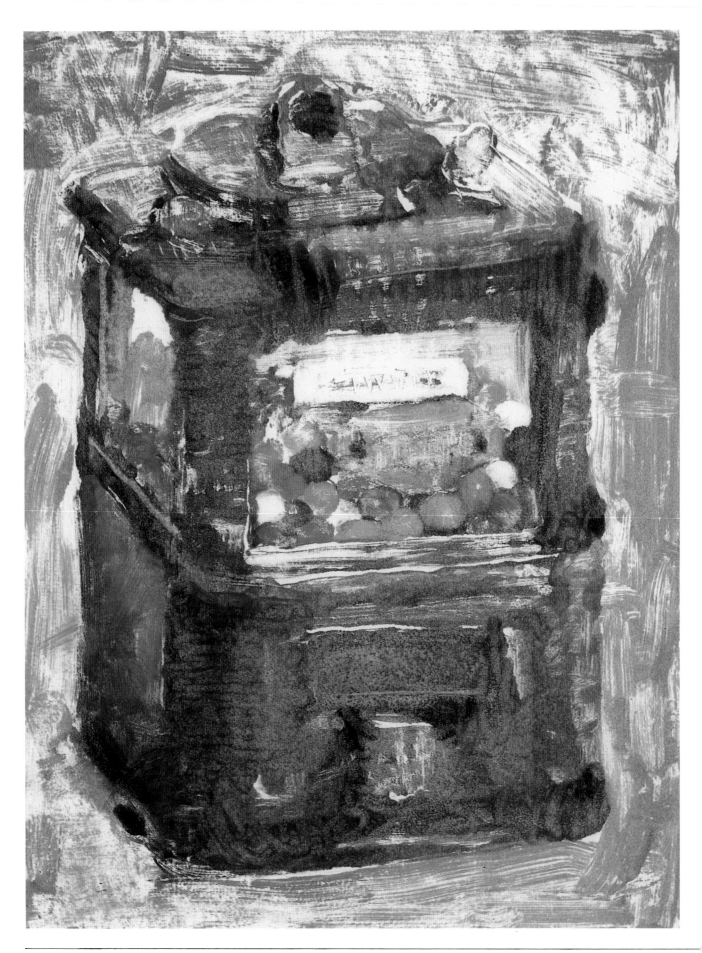

MONOTYPES

A monotype is a painting or drawing that has been printed on paper. The process of making a monotype is relatively simple. An image is painted on a nonabsorbent surface, such as glass or a metal plate, and transferred by laying paper on the plate and applying pressure. An etching press, a roller, or something as simple as a spoon can be used to supply the pressure necessary to print the plate. Unlike the more complicated processes of etching and lithography, this procedure yields one single print. While a second, or even a third, transfer print is possible, it is never the same as the first. The image is usually lighter and more vague and has an entirely different feeling.

I first became interested in this medium after seeing an exhibition of monotypes by Maurice Prendergast in 1979 at the Davis and Long Galleries in New York City and, sometime later, an exhibition entitled "The Painterly Print" at the Metropolitan Museum of Art. I was surprised to find that so many artists had not only done monotypes, but that they had obviously considered it a significant medium and had produced serious works in it. I was immediately drawn to monotypes, because they are very close to painting. Monotypes have a quality all their own, a freshness and spontaneity. Because they are done so quickly, the application of paint is bold and loose and can be very expressive.

HISTORY
Monotypes date back to the seventeenth century and have been approached somewhat differently by each artist who has ever experimented with them. These prints are often characteristic of their other work. This is probably because the process is almost as direct as painting on canvas. Degas did a great number of monotypes and was extremely inventive with them, as he was with every medium he used. Gauguin did watercolor monotypes. Matisse created beautiful white line drawings by marking into an ink-covered plate with the handle of his brush and then printing what remained on the plate. Willem de Kooning printed directly from areas of his wet canvas. Milton Avery applied oil washes to a glass plate, which already had a base of turpentine, and puddled his colors, creating a very unique effect. Picasso did more than a hundred monotypes. Many artists working now are experimenting with nontraditional surfaces and materials and doing their monotypes on a much larger scale. The possibilities are unlimited. There are so many options: many different techniques, variations in the printing process, many kinds of surfaces, tools, and papers. To get a feeling for what can be achieved with this medium, it is not only necessary to experiment but to do a great many prints, since only then will the possibilities become apparent.

For those interested in experimenting with monotypes, I would highly recommend *The Painterly Print* published by the Metropolitan Museum of Art and the Boston Museum of Fine Arts, in connection with their exhibit of the same name in 1980. Another very helpful publication is *Degas, The Complete Etchings, Lithographs, and Monotypes* by Jean Adhemar Francoise Cachin. I would also recommend *Monotypes by Maurice Prendergast in the Terra Museum of American Art* by Cecily Langdale, an extremely beautiful and informative book published by the Terra Museum in 1984.

MAGIC VENDOR
monotype, 12″ × 9″ (30.4 × 22.8 cm),
collection of Lois and Ronald Sherr.

This monotype is a favorite of mine. I feel it is one of my most successful monotypes. I like the colors, the shapes are distinct, and the image reads from a great distance.

MONOTYPES

METHODS

Traditionally, there are two basic methods for doing monotypes. In the first method, a fairly thick layer of ink or paint is spread or rolled evenly over the chosen surface, such as metal or glass. The image is wiped away or extracted from this dark tone. Broad areas can be wiped off with a rag, scraped with a cardboard, removed with a brush or even with your finger. The tonal range will vary according to the pressure you apply. The cleanest parts of the plate will print as white, and this is very important to remember. A white line can be made with the handle of a brush or with a variety of marking tools. This method is referred to as a subtractive or dark-field method.

The second method is very similar to painting on canvas. Paint or ink is applied directly to a clean surface so that the image itself is painted rather than pulled out of the background. However, the light areas are left alone, or not painted at all; the color of the paper becomes the light areas. When paper is pressed to this surface, the image, provided it is still wet, transfers to the paper. This method is known as an additive or light-field method.

MY BASIC APPROACH

My basic approach to painting a monotype is very similar to my method of painting with oils. My first concern is for a strong composition and I often do rough preliminary sketches on paper before starting, keeping in mind that the image will be reversed. Starting with the darkest darks, I work from dark to light, looking for the big shapes or masses of dark and the large areas of color in relation to one another, allowing the clean parts of the plate to work as the light pattern. I generally start with a clean plate, but work back and forth, using both methods described, sometimes adding paint to the plate and at other times removing paint from areas I've already worked on.

I usually prefer to use oil paints and a full palette. Watercolors and gouaches (provided they are printed on damp paper) or printer's inks can also be used. I use turpentine as a medium and, at times, a small amount of linseed oil. I use very little oil, because the oil can have an effect on the paper. Too much oil, over time, may cause discoloration. A halo may form around the oily areas (this can be seen on the back of the paper). Also, depending on the quality of the paper, too much oil could eventually break down the fibers. Monotypes (like other works on paper) should be stored in such a way as to prevent contact from one print to the next. I always separate them with a sheet of acid-free paper. When I frame monotypes, I make sure that the backing is 100 percent rag paper in order to further protect the monotype from deterioration.

SURFACES

Monotypes can be made on: metal, glass, plastic, wood, stone, or any surface that is not too porous. Each of these surfaces will hold the paint in a different way, depending on the absorbency, and cause different things to happen during the printing process.

A metal plate can be very confusing to work on. The plate itself will appear as a middle-tone value while you are painting, but those areas that are not covered with paint will print as white (if you're printing on white paper). Also, the tone of the plate will appear to be cool or warm (depending on whether you are using a copper or zinc plate), changing the color relationships when you print. Again, these areas will print as white. For this reason, I prefer to work on white plastic or on a piece of glass that has a sheet of white paper taped behind it. This enables me to see my painting clearly as it progresses, particularly the light areas.

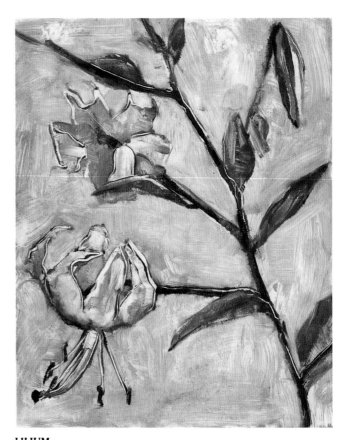

LILIUM
monotype, 10″ × 8″ (25.4 × 20.3 cm),
collection of the artist.

In this monotype of lilies I tried to capture the spraylike character of a lily stalk and the delicate folding back of the petals. The linear detail was created from the white of the paper, by the point of a brush handle drawn through the paint on the plate.

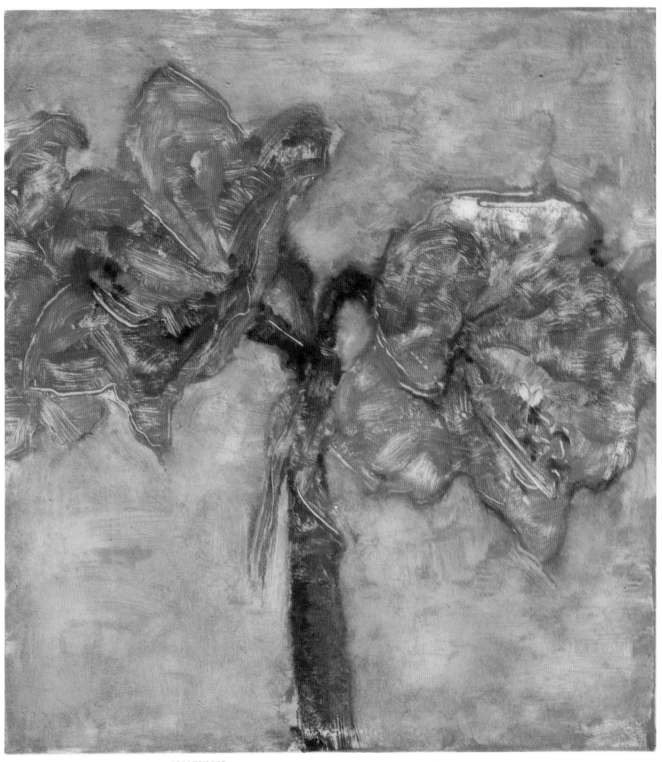

AMARYLLIS
monotype, 10″ × 8″ (25.4 × 20.3 cm),
collection of Wende Caporale-Greene and Daniel E. Greene.

*Although I seldom paint flowers in oils I enjoy doing
monotypes of them. My oils generally take so long that the
flowers are wilted before I can finish the painting. In this
monotype I particularly like the intensity of the color.*

PAPER

Many papers can be used, but keep in mind that the paper you use will make a difference in the look of the print. The rougher, more absorbent papers give the print a softer, more subtle look, whereas smoother, harder papers yield more solid areas of color that are denser, with sharper contours. The color of the paper also plays an important role. The contrast of light and dark in the print will be affected by whether the paper is light or dark. I always use good-quality papers. I usually look for a paper that resembles newsprint in color and texture but is of much better quality. Most often I use rice paper, but there are many papers available. I've tried so many types of rice papers as well as other kinds of paper that I have trouble keeping track of those I like. It's helpful to tear off a small piece when you buy paper and record on it the name and where it was purchased.

While it isn't necessary to soak the paper in order to get a good monotype, you will pick up more color if you do. When the paper is moist, it becomes softer, and more color will penetrate the fiber. This is particularly helpful for a second print, or when you're worried that a first print may not work because the paint may be too dry. However, I often use dry paper with good results.

I've found that it is a good idea to experiment with papers before printing. Not all papers can be soaked in water. If it's not strong enough, the wet paper will adhere to the plate and fall apart. These papers should be used dry. In the beginning I ruined several monotypes in this way. If you want to soak the paper, you are better off using papers that are handmade or mold made, rather than machine made. The fibers are usually longer, and the longer the fibers, the more intertwined they are, and this results in a stronger paper. If you want to use very thick absorbent paper (usually damp), it's better to print with a press, since a spoon will not easily give the necessary pressure.

TIME ELEMENT

Monotypes must be completed in a short period of time, usually in less than three hours. Paint and ink begin to dry as soon as they are applied to the plate, so you must work rapidly. It is difficult to determine how dry any given area is and, consequently, what will print (thinly applied paint will dry more quickly). If the paint dries, much of the image will be lost. If the paint is too thick and wet, it may spread, obliterating parts of the print (although this can also be an exciting effect). Deciding when to print is very difficult; ten minutes one way or the other may make all the difference between a very good monotype and a merely acceptable one.

PRINTING

When I am ready to print, I gently lay a sheet of paper on my painted plate—very carefully so as not to slide the paper and smear the image. I have a small printing press, but I prefer to hand-print with the back of an ordinary tablespoon. Even pressure should be used. I move the spoon gently but firmly over the paper with a circular motion, being careful not to damage the paper or to leave any indication of where the spoon has been. While I'm printing, I can partially lift the paper from one corner and check the progress in each area to see if the paint is adhering to the paper and to look for areas where more pressure might be applied to get a better transfer. I like this method, because it allows me more control while I'm printing.

If the image is transferred with a press, the print will have a different, more uniform look. Because the pressure is more extreme than the pressure exerted with a spoon, and more even, the colors will fuse differently into the paper. To protect the paper from being harmed by the sharp edges of the plate during the printing process, the corners and the edges of the plate should be filed or rounded. (This is also done for other printing processes.) When I print with a press, I use a metal plate, usually zinc because of its cool color, or Plexiglas. Too much pressure will bend the plate, glass will break. Very light pressure should be used to print a monotype, but exactly how much pressure will also vary with the use of different materials. Although light pressure may be sufficient for the first print, you might want to increase the pressure in order to pull a good second print. I always prepare ahead of time a tray of water for soaking the paper and blotting paper or paper towels for removing excess moisture from the paper (as the paper should be damp rather than wet), and I adjust the press to the proper pressure. I do this because time is an important factor, and I don't want to waste precious minutes while the paint is drying. It is also possible to print with a rolling pin instead of a spoon. There are several methods of printing, so you should experiment.

PROBLEMS

Many changes occur during the printing process, and the resulting print is always a surprise. Sometimes this is in your favor, but often it is not. Because the image is reversed, and because it's impossible to judge how dry or wet any area is or how strong your darks will be, few monotypes print the way they look on the plate. With many of my monotypes I've attempted the same subject four or five times before ending up with a successful print (or one even close to what I had anticipated). When

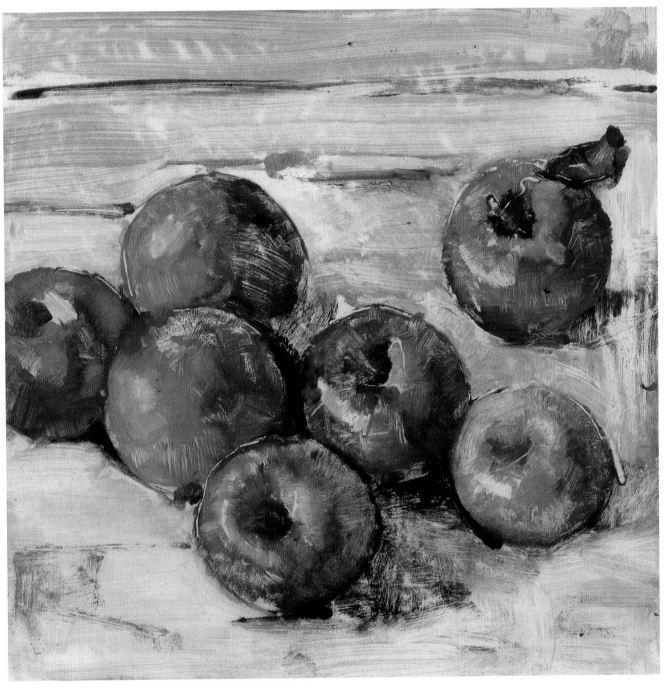

APPLES
monotype, 9″ × 9″ (22.8 × 22.8 cm),
collection of Mathew Miller.

*Monotype lends itself to vibrant and expressive use of color. In
this picture of apples I am particularly pleased with the way
the color worked out. It is very difficult to have any control
over color in monotypes, especially the intensity of the color.
As I describe in this chapter, the finished print rarely looks as it
appears on the plate.*

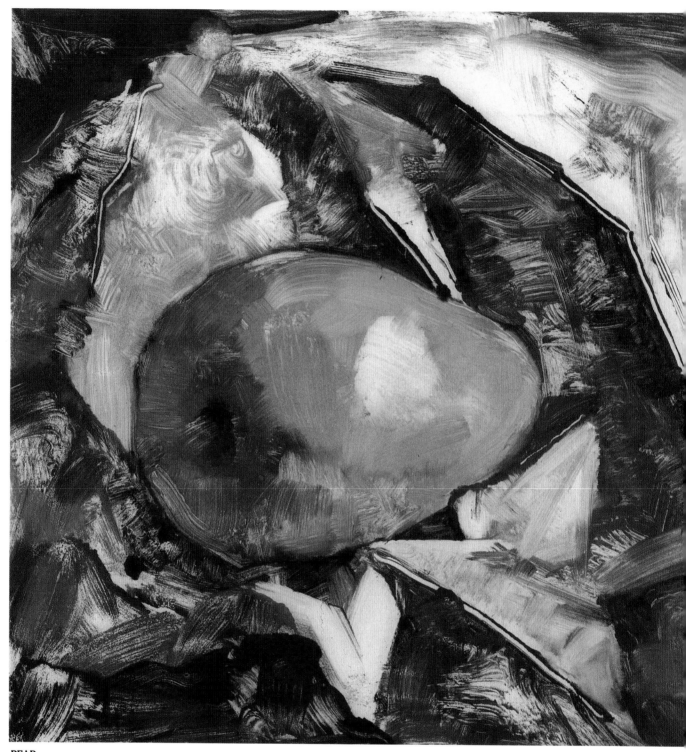

PEAR
monotype, 7½″ × 9½″ (18.5 × 24.1 cm),
collection of the artist.

*Because of its boldness I feel that this monotype is very
successful. I am pleased by the solidity and clarity of the
image and also by the relationships of the abstract shapes
surrounding the pear. Before I did this monotype, I had tried
this subject several times with very different results.*

they don't work after several attempts I generally lose interest in the idea altogether. I find that I usually do several monotypes, one right after the other, until I completely exhaust an idea, and then I don't do any for a while. Monotypes require a certain intensity. During one of these periods of activity, I am better able to predict the outcome of a monotype or at least I feel as if I am. But by the next time I do one, I feel as if I am totally in the dark again. Although experience helps in making a monotype, you can never have any real feeling of control.

Sometimes it is possible to make corrections directly on the print itself, but you risk changing the loose, free look of the image. Monotypes have an airy quality that is changed by painting directly on the print. I have also reworked a small area of the plate, and reprinted just that section, and this is usually more successful, although dangerous. When the paper goes onto the plate for the second time, everything must be carefully lined up before any pressure is applied. Sometimes I even strengthen the image slightly with a graphite pencil or a colored pencil.

A SECOND PRINT

If enough paint remains on the plate it is possible to pull a second transfer print, a much lighter version, some-what different from the first print. A second print is sometimes called a ghost or cognate. Occasionally, the second print will turn out better than the first, but this has seldom been my experience. At times I rework the plate, adding more paint, before attempting a second print. This print, however, will be very different from the first. A second print is a variation of the first print, never an exact duplicate.

For me, making a monotype is a refreshing break from pastel or oil paintings, which I work on over a much longer period of time. I've found that working with mono-types (or any different medium) forces me to think differently, and I like to stimulate my thinking in this way. I always carry something back to the other media. Mono-types can also be a means of experimenting with ideas for larger paintings. You can quickly reverse a composi-tion or play around with color, space, or tonal effects. Despite all the problems with monotypes, I love doing them because of the high level of spontaneity and freedom.

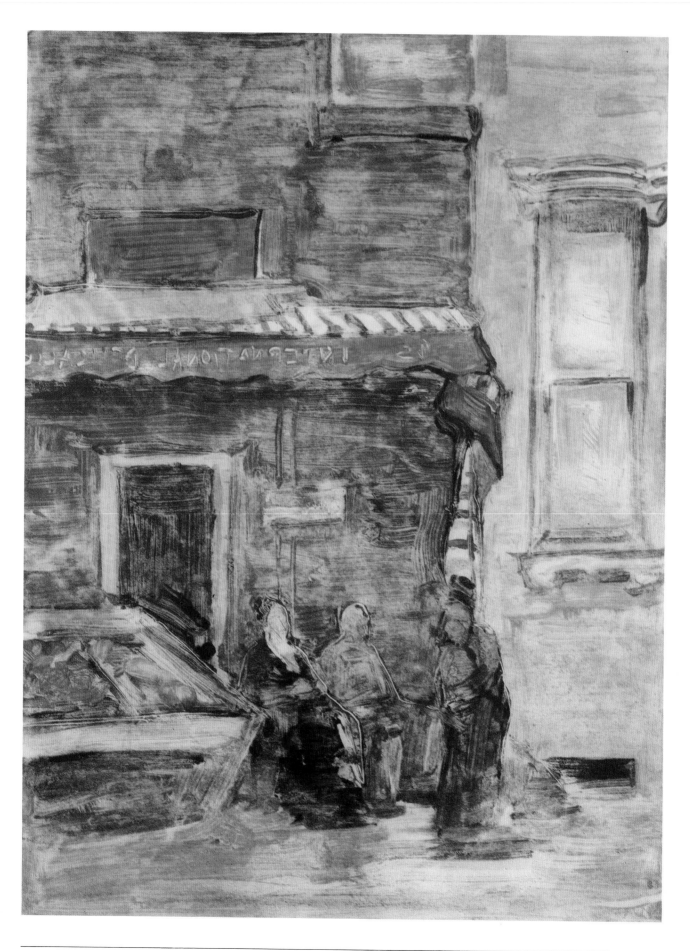

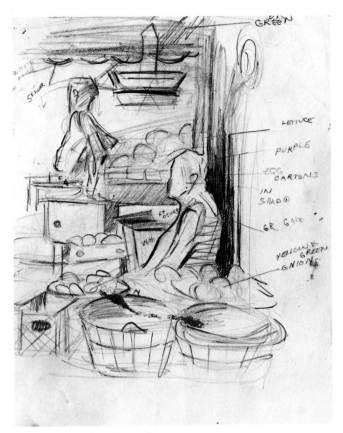

FRUIT STAND (two figures)
drawing for monotype (opposite).

With a monotype in mind, I did this rough sketch of a fruit stand in my neighborhood. I made color notes and indicated the placement of the lights and shadows.

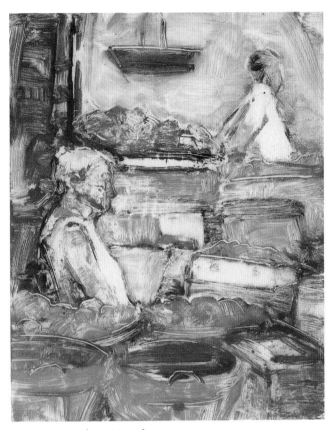

FRUIT STAND (two figures)
monotype, 8¼″ × 6½″ (20.9 × 16.5 cm),
collection of the artist.

This small monotype was done shortly after the sketch (opposite). Improvising on my original drawing, I added shapes in order to develop the composition further and to create a sense of the quantity and the variety of things being offered for sale.

INTERNATIONAL DELICACIES
monotype, 12″ × 9″ (30.4 × 22.8 cm),
collection of the artist.

Fruit and vegetable stands fascinate me, partly because of the abstract shapes and colors and the play of light on the stripped awnings and partly because they represent an historical aspect of New York's street life. Since less information is necessary for a monotype than for an oil painting, I often select subjects for monotypes that would be difficult to do as oil paintings that might require many sittings.

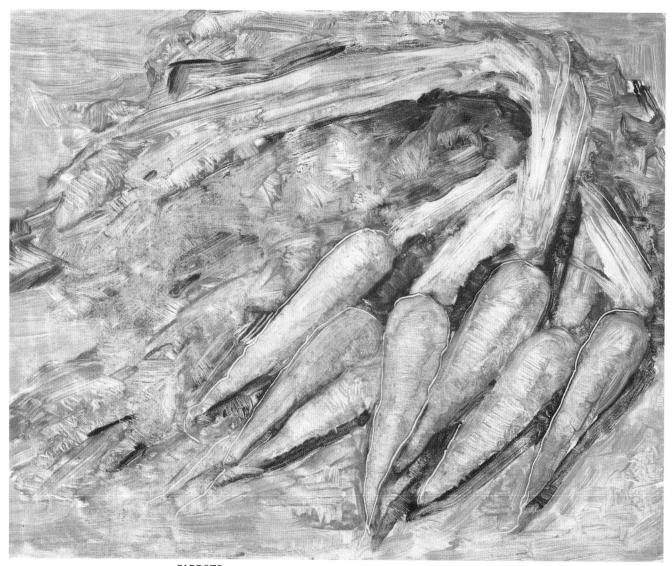

CARROTS
monotype, 8″ × 9¾″ (20.3 × 24.7 cm),
collection of the artist.

I find fruits and vegetables good subjects for monotypes. There is enormous variety in the shapes and colors. They must be painted quickly, especially the leafy parts, as they wither in a short time, which makes monotype a particularly appropriate medium.

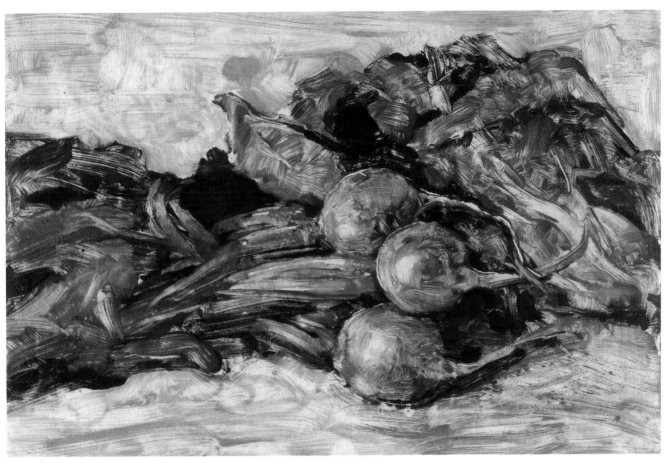

BEETS
monotype, 9″ × 14″ (22.8 × 35.5 cm),
collection of Marion and Ray Bodine.

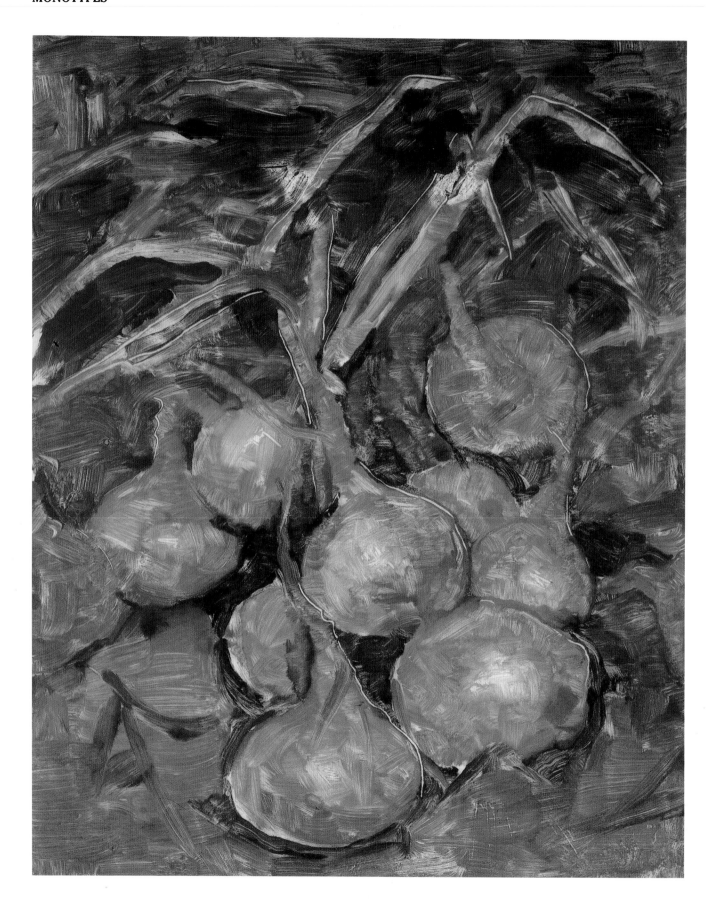

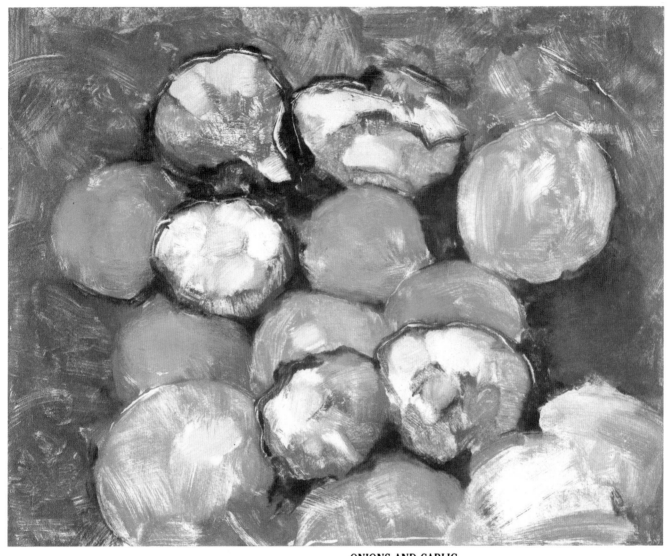

ONIONS AND GARLIC
monotype, 8″ × 10″ (20.3 × 25.4 cm),
collection of Claire and Burt Silverman.

*In this simple group of onions and garlic, I was intrigued by
the relationships of the subtle colors and abstract shapes.*

ONIONS
monotype, 10″ × 8″ (25.4 × 20.3 cm),
collection of the artist.

*This is a very active composition, held together by the
similarity of the shapes and by the restrained use of color. The
shapes between the shapes—the negative shapes—are very
important to the composition. The thin white lines were done
with the handle of a brush.*

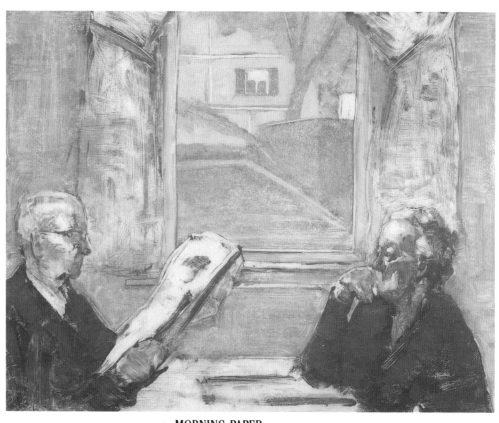

MORNING PAPER
monotype, 8″ × 10″ (20.3 × 25.4 cm),
collection of the artist.

I did this monotype from memory and from sketches. I used the scene from Backyard *(opposite) for reference when I painted the view from the window. In the initial print the view outside the window was too strong and overpowered the figures. To tone it down, I rubbed pastel into that area to give it less importance.*

FRONT PORCH
monotype, 9″ × 12″ (22.8 × 30.4 cm),
collection of the artist.

This is a good example of how easily monotypes can be done almost anywhere. It was done on a visit to my parents' house in Ohio. This scene is very much a part of my childhood. My parents spent a lot of time sitting on our front porch. In order to be able to do this monotype, I removed the glass from one of my mother's photographs, took paper from a desk pad of my father's, and used a spoon to print (I had oil paints with me).

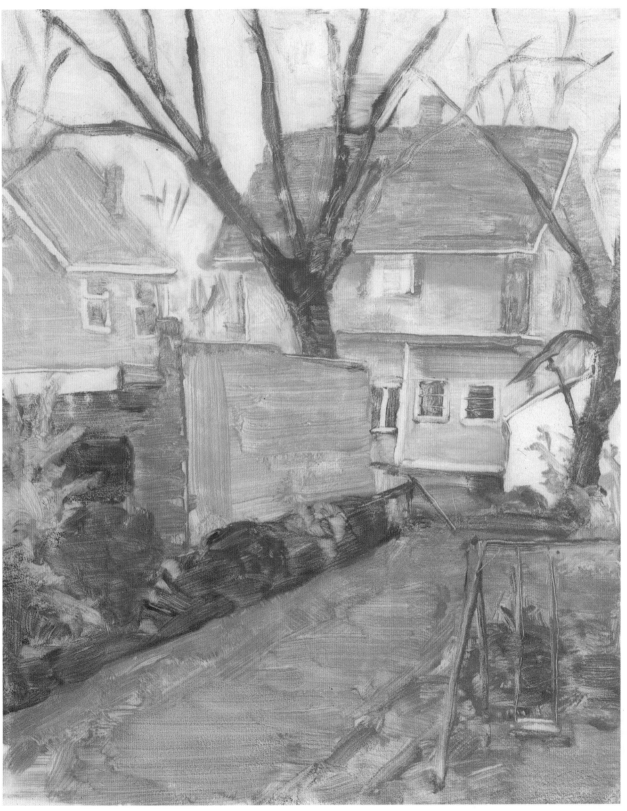

BACKYARD
monotype, 10″ × 8″ (25.4 × 20.3 cm),
collection of the artist.

*Backyard is derived from another childhood image. I did it
from a back window of the house in which I grew up in Ohio.
As with all monotypes, the image is reversed, so it conflicts
with the image I have in my mind.*

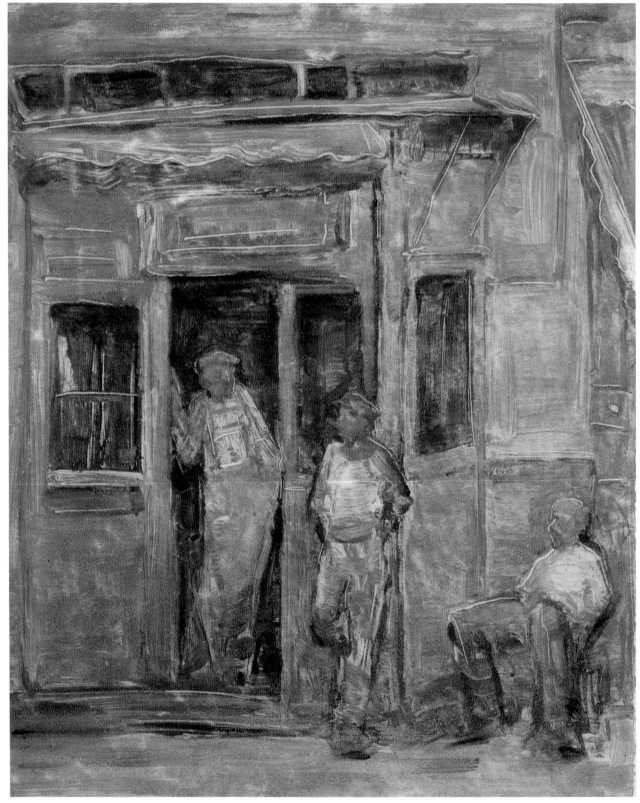

SHOESHINE STAND
monotype, 10″ × 8″ (25.4 × 20.3 cm),
collection of Kathy and Stanton Scherer.

*Many buildings in New York, like this small shoeshine stand in
my neighborhood, have a feeling of the city—or what it used
to be. I'm always drawn to subjects that have some sort of
history to them.*

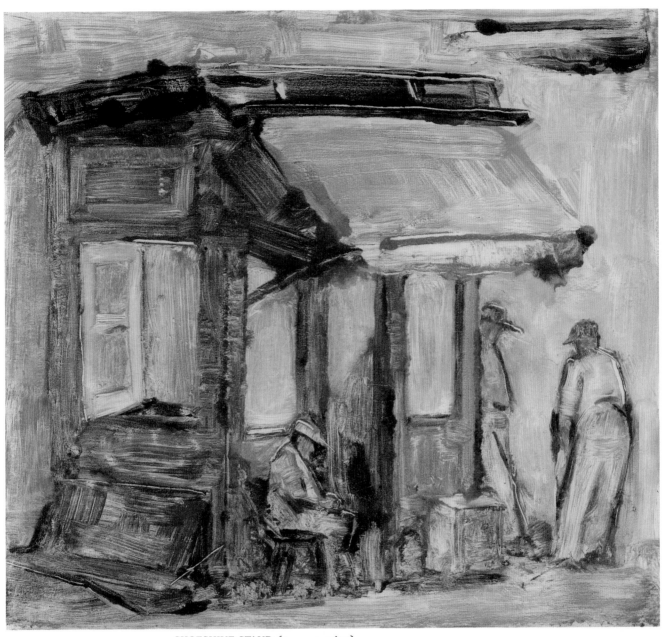

SHOESHINE STAND (green awning)
monotype, 8″ × 10″ (20.3 × 25.4 cm),
collection of Connie and Dr. Peter Ewald.

These two versions of a shoeshine stand were done at different times from different sketches. This shoeshine stand is in my neighborhood, and I've sketched it many times. The small sketchbook that I always carry with me is invaluable for making notes on things that I see that interest me. Many of my monotypes come out of these sketches.

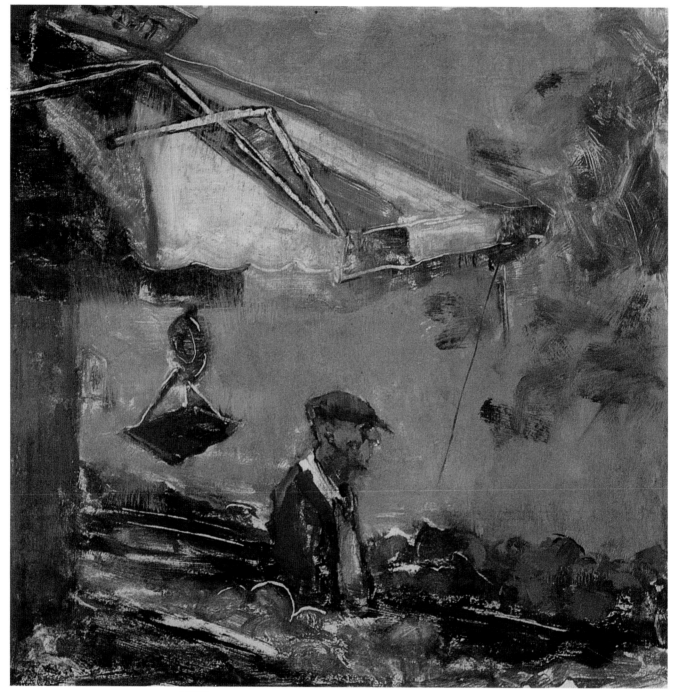

NINTH AVENUE FRUIT STAND
monotype, 9″ × 9″ (22.8 × 22.8 cm),
collection of R.J. Reynolds Corporation.

*This was done from rough sketches. Although I prefer to work
from life, I find it is too difficult to do monotypes outdoors.
There is too much built-in confusion working with the medium
itself, such as reversing the image or the critical drying time.
The street scenes are generally done from small sketches with
color notations or sometimes from more involved color studies
in oil that were executed on the spot. When I work from
sketches or studies I do the monotype right away, while the
scene is still fresh in my mind.*

TONY ASLEEP
monotype, 10″ × 8″ (25.4 × 20.3 cm),
collection of the artist.

*This was done from life, while my husband slept. Since he is
not fond of posing, I took this opportunity to do a quick study.*

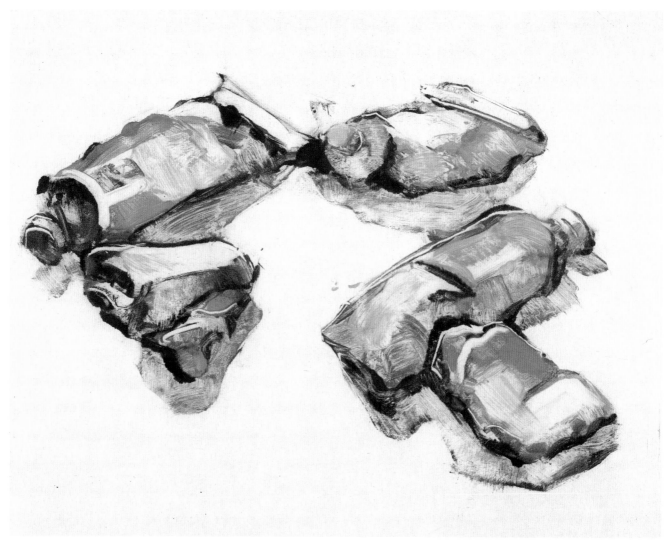

TUBES OF PAINT
monotype, 8″ × 10″ (20.3 × 25.4 cm),
collection of Mark Alan Isaacson.

In this monotype I have taken maximal advantage of the white paper, painting only those areas that show up as color.

ELEPHANT
monotype, 10″ × 8″ (25.4 × 20.3 cm),
collection of Maya Farnsworth.

This monotype was done immediately after seeing the circus last year. The Big Apple Circus is small and intimate, a one ring circus. It reminded me of what the circus used to be like and brought back some of the excitement of my childhood. I did several monotypes when I got home, working from sketches done at the circus.

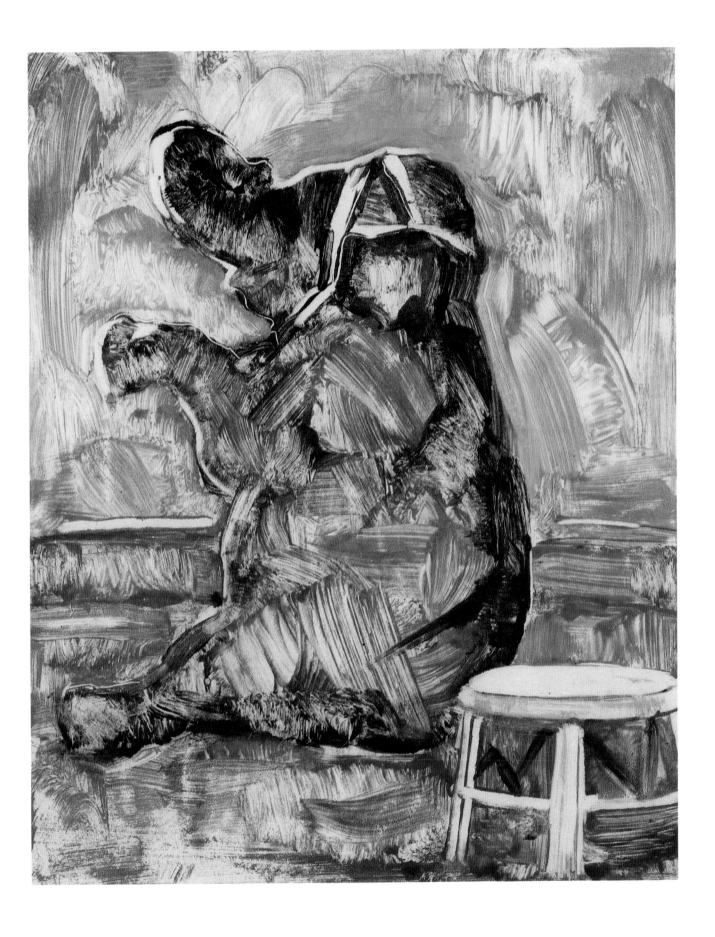

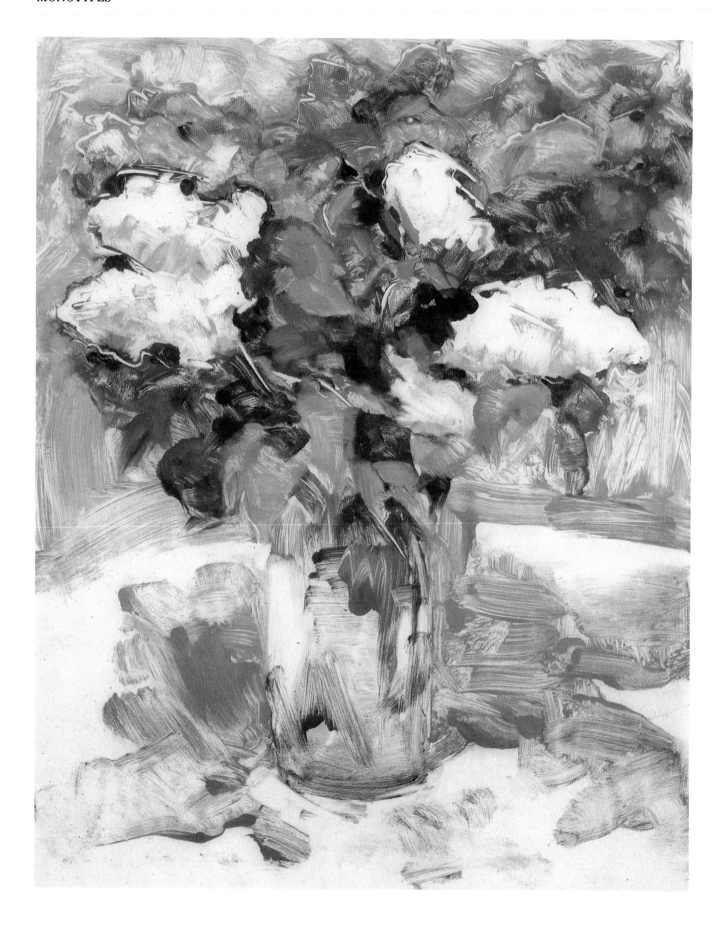

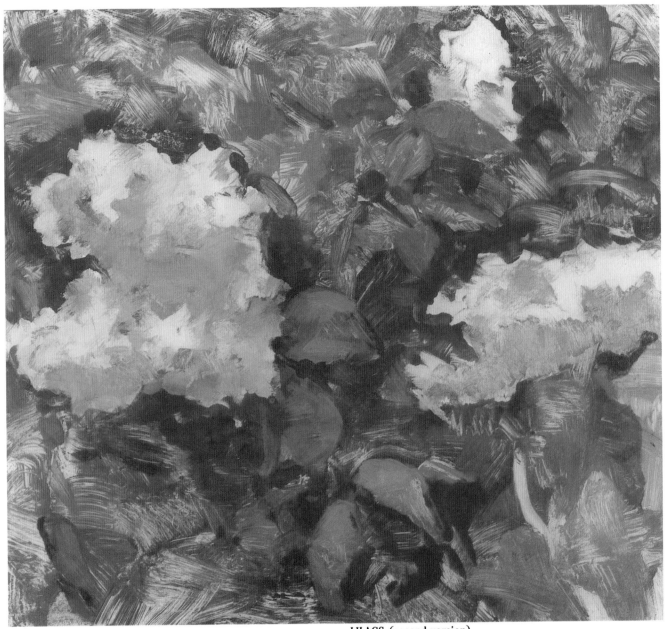

LILACS (second version)
monotype, 10″ × 8″ (25.4 × 20.3 cm),
collection of Sol and Bella Fishko.

*I often do several versions of the same subject. In this version
the flowers and the composition are dealt with in a more
abstract way.*

LILACS
monotype, 14″ × 11″ (35.5 × 27.9 cm),
collection of the artist.

*This is a good example of the important role that the color of
the paper plays. The white lilacs were not painted, but wiped
from the plate. I used a brush handle to delineate their shapes.*

MONOTYPE DEMONSTRATION
I enjoy doing monotypes. The medium forces me to work
quickly and boldly, and prevents one from fussing over
details. The color is fresh and strong—and unpredicta-
ble in its intensity—which is one of the challenges of
working in this almost automatically painterly medium.

*STAGE 1. Using a broad turpentine wash, I established the
scale and placement. I was concerned with a strong composi-
tion and tried to keep in mind that the final image would be
reversed. I began with the darks throughout the entire painting
and then began massing in the shadow areas at the same
time. I also indicated the color of the background. I left the
lights alone, allowing the white plastic to work as the light
pattern. None of this will print because it will dry too quickly.*

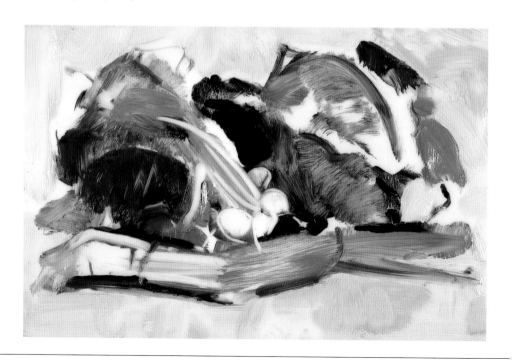

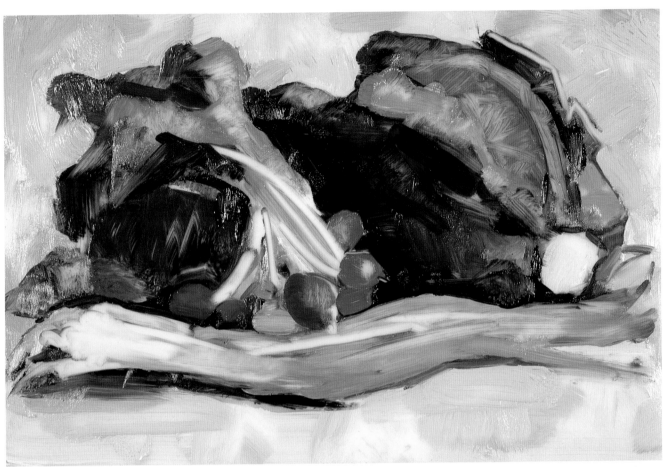

STAGE 3. As the monotype progressed, I wiped out areas I didn't like and repainted them. To get a light area back, I used a rag or my finger (Q-tips are also very useful for smaller areas). You have to keep in mind that the unpainted areas, or those left as the white plastic, will print as white. At this stage, I spent more time in each area and made the shapes more accurate. Painting very directly, I worked out the leaves of the radishes and the red cabbage, trying to keep them very simple.

STAGE 2. Time, as always an element with monotypes, forced me to approach the painting very boldly. Now that I had stated the background color, I realized that I had to strengthen the darks, because they were not strong enough in relation to the background. Working all over, I massed in the large areas of color, comparing each color to the surrounding colors and trying to get the relationships correct. At this stage, I was not concerned yet with details. Instead, I was trying to keep everything moving along together so that the entire painting was developing at the same pace.

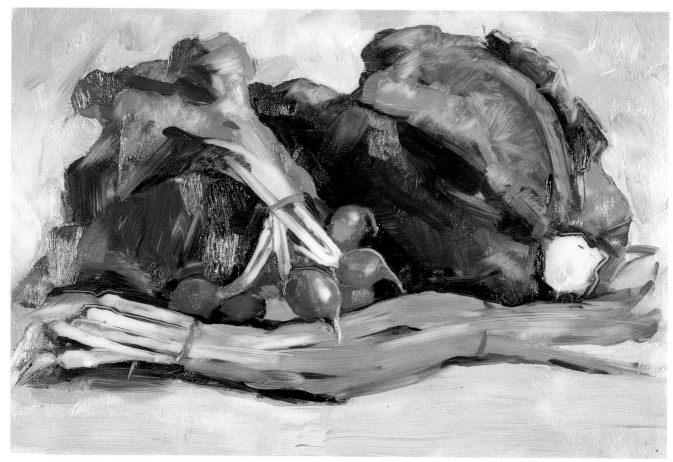

STAGE 4. At this stage, the painting was ready for more detail. I redrew the radishes and scallions; the stems seemed to repeat one another, which I found interesting, so I tried to get a repetition of the shapes. I also began to worry that I had spent too much time and that some areas may have already dried and wouldn't print. I used the handle of a brush to make a few crisp white lines in several places; for example, the light edges of the radishes and scallions, those edges that I wanted to emphasize. Some edges seemed too strong, like the outer edge of the red cabbage. I painted over the white line I'd already established, so that the edge would have less importance. If they are dry, the darks will lose their power, so right before printing I sometimes add a few very dark accents. At this point I usually hold the white plastic up to the light in an attempt to see more clearly what areas will print. I can also turn it around and get a vague idea of what it will look like reversed. (It's easier to see if you're working on clear glass because you can remove the paper from behind it.)

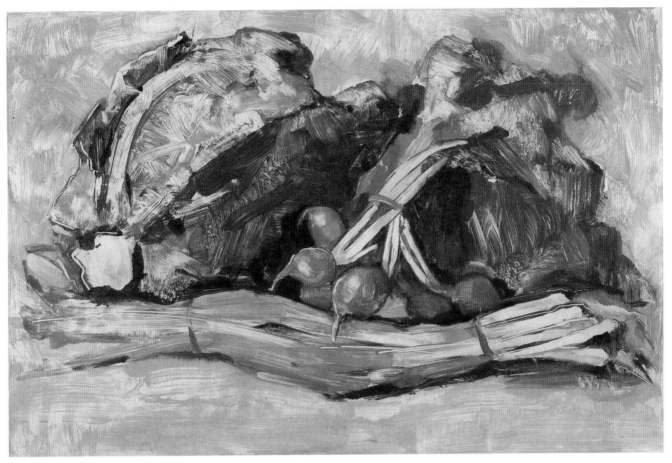

RADISHES, SCALLIONS, AND RED CABBAGE
monotype, 9″ × 14″ (22.8 × 35.5 cm),
collection of the artist.

*The final image is the reverse of what appeared on the plate. I
transferred the image by laying a sheet of rice paper (dry) on
my plate and then applying pressure with a spoon. I feel that
this monotype is successful in that the image is clear and
reads from a distance, but still something is missing for me in
the overall image. I'm not totally satisfied with it, but I'm not
exactly sure why. Perhaps the shapes are all of equal
importance or the colors are just a bit too strong. I guess I had
hoped for something different to happen in the printing. I'm
never sure how I feel about a monotype until I put it aside for
a while.*

INDEX